BASICS
CREATIVE PHOTOGRAPHY

02

Maria Short
Sri-Kartini Leet
Elisavet Kalpaxi

CONTEXT AND NARRATIVE IN PHOTOGRAPHY

2nd edition

D1212466

BLOOMSBURY VISUAL ARTS
LONDON · NEW YORK · OXFORD · NEW DELHI · SYDNEY

Context and Narrative in Photography

BLOOMSBURY VISUAL ARTS
Bloomsbury Publishing Plc
50 Bedford Square, London, WC1B 3DP, UK
1385 Broadway, New York, NY 10018, USA

BLOOMSBURY, BLOOMSBURY VISUAL ARTS and the Diana logo are
trademarks of Bloomsbury Publishing Plc

First edition published in Great Britain in 2005 by AVA Publishing SA as
Basics Creative Photography 02: Context + Narrative

This edition published in Great Britain in 2020 by Bloomsbury Visual Arts,
an imprint of Bloomsbury Publishing Plc

Cover design: Irene Martinez Costa
Cover image © Seba Kurtis
Original series design: Atelier www.atelier.ie

A catalogue record for this book is available from the British Library.

A catalogue record for this book is available from the Library of Congress.

ISBN: PB: 978-1- 4742-9117-0
 ePDF: 978-1- 4742-9118-7
 eBook: 978-1- 4742-9428-7

Series: Basics Creative Photography

Typeset by Lachina Creative, Inc.
Printed and bound in India

To find out more about our authors and books visit www.bloomsbury.com
and sign up for our newsletters.

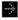

**Title: *Shared Shrines: Orthodox-
Muslim Interactions at 'Mixed
Shrines' in Macedonia*, 2010**

Photographer: Glenn Bowman

Bowman's anthropological
research on Christians and Muslims
sharing religious shrines in the
West Bank and in North Macedonia
supports his assertion that 'in
certain contexts the identities of
those engaged in shrine practices
might be relatively 'unfixed', an
ambiguity that is reflected in this
image itself. Photographs contain
visual clues that engage its viewers
in its reading, hinting at its broader
context and meaning.

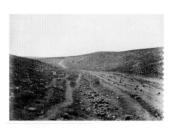
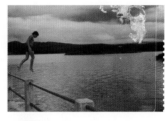

Contents

4

5

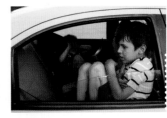

6

Most of us are surrounded by photographs; they perform a variety of roles and functions within and around our lives. From advertising images and news photographs to artworks on gallery walls or within digital collections, photographic images have become a ubiquitous presence in contemporary culture. Its applications range from everyday usage, for example, in the 'selfie' taken on a mobile phone to more distinct, specialized applications such as medical photography to aid scientific study. For some of us, photographs may be among our most treasured possessions.

Photographs tell us of the past; they can inform and contain memories. Photographs can aid in the construction of and influence our identity and our relationships with others. Photographs can promote the sharing of ideas, concepts and beliefs. They can also distort the truth; photographs can be highly subjective works of propaganda, they can be created and used responsibly or irresponsibly. As with most forms of visual communication, photographs reflect and promote particular ideologies.

Context is crucial to how photographic images communicate meaning. *Context* can be described as the circumstances that form the setting for an event, statement or idea. In photography, it can relate to the contents of the photograph, its placement in relation to words or other images, the site of display or place in which it is encountered or published, and the broader social, cultural, historical and geographical context. *Narrative* refers to a spoken or written account of connected events, a story that can convey an idea.

In using photography to tell a story or convey an idea, visual narrative techniques can be employed to create and develop frames of reference and specific contexts for the story, hold the attention of the audience and enable them to relate in some way to the story and its intention. In other words, narrative techniques are used to provide meaning and coherence to a standalone photograph or a set of images. The context and narrative of a photograph can work in a variety of ways to enable effective visual communication.

This book explores the concepts and mechanics behind the picture-making process in relation to context and narrative. It offers an introduction to some of the theoretical ideas that underpin and inform contemporary photographic practice and debate, extending this analysis to explore the ways in which photographers and artists have employed strategies to develop a coherent visual language. This book addresses photography as a creative and academic endeavour. It is intended for students and developing photographers to support their understanding of the relationship between practice and theory, as they define specific visual approaches to image-making. While it is possible to learn practical techniques and engage with theoretical debate, there is no prescribed formula in practice. The creative, thinking photographer makes decisions around the appropriate application of techniques informed by theoretical understanding, based upon their personal approach to visual language.

The book is divided broadly into two sections. The first three chapters focus on aspects of context; namely 'internal', 'original' and 'external' context. Building upon the concepts raised in the first half of the book, the final three chapters specifically address the narrative mechanics of visual language, exploring narrative devices in making meaning.

The photograph

Chapter 1 explores the photograph's 'internal' context: its content, form and choice of medium. Highlighting the photograph as a construction, notions of truth and reality within traditions in photography are discussed.

Visual approaches

Chapter 2 discusses visual methodologies and identifies a range of considerations to be made when either creating or responding to a brief, including an understanding of context that informs our decisions. Elements of the creative process, from concept, research, to practical production are explored.

Contexts of presentation

Chapter 3 examines the 'external' context of the photograph and how audiences' interpretations are affected by how and where images are encountered. Contemporary practices where images transgress the boundaries or contexts within which they were original made (for example, blurred definitions of traditional genres, found photography etc.) and aspects of photographic presentation are discussed.

Visual narrativity

Chapter 4 analyses notions of visual narrativity and explores a range of narrative devices that are employed to make meaning.

Photographic discourse

Chapter 5 introduces basic theory surrounding the use and reading of signs and symbols within photographs. It explores how photographs communicate and their potential for narrative development.

Image/Text

Chapter 6 explores the dynamic relationship between text and image and the myriad ways in which photographers and artists utilize these interactions in innovative ways.

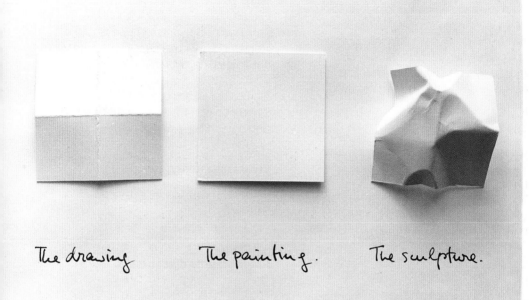

The drawing The painting. The sculpture.

The photograph.

The photograph

Title: *The Photograph*, 1981

Artist: Luis Camnitzer

As simple as this may sound, a photograph can be defined by its difference to other mediums, e.g. painting, drawing, or sculpture. As opposed to these, photography is a photo-mechanical medium that records fragments of this world as they appear to a particular observer and at a particular moment in time. Camnitzer's work reveals one more quality of photographs: transparency. Often, when looking at photographs, we look at the content and forget that we are dealing with yet another means of representation.

1

Looking at photographs is based on recognition. As with any other image type, viewers recognize shapes and decode messages, or narratives. Nevertheless, looking at photographs also implies an awareness of the means by which the images were produced.

Essentially, photographs are always of the past. These documented moments can be made with different intentions and can be used in many ways to bring relevance to the present. Understanding how these contexts can affect an image's role and meaning is most significant (in his 1990 book *Criticizing Photographs* [96], Terry Barrett calls these the 'original' and 'external' context of a photograph respectively), and it is the main topic of the next two chapters of this book; however, the viewers' expectations of the medium, their expectations of the 'internal' context of 'The Photograph', which is the main concern of this first chapter, underlies all other understandings and ultimately defines this conundrum that is photography.

An image's references to reality, to 'truth', as well as notions of form and materiality, are determining factors in photography. These considerations are sometimes overlooked because of the presumed directness and objectivity of the photographic image; their significance becomes more apparent in 'unreal', constructed images that invite questions such as: What is it that makes us think that we deal with photographs when we look at images that do not respond to reality? The answer to this, which is explored in the next sections of this chapter, but is also central throughout this book, seems to be that photography's realism, or the particular realism of the photographic image, allows us to immerse ourselves in an image as if it were part of reality, creating immediate, yet complex, forms of engagement.

Debates concerning truth and reality have surrounded photography since its inception. Photographs have the ability to literally depict visual appearances, but they can also be subjectively, conceptually and technically constructed or manipulated to present a particular view or idea (the latter ties in with the 'original context' of the photograph and the photographer's intentions that are explored in greater detail in chapter 2, 'Visual Approaches').

Most photographs do both: they replicate appearances, but they also conceal the codes and decisions that have been imposed onto the reality they represent. Even the most accurate photograph of an object differs from the object itself. This refers to the object's transformation from a three-dimensional entity into a two-dimensional one and the related lens distortions; changes in size, texture, colour etc.; and the context in which the image is shown (see chapter 3, 'Contexts of Presentation'). In their pursuit of the perfect document, photographers often create images that no longer respond to the object as we would experience it in reality. The resulting paradox is that the photograph reveals more than what empirical reality has to offer.

Photography's capacity to divert from reality becomes significant in documentary or photojournalism, where questions such as 'whose truth?' come to centre stage. Codes of ethics ensure transparency, but the photographer's view is always and necessarily a selective one and is influenced by his/her viewpoint, ideas and aspirations. Also the vast number of faked/transformed or manipulated images that surface in mainstream media outlets suggests that transparency is just an expectation.

At the other end of the spectrum is the argument that the photographer's responsibility lies with the ideas he/she communicates. In order to engage the viewer and evoke ideas, photographs need to communicate fluently; this is hardly the case if the photographer operates as just an assistant to the camera, which is presumed to record objectively whatever is in front of its lens.

The fashion and advertising industries have traditionally employed photography to promote and idealize products. Their commitment to images does not lie with objective truth but the creation of suggestive realities, dreams and fantasies of perfection. If these suggestive realities are likely to mislead or deceive the consumer, again there are mechanisms that protect consumer rights. And then there is art, whose purpose is to reveal an altogether different truth that is reserved for art alone.

Photography's complex relationship to truth and reality has led to a whole field of enquiry that belongs unto itself. Photography is ever-evolving, but some ideas that have surrounded the medium since its invention persist. For example, the capacity to manipulate images has increased with the advent of digital technologies, but this development does not undermine the realism of the photographic image and its ability to give evidence, provoke thought or create beauty.

Images are invested with expectations, and dependent upon the desired result, the photographer will engage with these 'levels of truth' in varying degrees, in both a practical and conceptual manner. The following pages provide a brief overview of some of the basic functions of a photograph in order to explore these 'levels of truth' in different photographic approaches. By no means an exhaustive or definitive list, the groupings highlight basic points relevant to some generalized functions of the photograph that will inform the photographer's approach in relation to notions of truth and reality and project development, as well as an image's production and reception, which are explored further in the next two chapters.

The literal depiction of appearances

In his 1844 book *The Pencil of Nature*, William Talbot, one of the principal inventors of photography, presents some potential applications of the newly invented medium. Talbot suggests that in the future photography could provide a valuable solution to archivists, publishers and collectors who would be able to record, copy and enlarge images faster and more accurately than ever before. Photography still had a long way to go towards expanding tonal range and recording colour, but its potential in documenting was already evident. As a mechanistic medium, which was produced using the 'pencil of nature', 'without any aid whatever from the artist's pencil' (Talbot 1844: 96), photography could potentially guarantee impartiality and objectivity, two main qualifying characteristics of documents.

Indeed, in the following years photography became a main tool for documentation. Museums, the police, scientists and schools all developed archives containing photographic documents. Geophotography, archaeological photography, art reproduction, microscopic photography, medical imaging (such as X-rays or MRI scans), police mugshots and crime-scene photography are only some of the genres that emerged out of this desire to document the world. Photographic documentation became the most common method of gathering information for analysis, and in a variety of disciplines.

The main function of photographic documents is to depict or record the visual appearance of something, someone or someplace. These photographs exist as evidence; so in these circumstances, the main thrust of the photographer's goal is to produce high-quality images that replicate the subject as closely as possible and according to the specifications indicated by the respective discipline. To achieve this, the photographer is required to be technically expert and make choices dependent upon equipment, lighting, composition and quality.

Title: *Sandy Springs Bank Robbery*, c.1920

Photographer Unknown, Courtesy of National Photo Company Collection (Library of Congress)

A scene-of-crime photograph; note the level of attention paid to exposure and tonal quality, thereby allowing the image to be as detailed as possible.

Enhancing the accuracy of a photographic document

- Think in advance: Which parts of the object/person/location are important to include/highlight in the image? This relates to the purpose and use of the image. In the case of documenting the effects of a blizzard, for instance, a clearly identifiable object like a car buried under the snow will be clearer than a wide-open landscape.

- If possible, isolate the subject. If you are documenting a small object, include a plain background, or, if on location documenting, for example, a building or architectural structure, choose a quiet time of day.

- Use direct/frontal camera angle and a telephoto lens to avoid perspective distortions. This is particularly important when recording abstract shapes and objects that viewers are not familiar with, such as an abstract sculpture.

- Illuminate the object from the sides to avoid reflections. When photographing paintings, for example, it is important to eliminate reflections that could be perceived as part of the work.

- Avoid harsh shadows: use soft light or a cloudy sky.

- A sharp lens and high resolution, or a fine grain film, can bring up the detail of the subject.

- For best results, use a medium/large format camera and a tripod.

- Use maximum aperture to increase depth of field.

- If scale/colour is important, include size/colour scales.

The documentary tradition – truth or fiction?

The photographic camera cannot produce an image out of a vacuum; therefore, documenting or recording reality could be seen as an inherent call of the medium. However, documentary photography exceeds the sole purpose of documentation.

In *What is Documentation?* Suzanne Briet (1951: 9–10) defines a 'document' as 'a proof in support of a fact'. 'Documentary production', on the other hand, is a process whereby documents are 'selected, analyzed, described, translated'. As such, documentary photography illustrates a secondary process of selection, analysis, description and translation of facts. This also applies to photojournalism, which is a subgenre of documentary that implies a weightier relationship with current events, text and news stories.

In simple terms, documentary photography and photojournalism can both refer to the photographic telling of a story with a particular intention. Storytelling in photography is extensively discussed in the second part of this book; what matters here is the character of these intentions. Karin Becker Ohrn (1980: 36) offers a definition that hints at this: 'The photographer's goal was to bring the attention of an audience to the subject of his or her work and, in many cases, to pave the way for social change.' Effecting social change requires a degree of responsibility, but it does not necessarily guarantee objectivity or access to truth.

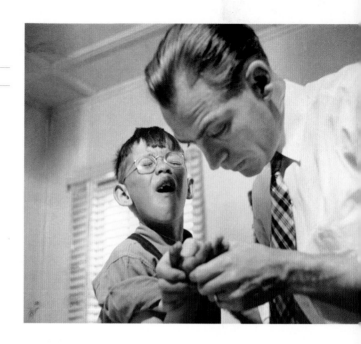

Title: *Dr. Ceriani Examines a Boy's Hand*, 1948

Photographer: Eugene Smith

For example, the photographic stories of British publication *Picture Post* (1938–1957) and American publication *Life Magazine* (1936–1972) were mass-produced and distributed and had the capacity to affect people's perceptions, but they were also often staged. It is an open secret, for example, that stories such as Eugene Smith's 'The Country Doctor' for *Life* in 1948 were staged. The story was written before the editors of *Life* had even identified a suitable doctor or a potential photographer. Further, Eugene Smith (2013) never denied that he was staging his images.

Documentary photography may not be entirely objective, but, as is also highlighted in chapter 2, 'Visual Approaches', it can be considered the means of conveying what the photographer feels to be the spirit or essence of a person, place or event. Social documentary is rooted in the photographer's experience of the subject and can offer a visual experience in order to initiate, share or convey an understanding or a narrative that goes beyond words. Documentary and photojournalism require the photographer's involvement with the subject; a sense of responsibility toward the photographic brief, subject and audience; and the ability to negotiate with ethical issues.

'I ask and arrange if I feel it is legitimate. The honesty lies in my – the photographer's – ability to understand.'

Eugene Smith, 1956 (Smith 2013)

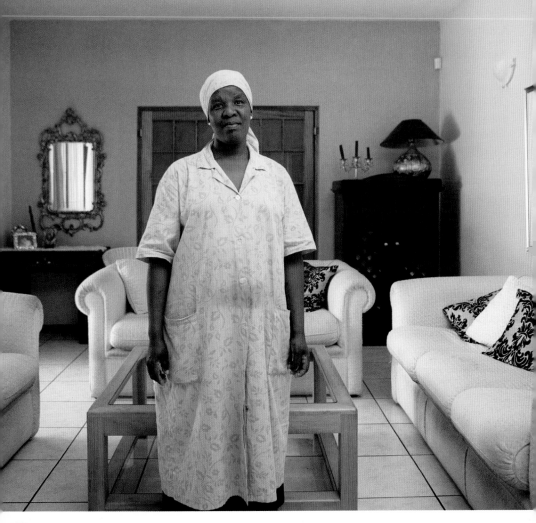

Title: from 'Boys and Girls', Gladys, East London, 2009

Photographer: Shaleen Temple

Temple describes her series of photographs as follows: 'This project is about black South Africans who work in white South African homes. Growing up in South Africa before moving to the UK means that this part of African culture is something I grew up with. The project questions how far the country has come since the end of the apartheid. It also looks at the relationship between the workers and their white employers' (Temple, 2010).

A different kind of truth

Photography's capacity to record the world did not only influence the development of documentary photography. Principles of objective and/or subjective adaptation of reality inspired photographers working in all genres, including fine art photography. Considering that the conventions regulating content and presentation that apply in other genres do not apply in art, photography's possibilities for expression in this field are limitless. Nevertheless, despite the exciting potential of this plurality of possibilities, the question of 'what art-photography should be?' has dominated the field since the beginning, and the answers vary greatly.

One answer that still dominates today is that photography should be concerned with its own characteristics as a mechanical medium of recording instead of trying to imitate techniques and styles coming from other mediums – as happened, for example, in pictorialist photography in the late nineteenth century that imitated painting in introducing colour, texture and atmosphere achieved through the physical manipulation of prints. In *The Photographer's Eye* John Szarkowski suggests: 'It should be possible to consider the history of the medium in terms of photographers' progressive awareness of characteristics and problems that have seemed inherent in the medium' (1966: 7). In this particular book, the characteristics that photographers became progressively aware of and increasingly drew their attention to consist of: 'the thing itself', meaning the objects and scenes that the photographer points their camera at, 'the detail', 'the frame', representation 'time', and 'vantage point'. This shift of attention from the work's social function to photography's inherent characteristics illustrates photographic formalism.

'A great photograph is a full expression of what one feels about what is being photographed in the deepest sense, and is, thereby, a true expression of what one feels about life in its entirety. And the expression of what one feels should be set forth in terms of simple devotion to the medium a statement of the utmost clarity and perfection possible under the conditions of creation and production.'

Ansel Adams, 1943: 378

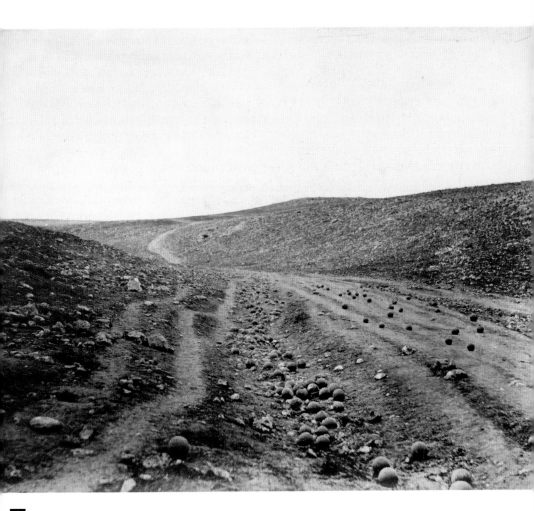

Title: The Valley of the Shadow of Death, 1855

Photographer: Roger Fenton

The Photographer's Eye contains documentary images that are arranged according to their emphasis on one of the 'formal' photographic characteristics ('the thing itself', 'the detail', 'the frame', representation 'time', and 'vantage point') without any reference to the photographers' intentions or the issues addressed in the images. Roger Fenton's image from the Crimean War, for example, is included as an example of an image presenting emphasis on 'the detail'. The description of the work in the book is reduced to its title.

Formalism is a mode of visual analysis that was influenced by principles dominating art in the 1920s and which has received much criticism for ignoring the photographers' intentions and for a lack of social considerations. However, there is also a whole range of images that have been made with formal issues in mind. From the 1920s onwards, a strand of photographers – including Edward Weston, Ansel Adams, Minor White and others – started depicting the world using sharp lenses and fine-grain film, as well as techniques such as the zone system – Ansel Adams's technique for identifying optimal exposure to create images of immense clarity, detail and tonal range. The value of these works does not lie in their use as 'proof in support of a fact' (see previous section), but in their aesthetic value and their reference to genres that had traditionally been linked to art, i.e. the landscape, the still life, the nude.

Formalist principles were also embraced by New Topographics, a photography movement characterized by deadpan aesthetics and a sense of detached objectivity. This style defined the work of a number of different photographers who were active in the 1970s, both in Europe and Northern America, whose work came together in an influential exhibition at George Eastman House in 1975. The show was titled 'New Topographics: Photographs of a Man-Altered Landscape' and provided a name, an umbrella term, that since then illustrates the work of a number of different photographers that shares similar principles and aesthetic values. The work of New Topographics photographers, such as the images of industrial structures taken

by Bernd and Hilla Becher in post-war Germany, could find no use outside gallery spaces. Their typologies are reminiscent of archive records, but the Bechers had no desire to associate their work with any scientific or historical research, nor did they think that their work could be useful to researchers; their interests lay with pattern, rhythm and repetition. What kind of 'truth' could such work that operates outside social realities reveal? According to Blake Stimson (2004), the value of the Bechers' work lies in pleasure and commitment, without any aim or personal/collective interest. This idea may contradict the principles of documentary photography, but it resonates with much photography in contemporary art and ties in with philosophical investigations of aesthetics dating back to the Enlightenment.

Title: 'Colours of Ethiopia': Somali VI, 2014 and 'Colours of Ethiopia': Somali VIII, 2014

Photographer: Leikun Nahusenay

Nahusenay's series 'Colours of Ethiopia' documents everyday life in Jijiga, Ethiopia's Somali capital. The images replicate signs of documentary photography in terms of content, but his choice of double-exposure, the images' saturated colours and superimposed textures encourage an emphasis on form. This body of work presents a tension between content and form, through which the series also achieves its meaning.

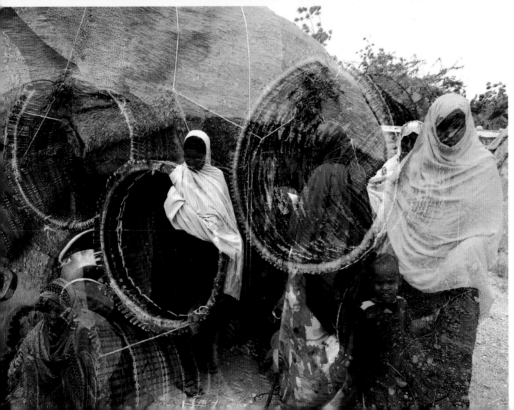

Even though the distinction between form and content has, for a number of years, marked the difference between photography in art and general culture, more recently the boundaries between the two have started to dissolve. As will also be discussed in chapter 3, 'Contexts of Presentation', documentary photography is now comfortably shown in art galleries and museums, and the emphasis on colour or composition does not seem to challenge the documentary value of a work. The current consensus seems to be that both form and content contribute to an image's meaning, within and outside art. This topic will be further discussed in chapter 2, 'Visual Approaches', with reference to the technical execution of the work and its importance in supporting the photographer's conceptual approach.

Beyond the recording of appearances

In his book *Camera Lucida*, Roland Barthes embarked on an exploration of the ontology of photography, meaning, 'what Photography was "in itself," by what essential feature it was to be distinguished from the community of images' (1980: 3).

Barthes starts with a classification of images based on his own emotions. Even though most images discussed in the book are by the well-known photographers – Alfred Stieglitz, André Kertész and Robert Mapplethorpe, amongst others – he is not particularly interested in the technical quality or artistic nature of the work. The images allow him to distinguish between what he calls, the *studium*, i.e. a generalized interest in an image because of its subject-matter, composition and

'mastery' of the photographer, and the *punctum*, a detail or a set of details that hold his gaze for much longer and manage to stir emotions and forgotten memories.

This distinction between the *studium* and the *punctum* does not only apply to images that we see in books and exhibitions but also to images of people we know. Barthes is in the apartment in which his mother died, looking through a collection of her photographs; looking, in his words, for 'the truth of the face I had loved' (Barthes 1980: 67). Eventually he finds a photograph that contains aspects of his mother's character that he was searching for. The faded image, taken before he even knew her, when she was five, allowed him to rediscover his lost mother. This incident helped him illustrate his definition of photography's essence.

According to Barthes, photography manages to transform a subject, e.g. a person or a scene, into an image. Within the fragment of time it takes to take a picture, we have a separation between the world and its image. The reality depicted in the image is irretrievable; there is no way we can literally return to the past. Yet, a photograph is a trace of the past, of a past that the image is already separated from. This reference to the intractable past, this notion that 'that-has-been', for Barthes, illustrates photography's essence and is an awareness that is sometimes experienced with indifference and some others with great astonishment.

Title: *A collection of family photographs*

Photographer: Unknown

A collection of formal and informal family photographs that offers a gateway into the existence of ourselves and others.

Barthes articulates a way in which many of us relate to photographs; the manner in which they convey an aspect of the shared human experience and provide some form of tangible evidence or gateway to the existence of ourselves and others. The manner in which the photograph can go beyond the recording of appearances and convey something of the individual's character or circumstances is something that we can relate to in both the production and sharing of our personal photographs. We may hold dear photographs of the deceased or from a time long past. Photographs may help confirm, or indeed even create, our sense of personal history and identity. In a similar way, we can use photographs to portray our identity, an identity that may be consciously constructed or simply revealed with a smile or gesture. Photographs can keep memories alive, but they can also create, distort or substitute memories.

Some questions for consideration:

What makes us recognize beloved people in some pictures and not in others?

Why do images divert from the essential 'truth' of a person as we have experienced it?

What are the implications in relation to members of the family that we have never met?

Photographs as objects

The value of a family album lies with the personal or collective memories that constitute a family's identity. We might not always recognize scenes and members of the family, or some images might be too old to reflect personal memories, but the images invite a particular type of engagement. This means that it is not necessarily the content of the image that invites personal engagement and identification. The images' authenticity is validated by their appearance (signs of aging, technology used, any written notes) and inclusion in personal archives.

This is to say that photographs are not just images; they are also objects, and sometimes their materiality and function as objects is crucial for their significance or meaning. In the introduction of *Photographs Objects Histories: On the Materiality of Images*, Elizabeth Edwards and Janice Hart explain: 'thinking materially about photography encompasses processes of intention, making, distributing, consuming, using, discarding and recycling, all of which impact on the way in which photographic images are understood' (2004: 1).

The technology and chemistry used for a particular image, as well as its signs of aging, can provide useful information about its history. These days, with the wider marketability of photography, marks on the surface of an image are seen as signs of authenticity that can influence the image's price.

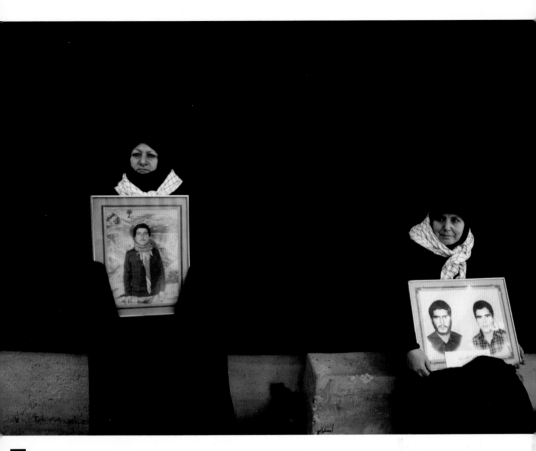

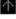

Title: from 'Mother of Martyrs', 2006

Photographer: Newsha Tavakolian

Every Thursday and Friday, Iranian mothers who are proud that their sons have given their lives for Iran visit the cemetery. Their sons died fighting Iraqi Republican Guards. They all cherish the portraits of their sons. This photograph is a clear example of how significant photographs can be to those who have lost loved ones.

Regardless of its reputation as a medium for the reproduction of appearances, in the course of its existence, photography has employed a number of different technologies and has allowed for a great deal of choice in presentation. The size and quality of a print can influence our impression of the image's content. For example, from its appearance, we can tell whether an image has been made for publicity and is to be shown in a public space (e.g. a poster). A landscape on a postcard most likely illustrates a tourist destination. Fine art prints are usually of high quality, allowing greater access to the image, and are usually made in limited editions for exhibition or archival purposes. All these conclusions are drawn from the format of the image and its material basis.

The materiality of photography seems to be less relevant in the digital age, where most images are made and viewed on a screen. Nevertheless, the material support of the image, i.e. the screen, can again reveal a lot about the image: the technology through which it was produced, the data that it consists of (including metadata), its capacity to network.

The function of photographs as objects has largely been ignored in the past, but it is increasingly inviting attention because it allows access to photography's myriad uses. Thinking about photographs as objects has also received attention in art, where artists employ different technologies and modes of presentation to enrich the meaning and communicative possibilities of the work, or they appropriate and re-contextualize existing images to highlight the difference between the image's initial purpose and its function in art (see chapter 3, 'Contexts of Presentation').

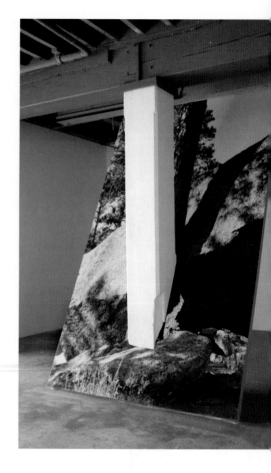

Title: *Ghost of a Tree*, 2012 and *Badlands Concrete Bend*, 2015

Photographer: Letha Wilson

Letha Wilson is an artist who works predominantly with photography, but her work is presented in a three-dimensional form. Wilson calls her work 'photosculptures'. The sculptural effect is often achieved through the arrangement of the images in space or mixed media techniques that create a play between reality and representation.

Altered photographs

The previous sections explored the idea that both content and form are crucial to our understanding of photographs. There are certain expectations linked to the photographic image. There is an expectation that photographs are made in reaction to light with the use of a photographic camera, and that even though they might not necessarily produce recognizable shapes and scenes, the images are records of actual moments in time. These expectations do not necessarily come consciously to mind when we look at photographs, but they underlie our understanding of them.

However, our ever-increasing encounters with images come with a growing awareness that images can lie, and that this has always been the case. In 'The Heroism of Vision' from *On Photography*, Susan Sontag describes: 'In the mid-1840s, a German photographer invented the first technique for retouching the negative. His two versions of the same portrait – one retouched, the other not – astounded crowds at the Exposition Universelle held in Paris in 1855. . . . The news that the camera could lie made getting photographed much more popular' (Sontag 1971: 85-86).

As Sontag illustrates through this incident from the early days of photography, our expectations are not reduced to recording the world. The camera can lie, and this dynamic between a mechanical tool and its highly subjective use has been central to photography since its inception.

Choosing between documenting real objects and scenes and constructing realities drawn from one's imagination defines two different approaches to photography and marks the distinction between documentary, where truthfulness and accuracy are of crucial importance, and creative uses that entail a degree of fiction. Some photographs operate as objective records of an object or scene; others are enhanced; and, finally, some images are clearly constructed in order to convey a particular idea or concept. This might be achieved through photographing a constructed set or by manipulating an image either in-camera or post-production, and sometimes both.

Brands and companies – from local independent businesses through to international conglomerates – use photography to varying degrees to state their company identity and promote their products and services. In some circumstances, the photographer is concerned with enhancing the product and its effects on the consumer. In other circumstances, the main thrust of advertising photography is to create a spirit of lifestyle. The photographer creates a piece of theatre, a stretched or distorted setting to allude to something beyond the product itself. Constructing an altered reality often leads to complex, playful and sometimes even shocking images that require the photographer to engage with an idea in a way that is often removed from the ordinary existence of daily life.

Title: *Untouched* and *Retouched*, c.1895

Authors: Robert Johnson and Arthur Brunel Chatwood

In 1895 Robert Johnson and Arthur Brunel Chatwood put together a comprehensive guide to photography that illustrates developments during the first half-century after the medium's invention. The authors have included a whole section on 'Retouching'. In this section they defend its use and justify their choice to retouch most parts of the face in a portrait: 'judicious retouching is a very great advantage we have no doubt whatever; it is an absolute necessity, in our opinion, in order to obtain the best result, which is admittedly the object of all art' (Johnson and Brunel Chatwood 1895: 121).

For example, musicians rely heavily on photography and other visual communication to convey their artistic identity. Often the visual language employed in album covers and music artworks extends beyond the visual representation of the musicians or the music and becomes a cultural experience of the band's creative ethos. The album cover for Nirvana's *Nevermind* (showing a baby swimming and reaching out for a dollar bill) was photographed in California in 1991 by underwater photographer Kirk Weddle. Designed by Robert Fisher at Geffen, the cover makes a striking image and is an ironic allusion to the band's counter-culture ethos.

Whether destined for private use or to be exhibited in a gallery or for use in advertising, the constructed photograph engages the viewer in a manner that challenges or distorts notions of truth and reality. Narrativization is inherent in many uses of photography, including documentary (see second part of this book); however, constructed images, more often than not, invite the viewer to immerse themselves in a fictional world. For example, Dolce & Gabbana's campaigns '# Italia is Love' (2016), '# Napoli' (2016) and '# DG Palermo' (2017) draw on the brand's origin in Italy. The images feature typical Italian street settings occupied by a mixed crowd of locals, fashion models and consumers dressed up in high fashion attires. The images illustrate warm-hearted interactions between the locals and the fashionistas, with the locals' attitude and gestures connoting tradition and hospitality and the fashionistas connoting openness and excitement. The strong sense of location, with 'trattorias' and fruit stalls in the backgrounds, marks Italy as a place where these two worlds meet. People's exaggerated gestures, as well as the vibrancy of the scenes, their saturated colours, and polished floors, suggest a stretched reality.

Advancements in technology, and computer-generated imaging (CGI) in particular, have allowed the creation of convincing images that closely resemble photographs and do not require any use of a camera. The proliferation of CGI in certain fields that were previously dominated by photography – such as architecture, the automobile industry and product imaging – has provided a new challenge to photographers who have lost some of their influence in the industry. However, the implications of technological developments do not concern commercial applications of photography only: they also concern philosophical questions regarding photography's survival. Will CGI replace photography as we know it, or should CGI be considered a strand of photography instead?

CGI is not new. In the 1990s the film industry and artists were already employing computer technology to create creatures and settings that had no correspondence in reality. Whether this was to refer to future or past realities or constructs of the maker's imagination, computer technologies opened up new avenues in the creation of alternative worlds that look as real as reality itself.

Lev Manovich in his influential 1995 essay 'The Paradoxes of Digital Photography' claims that computer generated images are too perfect to be credible. Computers can create images that do not contain any 'flaws'. This still applies today, and does not only refer to unattainable ideals of beauty, an issue that has received much attention in the media, but also 'flaws' of vision, human and photographic. The difference between a computer-generated image and an image created through a recording device, such as photography or video, becomes immediately apparent in composites that contain both, as happens for example in *Jurassic Park*, a film that is also discussed in Manovich's essay. The solution in this film, as explained by Manovich, was to reduce the quality of the computer-generated images in order to make them compatible to the inferior quality of the video.

Twenty or more years later, such issues of compatibility have been reduced. Digital technology has improved, and images are often composed in their entirety, eliminating issues of compatibility. Image-makers have found solutions in imitating textures to the point where they can produce three-dimensional virtual versions of objects that are more detailed than what the human eye can see. However, even though it does not have to, CGI technology continues to imitate flaws of photographic vision, such as depth of field, lens flares and camera distortions. What is at stake is not limitations of technology anymore but something entirely different, which links back to the content of this chapter: the notion that photographic vision is the means through which these images become plausible. The images are made as if through a camera in order to invite readings as if they were records of reality. CGI's truth is informed by our understanding and experience of photography in any mode of documenting, narrating, objectifying, idealizing, faking and ultimately, relating to reality. Such make-believe rules do not apply to CGI only but to every constructed photograph ever made during the history of photography: CGI only made them more apparent. CGI highlights the point that photography's realism is yet another realism. Photographs are not direct depictions but versions of reality that are defined by photographic technology and the flaws of its vision.

Levels of truth

The value the audience attributes to the photograph can be evidential, scientific, aesthetic, emotional, and physical. As such, expectations in relation to the truth-value of the image can vary greatly.

Further, a photograph can distort reality by:

- Portraying the moment, person, place, event or idea in a particular way.
- Including/excluding relevant factors, composition and timing.
- Encouraging projection of the viewer's feelings and ideas onto the image (e.g. in family portraits).
- Abstracting reality, e.g. focusing on detail, form and unexpected viewpoints.
- Being altogether fabricated, staged or constructed.

Do your photographs distort reality? To what degree does it matter?

Title: *Gumball*, 2012 and *Lost Water*, 2010

Photographer: Richard Kolker

Kolker started creating complex computer-generated images while he was still studying photography in the London College of Communication. The images are created with a computer, without the use or aid of a camera; they are, however, exhibited and discussed as photographs.

Regardless of the nature of a project – professional brief or self-directed – it is important that the photographer is conscious of the way their work communicates. Chapter 2, 'Visual Approaches', will expand on notions of research and documentation with reference to the photographer's intentions and approach. However, as a project develops it is important not to lose sight of basic questions, such as the following: Why a photograph? Why not present the subject through another form of representation, such as words or painting? Such questions, as simple as they may sound, are crucial for the development of mature projects. By choosing to make a photograph, one is engaging with a range of references and implications that the audience will bring to their reading. It is therefore important that photographers too are conscious of these references.

As a photographer's awareness of his/her chosen medium and the issues they deal with grows, their projects and approaches change. Research and documentation can help formulate ideas/concepts as they develop, as well as bringing consciousness to different decisions.

Research

Research aims at a better understanding of a topic or a field. Photographs can be . . .

a. Subject to research: Photographs can be used in order to extract information relevant to research and in a variety of disciplines such as medicine, ethnography, anthropology, archaeology, history and art.

b. Outcomes of research: In this case, research precedes and informs the photographer's approach. Research can be primary (including interviews, questionnaires, surveys and direct observations); or secondary, drawing on existing knowledge bases (including historical, political, aesthetic, legal and market).

Documentation

Most photographers keep a record of their research and project development. This can take the form of a sketchbook, a container or a digital folder containing a range of material relevant to a project and ideas under development:

- Outcomes of research
- Diaries and field-notes
- Release forms
- Budget calculations
- Sketches
- Photo-shoot plans
- Ethics and risk assessment forms
- Technical experimentations
- Sources of inspiration
- Contact sheets
- Ideas about presentation
- Letters and communication

And much more . . .

Title: *Pages from the artist's sketchbook*, 2009-2011

Photographer: Elisavet Kalpaxi

These two pages from the artist's sketchbook illustrate the gradual development of her composite narrative images. This series of images is further discussed in chapter 4, 'Visual Narrativity'.

'Photographers should actively look for ideas, attitudes, images, influences from the very best photographers of all ages. You cannot learn in a vacuum. The whole history of photography is a free and open treasure trove of inspiration. It would be masochistic to deny its riches and usefulness.'

David Hurn and Bill Jay, 1997: 90

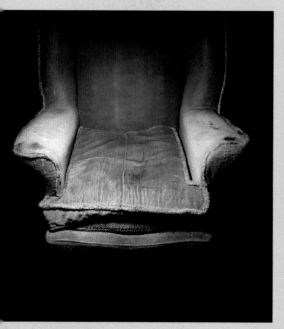

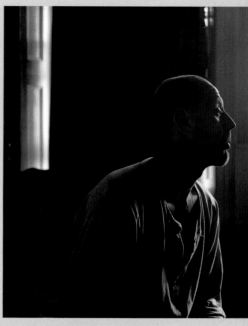

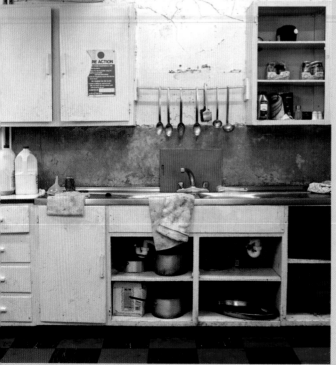

Title: from 'The Regency Project', 2007

Photographer: Richard Rowland

Guided by his previous working life as a drugs counsellor and homeless support worker, Richard Rowland applied a documentary approach to photograph the space, its marginalized inhabitants and the objects left behind by previous residents. Using a Kodak Portra VC 400, a Hasselblad 6x6 format and mainly natural lighting with the occasional use of direct flash, Rowland made approximately fifty-five visits to photograph the location and its inhabitants.

Case study 1

For almost a quarter of a century the Regency House, a building dating back to 1827, has offered privately run accommodation for homeless men in the south of England. By the early 2000s, when it was acquired by the Brighton Housing Trust, the building had developed a reputation as an abandoned and dangerous place.

Change came in the shape of the Brighton Housing Trust's plans for a radical refurbishment. During the next three-year period, the building would be divided into two halves and the entire interior would be dismantled and restructured, whilst the residents still lived there.

At this time, Richard Rowland was working for the housing association that had recently purchased the building. When he heard about the state of the building and the plans to redevelop it, he thought it seemed like a great project to get involved with. He arranged a meeting with the director and outlined his project proposal: to document the restoration process of the building.

Supported by the Heritage Lottery Fund, Rowland recorded the building's restoration throughout its refurbishment until the project's completion in 2007 in the book *The Regency Project*, released the same year and co-authored by David Chandler. He conducted interviews with the building's previous and current tenants and compiled a complete record of the property's ownership history. Although his initial intention was to record the building's interiors only, his motivations gradually changed, as he writes: 'People's lives had become enmeshed with this place and the initial process of recording the physical refurbishment became more of a response to the human presence in the building' (Rowland 2007: 11).

Rowland drew upon his professional experience as a drugs counsellor and homeless support worker to interact in an appropriate manner while photographing on location and when engaging with the ethical issues surrounding the project. Rowland's vision of the potential for this project comes from him combining his cultural and social awareness with his personal approach to photographic language; thereby employing his own personal and professional strengths.

Case study 2

Originally trained as a painter, Keith Arnatt is a photographer whose work, besides its references to documentary, exposes an interest in form. Unlike the formalist critics of the 1920s, however, Arnatt believed that art should not be separate from life.

'Miss Grace's Lane' (1986–1987) is a series that emerged out of his continuous desire to document his immediate surroundings in Wye Valley, on the border between England and Wales, but also out of his awareness of the conventions of the landscape as a genre in painting.

Wye Valley is designated as an Area of Outstanding Natural Beauty, and through the ages it has lent itself to romantic representations by painters such as J.M.W. Turner and Samuel Palmer. Instead of idealizing the landscape, as these painters had done in the past, Arnatt decided to include signs of human intervention that earlier artists and photographers chose not to include.

Arnatt's approach embraces – and objects to – elements from both photographic and painterly traditions of image-making. His decision to use a 5x4 camera and his interest in 'matter-of-factness' derives from the documentary tradition. However, unlike documentary photographers whose main intention is to raise awareness and to be a vehicle for social change, Arnatt's intentions were to comment about 'the nature of picture making' (Oral History of British Photography 1993). His decision to depict landscape in colour, which was still an unusual decision in the 1980s, was influenced by Samuel Palmer's use of colour and light. The fact that some of these images could make reference to that tradition through their light, colour and composition was a determining factor in the selection of the images for the series.

Arnatt's images draw on different traditions of picture making and were made with an art-historical framework in mind. As such, the kind of audience that this kind of work invites is an informed audience that understands or can recognize these references. Without this awareness, the work's meaning is lost.

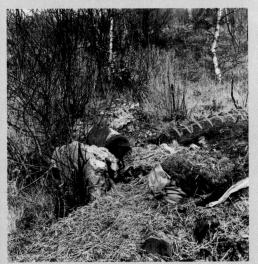

Title: from 'Miss Grace's Lane', 1986–1987

Photographer: Keith Arnatt

'The idea of making pictures . . . which are not chaotic, out of chaos, is something that interested me. . . . What you have in front of you is so, so, so chaotic, that you are almost bound to take chaotic results. . . . But by positioning, by a number of devices, choosing the right light, the right time, and so on, occasionally you will bring some kind of sense to it.' (Oral History of British Photography 1993a)

Title: *Arkwright Road*, **2012**

Artist: Zoe Leonard

'Neither analogue nor digital, the camera obscura offers a state of looking, an experience that is not fixed. It opens doors between things, brings awareness into our looking' (Leonard 2014).

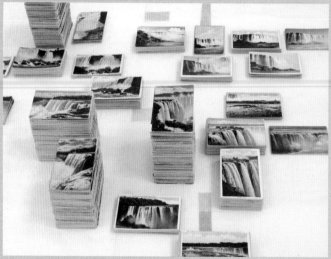

Title: *Survey*, **2009-2012**

Artist: Zoe Leonard

Survey provides a geographical mapping of the most popular views of Niagara Falls. The work addresses a number of ideas relevant to mediation, collecting and a systematic, even obsessive, sense of organization.

Title: *Lost for Words*, **2011**

Artist: Zoe Leonard

'Turning to the sun breaks every rule – it's not only the textbook "Don't shoot into the sun," but also a more primal rule, "Don't look at the sun" – since, as you say, it will burn your eyes out' (Leonard 2014).

Case study 3

'Observation Point' (Camden Arts Centre, 2012) by Zoe Leonard is an exhibition that is set apart from other photography exhibitions in that, instead of presenting a photographer's response to a theme, its main concern is photography itself. Each gallery, each body of work in the exhibition, suggests different understandings of photography.

Lost for Words (2011) is a series of hand-printed photographs of the sun. The work presents source (light) and outcome (prints), eliminating anything in between.

Survey (2009-2012) presents a collection of 6,266 postcards of the Niagara Falls. Similar images are stacked together in uneven piles, indicating the popularity of each vantage point.

The third space of the exhibition was converted into a camera obscura, *Arkwright Road* (2012). This work is not photographic per se, i.e. it is not a photograph, but it takes the viewer back to photography's ancient origins.

Zoe Leonard is looking at photography as a changing medium. She has often claimed that much of her work is about what we seem to be losing with the advent of digital technologies and photography's contemporary condition:

> I was frustrated by many of the conversations I was encountering around contemporary photography. They often seemed defined by a series of binary categories: analogue versus digital, subject versus material, representation versus abstraction, conceptual versus so-called straight photography. I wanted a more expansive way to think about the medium and found myself asking what photography is, what its limits are, what defines it (Leonard 2014).

Through this body of work, Leonard takes us back to Roland Barthes's *Camera Lucida*, his search for what photography was in 'itself'. Her response to the question is a practical one, taking photography's history, processes, and channels of distribution as a medium for her work. Leonard's work shows that the quest into photography's ontology is an ongoing one and receives new currency alongside technological, theoretical and creative developments.

Exercises: Considering the photograph

→ Assemble some photographs by photographers whose work you are instinctively drawn to; put the photographs somewhere you can see them regularly and try to identify the inherent qualities that you are attracted to.

→ Compile a set of photographs from your personal collection or 'family album'. Contemplate the photographs and think about their key components in relation to your response or relationship with them.

→ Visit a photojournalistic image bank such as MAGNUM. Think about a general topic and type it into the search field, such as 'drone' or 'Syria'. Have a look at the results, choose five images that you feel best represent the topic, and explain why.

→ Pick a documentary image from a newspaper. Read the relevant article and discuss with your peers: How effective is the image in illustrating the story?

⇥ Choose an existing image that you are interested in and try to imitate it. Create two images, each one imitating a different aspect of the image: content and form.

⇥ Visit an exhibition and consider the presentation of photographs: Did it inform your response?

⇥ Think about different output formats for an image (for instance: colour or black and white; colour transparency, print or digital file; different sizes and shapes) and presentation methods (newspaper, postcard, book, light box, a three-dimensional sculpture, an installation). How would each option affect the meaning of the image?

⇥ Go through a book on the history of photography. Make a choice of images that refer to different traditions, and try to identify contemporary examples that refer back to these traditions.

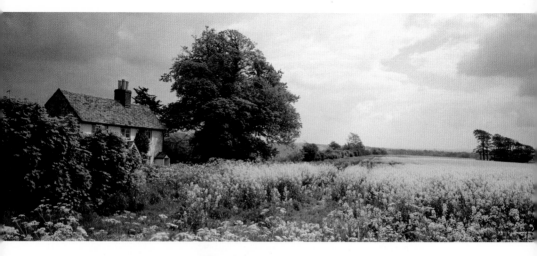

Title: *Summer's Bounty*

Photographer: Ray Fowler

Ray Fowler knows this area of English countryside well and has experienced the landscape through the changing of the seasons over several years. Through his knowledge of the area, he was able to anticipate the seasonal conditions and ensure he used the appropriate equipment and materials at the right time of day to record this scene. Using a Hasselblad Xpan, with a 45 mm lens and Velvia film, Fowler set out to maximize the sweep of the landscape, sky and colours, being aware that condensing the landscape through a camera lens can be a disappointing experience in comparison to the joy of experiencing the landscape in three-dimensions; hence his choice of a panoramic format. His experience of the location, combined with his vast knowledge of equipment, equates to researching his subject and technique in order to produce the image he had in mind.

Visual approaches

Choice of subject and how it is photographed is a crucial aspect of visual language. The ways in which a photographer approaches a subject influence the range of interpretations implicit within the subject itself and the audience's understanding of it. This chapter will build upon the internal context defined in the first chapter to develop the context of the image's making, its *original* context, as Terry Barrett defines it in his 1990 book *Criticizing Photographs*, which is tied to the photographer and particular methodologies he or she adopts.

In reading or interpreting photographs, Barrett refers to the original context of the photograph which relates to knowledge acquired beyond the basic consideration of what an image is or presents; for example, how a photographer choses to make his or her photograph and why certain elements were included or excluded. Photographs are made in instants, and as such, they only represent a fragment of reality; they are extracts of a spatial context and temporal continuum. Therefore, being informed about the social and political situation during which a photographer worked and the particular circumstances surrounding the making of a photograph can contribute to the understanding of the image. Barrett also states that the photographer's intentions can be revealing, as well as their own experience and personal and stylistic influences on their work. This chapter will provide an overview of the range of considerations that a photographer needs to make when undertaking an assignment.

2

The process of making meaning through photography is dictated in part by the project brief and the particular demands of the undertaking. The photographic brief defines the context of the final output and, depending upon the nature of the brief, may also contain relevant information regarding conceptual approach.

The student brief

Depending upon the nature of the course, students will often be assigned a project brief to work to for a defined period of time. If the project brief is specific – for example, stating that the outcome is to produce work in a particular style, theme or using a specific technique – then the main thrust of the work to be undertaken is quite clear. However, many undergraduate courses will assign quite loose briefs to encourage a more personal response and, in doing so, help students to identify their own key areas of interest, which will also act as a vehicle for developing a personal visual language. Either way, the brief will require students to initiate, develop and articulate ideas by translating them into photographic work.

It is important from the outset to start researching ideas and making work consistently in order to participate in the interactive feedback process at individual tutorials or group critiques. This approach to learning encourages a genuine engagement with the idea and visual methods of execution, and it develops an understanding of the relationship between concept and approach, as well as good working methods and problem-solving techniques. The developmental processes need to be documented and evaluated within critical sketchbooks.

'Original context is history: social history, art history, and the history of the individual photograph and the photographer who made it.'

Terry Barrett, 1990: 99

Responding to a brief

- Read the brief carefully and list the key points you need to address.

- Clarify your learning aims within the context of the brief.

- Note down all ideas that spring to mind; classify in groups aspects that possibly overlap; evaluate the practicalities of each idea or approach.

- Break down your time into manageable parts. Make time for research, experimentation, processing, printing, digital manipulation and preparing the final presentation.

- Consider financial issues and plan a budget (for example, transport costs, film, processing and printing costs).

- Ensure you share your developmental work at tutorials and seminars.

- Keep a critical sketchbook and note down feedback given or specific advice on how to take your project forward. Act on it, and do not be afraid to ask for further advice or clarification.

- Practice verbalizing your idea; writing this down in order to organize your thoughts can help. At a later stage of development, work towards writing a project statement of between 300 and 500 words.

The self-directed brief

Having identified key areas of interest, in terms of conceptual approach and subject, one can set oneself a project and undertake it over a period of time alongside other work. These self-directed projects can often develop in intriguing and unexpected ways. In the discussion of his work with Susan Butler that is also referenced in the second case study of chapter 1, 'The Photograph', British artist and photographer Keith Arnatt explains:

> You start with an idea, however minimal, and then you get a result and you look at the result. . . . I can't say exactly what, but something might have happened, you might see something in it, which departs or seems to depart radically from your original idea – it seems to give you a result which leads you somewhere else. This is not something I feel you can preconceive. The ability of the camera to transform that which is photographed, seems to me to be an eternal source of fascination. (Oral History of British Photography 1993)

Arnatt's comments highlight the importance of giving oneself time to develop an idea through practice. Ideas can change and evolve in unimagined ways, so allowing the time for this development is important. The picture-making process allows for the assimilation of ideas generated by the photographer's experience and interaction with their subject.

Developing ideas

- Try picking a topic of interest and make your own photographs to build up a body of work.

- Collect images that you find inspiring in a critical sketchbook. This may include the work of other photographers as well as inspiration you can find in other media or art forms, such as painting. Add notations and evaluate particular points of interest.

- Set a target, such as one day a week to photograph your subject.

- Set aside time each week to research your ideas. Find appropriate visual and theoretical research to understand your subject better. Add extracts of these to your sketchbook and evaluate their importance to your ideas and approach.

In an interview with Brian Sherwin in 2008, Michelle Sank speaks about the relevance of her upbringing to her photographic work and emphasizes the importance she places upon the actual picture-making process: 'I am very connected to my subjects, whether it is on the street or in more constructed working environments. It is very much a two-way process and I have always said that the interaction I have is as meaningful as the photograph' (Sherwin 2008).

Sank explains that the people she photographs have often experienced quite difficult lives and that she attempts through her portraits to 'show the social, psychological and physical nuances of these people' through their sense of humanity. As she says: 'I believe growing up in the Apartheid system, myself being part of a refugee community, drew me to photograph people living on the edge of society' (Sherwin 2008).

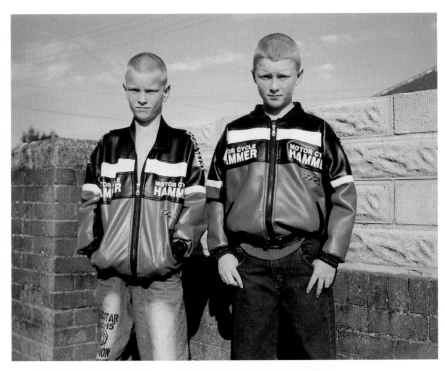

Title: from 'Young Carers'

Photographer: Michelle Sank

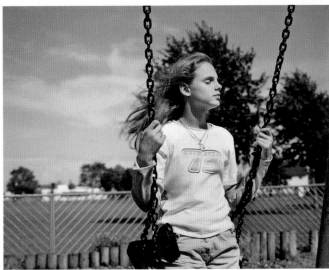

This project by Michelle Sank, entitled 'Young Carers', was undertaken during a residency supported by Ffotogallery, Cardiff, Wales. The subjects of this work were children under eighteen who were often the main caretakers for a sick parent or sibling. In her personal website, she explains: 'With these portraits, I wanted to empower these young people with a sense of their own identity and normality. I wanted to remove them from their home environment and place them within "light" and outside spaces. By getting them to dress in something they chose and to be themselves, I think for that moment in time they felt special, grounded and free' (Sank n.d.).

The professional brief

The professional brief is either 'pitched' to a potential client or funding body or responded to by the photographer when they are contacted by a potential client. Depending on the desired outcomes, photographers may be asked to submit an initial quote, offer ideas or make samples of work available to the client.

The context of the final outcome will inform not only conceptual and practical considerations but also financial ones. It is, therefore, always worth taking time to gather as much information as possible at the first point of contact. It is important to find out how much time there is to put the quote together and agree when and how to send it. Responding and quoting on the spot can be fraught with hazards; avoiding this ensures there is enough time to research and reflect upon professional priorities and the ability to respond to the brief in an appropriate manner.

Responding to a brief in an appropriate manner is clearly demonstrated by British photographer Keith Morris, who photographed musicians over a period spanning four decades. Marc Bolan, Nick Drake, Janis Joplin, Ian Dury and Dr Feelgood were among the many musicians he worked with. Morris was known for his passion and commitment, his ability to draw out the personality of each musician and, importantly, his ability to achieve high-standard professional outcomes. Morris's awareness of the social and cultural climate of the times can be seen in his documentary work and is echoed in both his approach to his musical subjects and in the environments in which he placed them.

'A great photograph is a full expression of what one feels about what is being photographed in the deepest sense and is a true expression of what one feels about life in its entirety.'

Nathan Lyons, 1966: 29

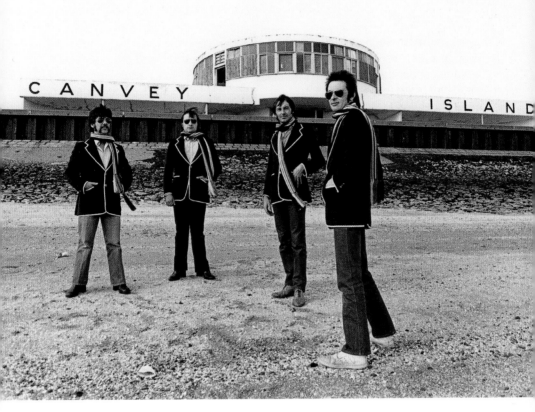

Title: *Dr Feelgood, Canvey Island*

Photographer: Keith Morris

Keith Morris was famous for photographing musicians of diverse genres. Ex-Stiff Record's boss Jake Riviera observed: 'He had the knack of knowing exactly what a band was all about and capturing it quickly' (Estate of Keith Morris 2008).

In his book, *The Decisive Moment* (1952), French Magnum photographer Henri Cartier-Bresson states:

> I believe that, through the act of living, the discovery of oneself is made concurrently with the discovery of the world around us, which can mould us, but which can also be affected by us. A balance must be established between these two worlds – the one inside us and the one outside us. As the result of a constant reciprocal process, both these worlds come to form a single one. And it is this world that we must communicate.

To be a photographer, you need to be passionate about communicating an idea, as this will inform the choices you make in relation to your work. You also need to take an interest in the world around you and to engage with issues beyond photography. The substance of the work develops through your commitment to your subject, as this will show in your photographs, particularly in the way your work becomes 'personalized'. If you are clear about why you are photographing your subject then you can choose how to photograph your subject, and in turn communicate its meanings clearly to audiences.

Concept

Concept refers to the ideas underpinning your work. It relates to the reasons why you are photographing your subject in certain contexts, and using particular approaches. To a certain extent, concept develops from one's intentions and motivations. It is therefore necessary to clarify your intentions for your work. What do you want to communicate? If your intention is pure documentation, then accuracy and objectivity may be the main focus (see chapter 1, 'The Photograph'). Documentation conceals the photographer's subjectivity; however, in most applications of photography, the photographer is invited to take into account a number of methodological considerations that exceed the main purpose of documentation or basic considerations relevant to their choice of medium (discussed in chapter 1, 'The Photograph') and ultimately define their unique approach.

'Choosing a research methodology means developing a research question and the tools to generate evidence for its answer; both of these should be consistent with a theoretical framework.'

Gillian Rose, 2007: 1

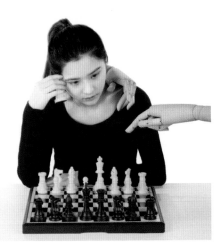

Title: *Chess and Two Wooden Hands*, 2016

Photographer: Xu Qunhan

'The chess game represents my life with the hands symbolising my parents. I grew up in a family where there was excessive love and care from my parents, and I wasn't given enough freedom and did not have the right to decide' (Xu 2016).

Title: *Student*, 2016

Photographer: Xu Qunhan

'I am dressed as a Chinese elementary student, wearing the red scarf as a prop, as well as other 'good student' labels. This represents my childhood memory exactly. My gesturing hand, raised when a student wanted to express themselves or ask a question, is a typical characteristic of a Chinese classroom.' (Xu 2016)

Communicating intention – some methodological considerations

• What do you need or want to communicate, and how are you going to do that? Do you actually need to photograph the subject itself? Can you communicate your intention by referring to, implying or photographing around it?

• How important is location, time of day, quality of light, equipment and materials in relation to the concept?

• Take a step back from your work. Seek feedback from others, including your peers. How will you refine your idea and approaches as you evaluate your outcomes?

The works of students Xu Qunhan and Benjamin Mensah both develop issues around identity and self-representation, each drawing from specific terms of cultural reference. Xu was born and raised in China, where she has lived and studied for more than twenty years, and is conscious that Chinese culture has had tremendous impact on her. When she arrived in the UK to undertake further study, she recognized vast differences between our societies, habits and culture. Drawing from her experience, she utilized self-portraiture to analyse cultural identity, and reflect on what it means to be a young Chinese female. In her research, she examined a range of cultural and social expectations imposed on individuals growing up and living in China. The autobiographical and performative aspects of self-portraiture are explored, and her images are carefully styled with a variety of props used to express particular characteristics and facets of her life.

In Benjamin Mensah's work entitled 'Man' (2016), consisting of a series of self-portraits, he explores 'the possible, extreme and melodramatic dangers of rejecting all of society to be false, and living in complete seclusion and solitude' (Mensah 2016). His images represent man's return to a primitive state and confronting the bareness of being. Captioned with extracts from the Bible, Mensah's work offers a reflection of his deep relationship with religion and its presence in his everyday life.

Title: *Before a Downfall the Heart Is Haughty, But Humility Comes Before Honour*, from the series 'Man', 2016

Photographer: Benjamin Mensah

Mensah comments: 'Flinging his axe into the air, this image presents a visual metaphor of the haughty spirit that the man has towards modern civilisation. He despises the rules and regulations, and the boundaries of what is considered taboo and what isn't. He loathes the 'average' life of the average man, and has a passionate distaste of human accomplishment, particularly in industry, as he believes that it has all been built on the wrong moral grounds as well as on the backs of hardworking people for the financial benefit of very few. He finds restitution being hidden away from modern society.' (Mensah, pers. comm. 2016)

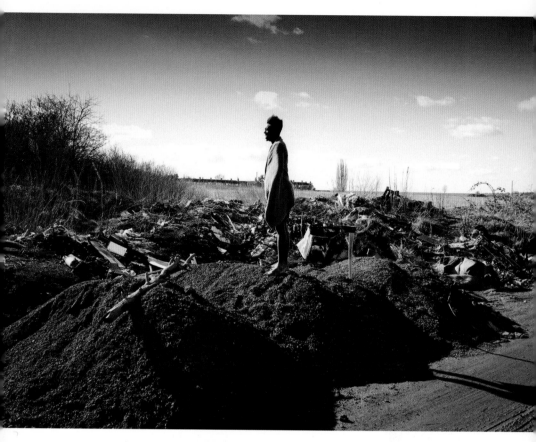

Title: *Promising Them Freedom, They Themselves Are Slaves to Depravity, for a Person Is a Slave to Whatever Conquers Him,* from the series 'Man', 2016

Photographer: Benjamin Mensah

Mensah comments: 'This is the image of a man who has lost all hope. He has reached the end of the line in his realisation that his continued battle with 'civilised life' has brought him neither peace nor comfort. He looks on into the distance pondering if there's still a way back into modern life for him. . . . The look you're seeing there is one of regret and agony. He has, in essence, gone mad.' (Mensah, pers. comm. 2016)

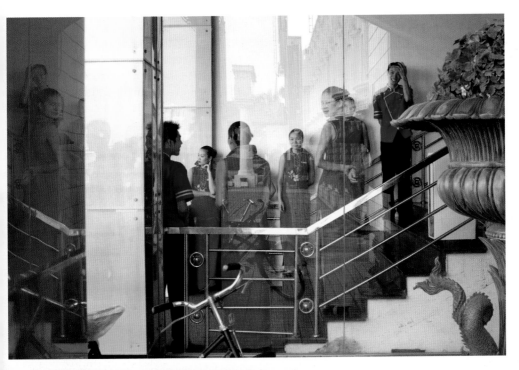

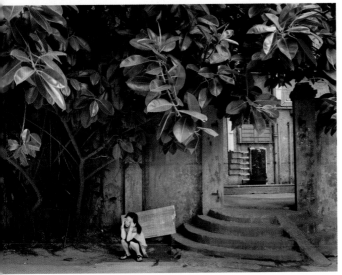

Title: *Restaurant Staff Gather for a Pep Talk* and *What Time Is It There?* from 'China Between', Xiamen, 2007

Photographer: Polly Braden

'China Between' is a photographic essay on the modern city culture of contemporary China. David Campany, writer and curator, describes Polly Braden's work: 'What she was trying to discover, without fully knowing it for a long while, was a form of observing, shooting and editing that might express the complicated relation between everyday life in China's burgeoning cities and the great transformations that have been taking place there' (Brady et al. 2010).

An individual viewpoint

Your own experience, beliefs, sense of integrity, intuition, personal qualities and technical skills will all influence the rationale and concept for your work – what you photograph, how and why. These individual characteristics are essential components of the image-making process. American Magnum photographer Eve Arnold is a useful example of how a subjective viewpoint and personality can lead to insightful photography. In an interview with Mark Irvine in 1997, Arnold responds to a question on the political agenda of the photographer by explaining her intention in photographing her chosen subjects:

'There have been times when I've set out to show people to be what they are – like Joe McCarthy, who held America for ransom for many years and ruined a lot of lives.' Arnold goes on to stress the inevitability of being influenced by wider society: 'We're all political agents. How do you divorce yourself from the system you live in? You have feelings – it's not just wind whistling between the ears' (Irvine 1997).

Arnold is acknowledging that, particularly in the case of controversial US politician Joseph McCarthy, her own attitude to the subject influenced how she photographed him. She goes on to explain that photographers can develop a more meaningful interpretation of their subject through physical proximity and by developing a level of personal understanding and involvement.

Eve Arnold used her social skills to gain access and a fuller understanding of her chosen subjects, and she was able to use this insight to develop a concept for each. Having a clear understanding of concept, the rationale for a piece of work, will inform many decisions you will make as a photographer; prior, during and after the actual picture-making event. The conceptual approach is the essence of the process and the photograph. Informing subtle choices concerning subject, materials, framing, composition and final presentation, the relationship between concept and subject underpins a photographer's approach.

It is also possible for photographers to question their own intentions when faced with situations that are charged with moral, ethical and emotional implications. In an interview in 2010, British photographer Don McCullin described how an experience in the field caused him to reflect upon his motivations and shift his intention. He explains that at first his motivations had little to do with changing perceptions: 'I was young and enthusiastic and wanted to take good pictures to show the other photographers. That, and the professional pride of convincing an editor that I was the man to go somewhere, were the most important things to me' (Wroe 2010).

It was when he was covering the Biafran War in 1969 that it occurred to him that his purpose should be to highlight the unacceptable through his images: 'It came to me in a schoolroom being used as a hospital, and I saw 800 children literally dropping down dead in front of me. I had three young children of my own. That turned me away from the Hollywood gung-ho image of the war photographer. It converted me into another person' (Wroe 2010).

The key point here is that a photograph can have greater resonance than a mere record of events. As a photographer, it is important to clarify your own intentions and contemplate the photograph based on these priorities, as well as examining what is actually there in the images and how it is presented. Ultimately, this is what the audience will see and respond to.

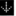

Title: *Cuba. Havana. Bar Girl in a Brothel in the Red Light District, 1954*

Photographer: Eve Arnold

On the day after her ninety-eighth birthday, at the annual awards ceremony in Cannes on 22 April 2010, Eve Arnold received the Lifetime Achievement Award at the Sony World Photography Awards. Baroness Helena Kennedy QC said: 'Eve always created real trust with the people she photographed and I think that meant she captured things about those people that were often missed by others' (Kennedy 2010).

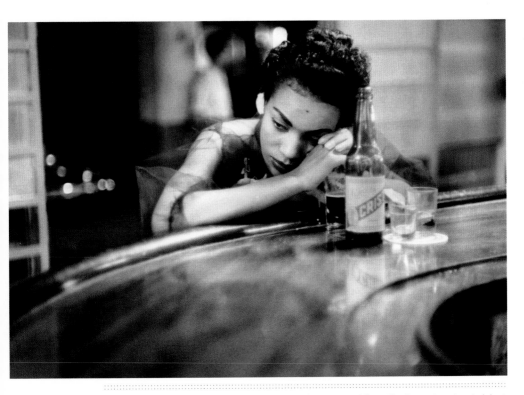

Having considered subject and concept, the next stage is to select appropriate equipment and materials to realize the project. The equipment and materials you use will inform the aesthetic quality of the resulting images. However, it is important to remember that the viewer's response will depend not only on the way in which materials have been used but also on the viewer's pre-existing expectations about them – for example, in the case of Polaroid's associations with candid, personal photography, or the particular aesthetics of black and white documentary images. Of course, one can challenge these expectations or subvert them, but, as is also mentioned in chapter 1, 'The Photograph', it is important to recognize the preconceptions in order to address them appropriately.

Although formalism, as described in chapter 1, 'The Photograph', is only a partial and context-specific way of thinking about photography, technical execution is important in all photography. Technical execution is vital in supporting the conceptual approach and has an impact on an audience's response to the work. It would be a useful exercise to look at the work of a range of different photographers and consider how their choice of format, film quality and presentation informs your reading of the image. Similarly, think about the rendering of tonal quality and sharpness of detail in relation to your reading of the image. For example, would your responses be altered if the image were more or less grainy, or if it was made in colour as opposed to black and white?

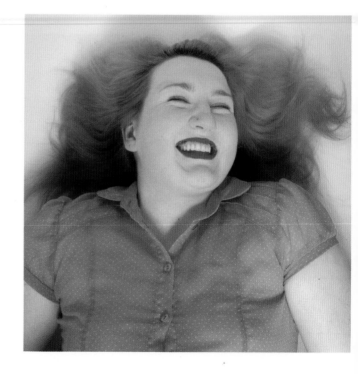

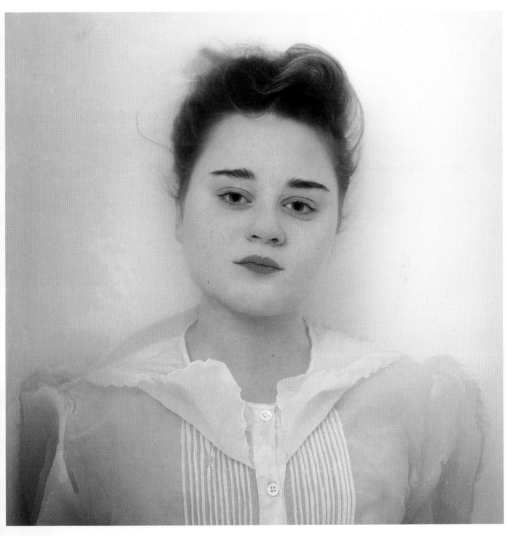

Title: from 'Pickled'

Photographer: Olena Slyesarenko

Olena Slyesarenko photographed her subjects under water. Keen on ambiguity, Slyesarenko aimed for the water to be as unnoticeable as possible to the viewer. She used the water to reduce the amount of control her subjects had over the resulting images. Slyesarenko observed how, despite enduring a range of pain and panic, her subjects still strived to maintain composure and present themselves in as controlled a manner as was possible, as they were mindful that their 'image' would be recorded as a permanent photograph.

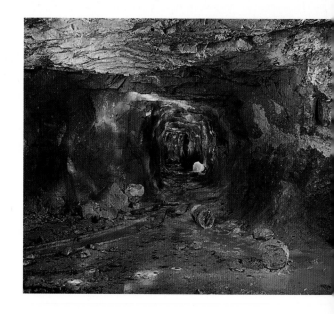

Camera format – key questions

Choosing the appropriate equipment, and developing a personal style of using it, is intrinsic to any photographer's unique approach. These decisions impact upon the resulting images, contributing to their visual language. Some key factors to consider when choosing equipment are:

- Which format camera will best suit your conceptual intention, e.g. Polaroid camera; digital SLR or medium format; 35 mm; film-based medium or large format?

- What kind of image quality will best reflect your intention, e.g. is fine, very sharp detail important?

- What shape do the images need to be, e.g. square or rectangle?

- Will any converging lines need to be corrected (i.e. for architectural photography)? Will these be done 'in camera' or through post-production processes?

- Do you need to be quick and mobile? If so, a heavy, large-format camera may be inappropriate.

- How large are the final prints intended to be, or will they be presented on-screen? The scale at which you may need to print at is dictated by the quality and resolution of film or digital files.

- Are you making reference to an established style or genre of photography?

- Will film or digital be most appropriate for your required final output? Justify this choice.

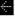

Title: from 'The Red River', 1982–1987

Photographer: Jem Southam

British photographer Southam created 'The Red River' series from 1982 to 1987. The project follows a stream stained red by mining from its source in West Cornwall, UK, to the sea. Travelling through a landscape affected by copper and tin mining, horticulture and tourism, the series conveys the history and legacy of cultures that have shaped the landscape. Southam frequently revisited particular sites; his knowledge of and connection with his subject, combined with his sympathetic use of photographic technique, resulted in works that communicate articulately and poetically.

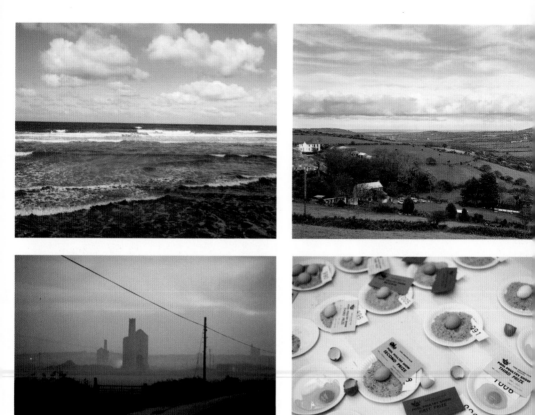

'My overall artistic intentions are to make work that explores how our history, our memory and our systems of knowledge combine to influence our responses to the places we inhabit, visit, create and dream of. But that's me putting a gloss on it. I am compulsive and I work because it is what I want to do. The photographs are the result of a need to make work in the most challenging and enjoyable way possible.'

Jem Southam, 2005 (Schuman 2005)

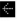

Title: from 'The Red River', 1982–1987

Photographer: Jem Southam

Jem Southam explains some of the technical decisions that have influenced his work: 'I bought a MPP 5" × 4" Field Camera in 1975 and started working in colour. But I didn't like the results. They were too saturated and not what I was trying to do. So I stopped and spent the next six years working with the same camera in black and white. I became heavily influenced by the Bechers and pursued architectural landscape work' (Schuman 2005). Southam explains that it was Paul Graham showing him some of William Eggleston's work that caused him to realize that materials which would allow him to work with colour in a way he wanted to did exist, and so he switched back to colour and has not taken a black-and-white photograph since.

Technical considerations

Your choice of film type, speed, lighting and other technical considerations in relation to the intention and final output are important factors in the image-making process. Before making these decisions, it is worth asking yourself whether you wish to lean toward particular colours and tones, how much grain or noise you want and if you plan to do any correction or manipulation at post-production stage. Considerations around image quality must be made in relation to how your final work will be exhibited or viewed; for example, the requirements for a screen-based output will be different from a large-scale print on a wall. Technical points to consider include:

- Colour or black and white?
- Digital or film?
- 35 mm-, medium- or large-format film?
- Film speed and grain?
- Print, transparency or projection?
- Print, page or screen-based?
- Available light, flash or other mixed lighting sources?
- Cameraless photography?
- Scale of final images?
- Paper type?
- Printing process?

In her series 'Glass', Laura Pannack's process is the conceptual rationale behind the images, as she explains:

> I looked at the relationship between the subject and photographer and decided to let photographers experience the position of the subject. I placed a sheet of glass between myself and the subject to symbolize the glass of the lens, which is the only obstacle from actual content. I then asked each subject to close their eyes to ensure they were unaware when I was going to take the photograph, thereby taking away any control they may have felt and inflicting isolation. It relates to my thoughts on how people often object to having their portrait taken and how they react when faced with the situation. I wanted my subjects to have no control over the image as I was aware that, as photographers, their awareness and involvement would be much more apparent. (Pannack, n.d.)

Pannack's work reflects the way in which the chosen visual approach determines the photographer-subject relationship, and informs the presentation and interpretation of the photograph.

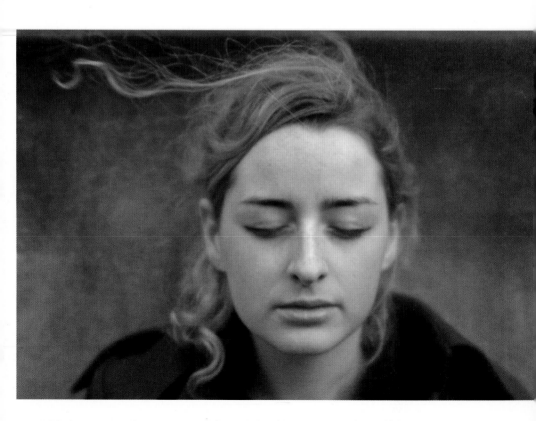

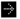

Title: from 'Reverberations of the Past', 2011

Photographer: Liza Campion

Liza Campion was commissioned by White Star Memories to photographically record and document their entire collection of surviving artefacts from the RMS *Titanic* for a catalogue in commemoration of its sinking 100 years before. External to this commercial assignment, Campion was intrigued by the history of the *Titanic*, an amazing feat of engineering that strove to defy the laws of nature and a tragic story that is one of most memorable maritime disasters ever recorded. She, therefore, decided to create an additional body of work, using a different approach that was personal and creative. She chose to produce figurative images derived from photographs she had taken of White Star memorabilia. Through her explorations, she worked closely with White Star historians and engaged with various camera formats, developed and printed on diverse surfaces, manipulated film and experimented with photo etching. Campion also degraded her negatives using seawater from Liverpool in order to make a deeper connection with her subject (White Star, which owned the *Titanic*, was Liverpool-based, and many of the crew who perished were from Liverpool).

Title: from 'Glass'

Photographer: Laura Pannack

Pannack placed other photographers in the position of subject by using a piece of glass between them and the camera and asking them to close their eyes while she made the photographs.

'A photograph is a subjective impression. It is what the photographer sees. No matter how hard we try to get into the skin, into the feeling of the subject or situation, however much we empathize, it is still what we see that comes out in the images, it is our reaction to the subject and in the end, the whole corpus of our work becomes a portrait of ourselves.'

Marilyn Silverstone ('Marilyn Silverstone Profile', n.d.)

Planning: place and time

The nature of the brief will dictate whether photographs are to be made during a 'once only' opportunity or over an extended period of time. Lighting conditions, and the appropriate use of them, will have been explored as part of the research and preparation for the project. In some cases, an image might depend upon weather conditions and require specific light at a certain time of day. This may require a level of flexibility and patience, waiting for clouds to move into or out of the frame or dawn/dusk to approach.

In 'Remembrances of Sudek', Sonja Bullaty describes her experience of working as assistant to Czech photographer Josef Sudek:

> His sense of light became crucial, often planning for a year or more to capture the exact lighting situation. . . . We set up the tripod and camera and then sat down on the floor and talked. Suddenly Sudek was up like lightning. A ray of sun had entered the darkness and both of us were waving cloths to raise mountains of ancient dust 'to see the light', as Sudek said. Obviously he had known that the sun would reach here perhaps two or three times a year, and he was waiting for it. (1978: 14)

This clearly illustrates the value of knowing one's subject matter and being prepared to catch the right lighting conditions. Conversely, as important as it is to be prepared to be in the right place at the right time, it is also important to be flexible with how one's intention can be manifested visually. Being too prescriptive in approach, spending hours looking for an exact image, can mean that you may overlook other possibilities. It is therefore important to cultivate a sense of openness towards the subject, looking for alternative compositions and dynamics.

Title: from 'Equilibrium/Scars', 2013

Photographer: Liza Campion

In 'Equilibrium/Scars', Campion presents a series of abstract perspective of open mines, which are combined with the scars of females, all of whom had undergone surgery resulting in extraction, mirroring the man-made scars created upon the earth's surface: 'The human body is indicative of the planet's ecosystem; its organisms will attack and rejuvenate those areas of vulnerability. Like a scalpel, the female scars slice through the landscapes, metaphorically emphasizing the intrinsic link between humans and the planet' (Campion 2013). Being resourceful, Campion was able to find, through her networks, a pilot/plane (at no cost) in order to produce her aerial shots. Through careful planning of a flight route with the pilot well in advance of each shoot (and analysis of specific mines in relation to the original flight plan), she had to await the right weather conditions. Obtaining sharp images was the most difficult challenge, as she was held in with a seat belt and had to photograph when the aircraft made a banking turn in order to obtain the perspective she required; the wind factor, too, was immense.

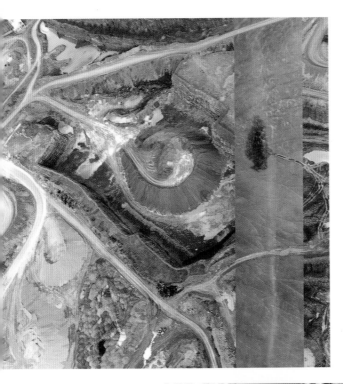

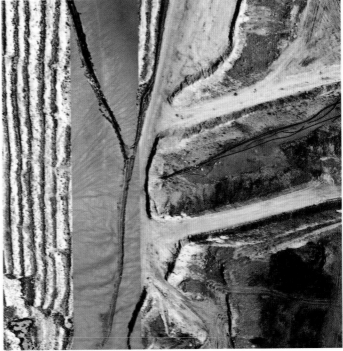

Photographers frequently need to deal with external factors, such as delayed transport, weather conditions and people. Any one of these elements can completely change the nature of a shoot. This is when thinking on one's feet is required – using interpersonal skills and creative ability to improvise in challenging situations. The key is to bear in mind your conceptual intention and look for other ways in which it can be visualized.

It is important also to plan ahead and communicate clearly with others. If your work involves photographing people, for example, it is worth bearing in mind that they may have their own expectations of how the photographer and subject will and 'should' behave (e.g. either posing for the camera in a certain way or expecting lots of photographs to be made very quickly). It is therefore important to set out the terms of your work clearly and to establish what your expectations of them are in the preparation stage, as well as how long a shoot may likely take.

One example of external factors influencing, or in this case creating, a project is Seba Kurtis's 'Salam'. In an interview in 2009, Kurtis describes the making of 'Salam' as follows:

> I went to photograph in North Africa, where human traffickers create new routes to smuggle immigrants to Italy, Greece and so on. After two days, my fixer gave me a knife for protection and then disappeared. I don't speak Arabic, my 5x4 and I weren't welcome in many places and I felt a lot of friction, even with the everyday people in the streets – some even physically tried to stop me taking photographs. (Kurtis 2009)

During his journey, Kurtis was fascinated to come across photo studios in every village. Here in these studios he was greeted warmly and enjoyed passionate and enthusiastic exchanges about photography. He then took to visiting the studio in each village while he was waiting for access or a contact to appear. He describes the experience:

> Solace was found in local photographic studios where both my face and camera were warmly received with respect, our common passion uniting us – the language of photography. There was something beautiful yet naive about their struggle to resist globalization, their willingness to sell ice creams and hair products within their practice just to keep their dreams alive. Unexpectedly, this project came alive in those places where time seems to have stood still but hearts were open. (Kurtis 2009)

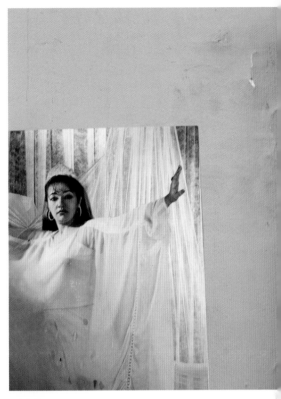

Title: from 'Salam', 2009

Photographer: Seba Kurtis

Seba Kurtis went to North Africa and, while experiencing hostility and difficulties in accessing his intended subject matter, he wandered into a photographic studio out of curiosity. Here he found a warm welcome and the shared passion for photography enabled a positive exchange. So his subject shifted to encompass the photo studios in the towns and villages on his journey.

As the work by Aida Silvestri or Mari Mahr proposes, the personal background of a creative practitioner is often influenced by their personal background and experiences. In this context, it is worth bearing in mind that Seba Kurtis was born in Argentina in 1974 and grew up in Buenos Aires under a dictatorship. He studied journalism and was a political activist. In 2001, Argentina fell into economic and political crisis. Kurtis left for Europe and remained in Spain as an illegal immigrant for more than five years. It is therefore significant to make connections between his life experiences and the manner in which he pursues and develops his photographic work. For example, in his series entitled 'Drowned' (2008), Kurtis reflects on the lives lost by thousands of African refugees over the years in attempting to reach the Canary Islands. He literally drowned his sheets of film in the ocean they had crossed. His 'Shoebox' (2008) project is more personal, where he recovers the remnants of family photographs damaged by a flood.

Title: *Untitled*, from 'Shoebox (fronts)', 2008

Photographer: Seba Kurtis

Kurtis states in 2010 that, in his 'Shoebox' project, he attempts to reclaim his past through the salvaging of family photographs which were reclaimed after a flood: 'I decided to include some of the backs of the photographs, they were stuck to each other. . . .I was attracted to them, the traces of other pictures, emulsion, colours . . . photos that we never will see again, but they leave a mark' (Kurtis 2010).

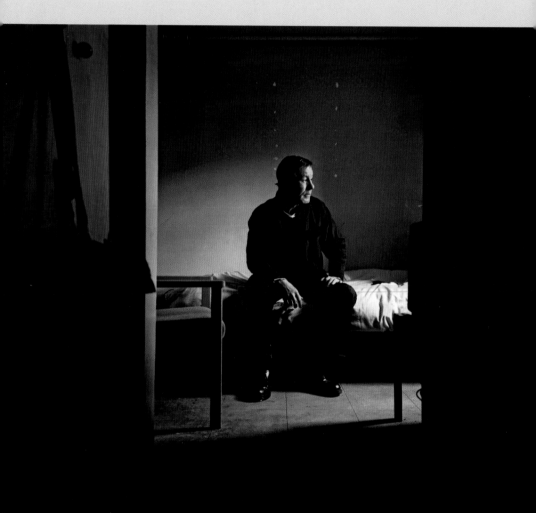

**Title: from 'Homeless
Ex-Service', 2005**

Photographer: Stuart Griffiths

Using a Leica camera and Kodak
film, Griffiths documented the
residents of the hostel for ex-
servicemen.

Case study 1

In 1988, at the age of sixteen, Stuart Griffiths joined the Parachute Regiment. It was a move to avoid what Griffiths describes as 'the mundane life' of his home town of Warrington, UK. After five years of service, Griffiths recognized that what he enjoyed most about his service career was his role as a unit photographer. Griffiths therefore decided to leave the Parachute Regiment and pursue a career in photography.

In 1997, four years after leaving the army, Griffiths obtained a degree in editorial photography. He went on to pursue self-directed projects exploring military conflicts in Albania, private military armies in Baghdad and the civil war in Congo. As Griffiths recounts, these projects could be fraught with danger: 'The trip to Kinshasa was probably the one place I was totally ill-equipped for; emotionally and mentally. It was here I found myself being taken through jeering crowds, mock executions, intimidation and abuse; I ended up in a Congolese jail' (Griffiths, pers. comm. 2010). However, the deep-rooted conviction that his life, his voice and his opinions had relevance and value kept him working. Specifically, Griffiths wanted to convey an aspect of the reality of army life. He wanted to create a sense of empathy with, and understanding of, the challenges facing ex-soldiers.

Funding these projects while trying to support himself was a costly exercise, and by the year 2000, Griffiths was homeless and working as a paparazzi photographer in London. While trying to find somewhere to stay, he became aware of a hostel for ex-servicemen. Here Griffiths met a group of men whose challenges he could identify with. Griffiths began photographing homeless ex-servicemen, and this work was first published at national level in UK newspaper the *Guardian* in May 2005.

Griffiths emphasizes the importance of having a connection with, or passion for, one's subject as he talks about his influences from his early teens being Nick Knight's *Skinhead* (1982), since he was a skinhead himself and wanted to find out more about the subject. He also cites Paul Graham's *Troubled Land* (1987) as an influence when he was a student. His interest stemmed from the fact that Graham photographed some of the areas he became familiar with as a soldier in Northern Ireland and specifically that his photographs made only subtle suggestions about the ongoing conflict in Ulster.

> I was encouraged by Philip Jones Griffiths, notably his book *Vietnam Inc.* (1971). When I first saw his work I was deeply moved by his commitment to his subject and how the book was from the Vietnamese perspective. . . . I met Philip Jones Griffiths a year before he died and he was a kind of mentor to me, urging me to carry on with my veterans' work. We also shared a similar contempt for the controlling 'embedded' photographer position that is currently the norm in modern war reporting. I was also inspired by the commitment of Chris Steele-Perkins to bodies of work surrounding socially excluded areas, in 'The Teds' (1979) (pers. comm. 2010).

Griffiths was also inspired by the work of American photographers: William Eggleston, Stephen Shore, Lee Friedlander, Diane Arbus and Nan Goldin. He states, 'It was the documentation of their own personal journeys that had a huge impact on the way I look at what is around me. It is this subjective autobiographical viewpoint that I look for in my own practice as a photographer' (Griffiths, pers. comm. 2010).

Griffiths's story is documented in the film *Isolation*, directed by Luke Seomore and Joseph Bull in 2010.

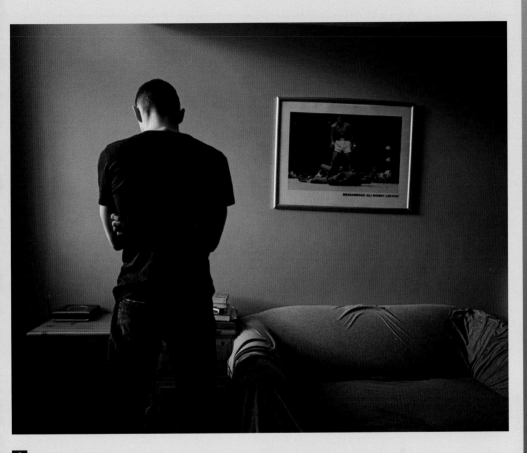

**Title: from 'Homeless
Ex-Service', 2005**

Photographer: Stuart Griffiths

Griffiths wants to create a
sense of empathy with and an
understanding of the challenges
facing ex-soldiers.

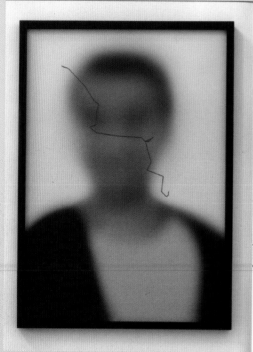

SAMUEL

I am accused of misconduct.
I am imprisoned and tortured.
I escape.
I am promised the Promised Land.
But end up in the hands of the wrong people.
I am not an animal. I am not for sale.
I am sold and re-sold... three times.
I am detained and taken to a far land by my new owners.
Here, I am in this desert-like place,
packed like a sardine in a small and steamy room.
My eyes don't want to see but I have to see.
I have to see in order to be ready mentally.
I am waiting... waiting and waiting.
I am dreading my turn; the anticipation is worse than any pain.
When is it going to be my turn?
I am chained, tortured, burned with melted plastic and raped.
I am begging, begging them to stop:
'Stop.'
'Stop.'
'Stop.'
Begging to my family to get me out.
My family is poor now. They wasted their entire life savings...
I am free.

Date. 2013
Eritrea to London on foot, by car, lorry, boat and train.

Title: *Samuel*, 2013

Photographer: Aida Silvestri

'Eritrea to London on foot,
lorry, boat and train.'

Case study 2

Aida Silvestri was born in Eritrea, east Africa, and is currently based in London. The work she produced for 'Even This Will Pass' has grown out of the connection she has with the place of her birth – documenting the experiences of Eritrean refugees who have fled their homeland and the perilous journeys they undertook in search of freedom. The title was derived from a message Silvestri came across on a wall in Mount Sinai during her research. She explains in an interview in 2013, 'People wrote messages of hope during their journeys and I thought this one was quite special' (Padley 2013). 'Even This Will Pass' consists of a series of abstracted portraits and poems written as personal testimonies by each individual.

As Renée Mussai (2014), Curator at Autograph, observes, Eritreans lived under a dictatorship for several decades, where opponents to the regime or those who publicly voice criticism will be imprisoned and/or disappear. Without freedom of speech, press, or religion, the refugees who made their escape carried with them a sense of intense fear which even her friends have experienced, and which Silvestri recognized when she spoke to these individuals about their experiences.

Furthermore, Silvestri has traced the route that each person took and hand-sewn this on the surface of each photograph, physically mapping their journeys onto blurred imprints of their identities. Mussai (2014: 6) comments that the three-dimensional effect of the stitching 'intensifies the dramatisation of the portrait and heightens the conceptual meaning of the journey, but also adds a deeply personal dimension through the intimacy of the act and meditative process of sewing by hand'. The caption, which accompanies each image, details the method of travel, for example, camel, foot, car, plane etc.

Silvestri's objective is to draw attention to the brutality of Eritrea's regime and the plight of refugees at the mercy of human traffickers. She considers her work as documentary, even though she has utilized novel approaches and sensitive ways to depict a subject that is visually saturated in the media. She states:

> I wanted to do this in an artistic and conceptual way, rather than showing the injuries that people have sustained. It's less gruesome but more powerful and dignified for the sitters. I had to be discreet for fear of endangering myself, my family in Eritrea and my subjects. We are used to seeing images from Syria and Iraq, so I wanted to take a different approach. (Padley 2013)

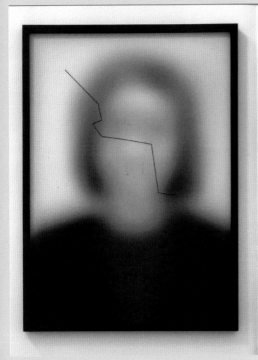

KIDAN

I am sentenced for two months for not obeying orders and
for reporting someone for rape.
I am carrying the innocent fruit of the rape.
I have money, plenty of money. I can buy my way there.
The journey is overwhelming.
Very harsh weather conditions.
Very harsh leaving conditions.
I am dehydrated and not eating well.
I am worried and scared for the baby.
I can feel it...
I am losing the baby.
I lose the baby; maybe it is best this way,
even though I never blamed the baby.
The journey doesn't get easier. I am not feeling well.
I think I have an infection...
I do have an infection, a very bad infection.
I cannot have another baby.
But I am healthy now.

Date. 2013
Eritrea to London on foot, by car, lorry, boat, train and aeroplane.

Title: *Kidan*, 2013

Photographer: Aida Silvestri

'Eritrea to London on foot, by car, lorry, boat, train and aeroplane'

Silvestri states that in her work, she had to find a means to protect her subjects' anonymity, as well as to project this sense of fear: 'People are scared because of the oppression back home. I wanted to find a way to tell their stories. I didn't want to get into the political situation but to discuss the journeys people made. People were frightened to talk about their experiences. I wanted to show this fear, and I wondered how I could do this through photography. In the end I decided to blur people's faces by defocusing the lens. I took just one photograph after I had interviewed each person. The people may not be there physically but their soul is there.' (Padley 2013)

Exercises: Discovering your subject;

⇥ Make a list of activities you enjoy, the environments you prefer and note whether you enjoy them with others or alone. Consider the kinds of photographic processes you are proficient in and what aspects you wish to develop further. This will inform your 'process' list. It may indicate your aptitude for certain techniques, working environments and conditions. Next, make a 'subject' list based on topics or ideas that interest you. When you read, watch television or films, listen to or read the news, or through your interactions with others or in particular environments, which stories appeal to you most?

⇥ From these lists, identify which items can be translated into the process of photography and which items can be translated into subject matter. Now from your list of subject matter, ask yourself, is it visual? Could a mixed media approach (e.g. using painting or video) also involve photography simultaneously?

formulating your approach

→ Choose one point from your 'subject' list and one point from your 'process' list. Consider ways of combining the two points and photograph your chosen subject using your chosen process. This may help clarify your strengths and may give you an insight into your true interests and motivation.

→ Look at the work of other photographers. What appeals to you – visually, technically and conceptually? Pick a photographer or an approach and set yourself a brief to respond to using a similar technique or concept. A simple brief that has clear boundaries and time scale can be helpful. Photographing your ten favourite possessions, a regular route or in one place for a set time period can be helpful ways of identifying the kind of work you find engaging. Furthermore, ask yourself if there is a particular subject that you feel driven to explore, whether it is personal, social or political.

Title: *Stills from exhibition view of 'Shades of Time'*, 1974–1997

Photographer: Annelies Štrba

Annelies Štrba is a Swiss photographer and video artist whose work is concerned with notions of time and history, including personal, familial relationships. Her first major body of work entitled 'Shades of Time', consisted of 240 photographs, which captured four generations of her family over more than twenty years, from the time before she was born to 1997.

The images were 'originally made entirely for the family album' (Štrba 2006), and it was only by chance that her work was catapulted into the art world, when on visiting her home in 1990, Bernhard Bürgi, director of the Kunsthalle Zurich, saw her photographs and invited her to do a one-person show at the institution. These images provide snippets of Štrba's *Shades of Time* exhibition (The Photographers' Gallery, London, 1998) which utilized a series of slide projectors displaying images presented as triptychs, changing rhythmically to the pulsating beat of an accompanying soundtrack. Organized nonchronologically, the past and present is intimately intertwined in Štrba's work.

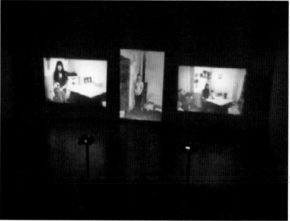

So far, we have discussed two understandings of the term *context* in relation to photography. The first one relates to photography as a whole and the viewer's understanding and general expectations of the medium; the second relates to the photographer's intentions and the conditions under which the images are made. To these, in this chapter we will add a third variety: the context in which an image is encountered.

The context in which an image is encountered will inform the viewer's responses to and interpretation of the photograph. The same photograph can be used in different contexts and take on different meanings in relation to that context. As photographers working to fulfil a brief, therefore, it is important to recognize the context in which the work will be used and seen. Context can be defined by factors such as: the function of the photograph; the placing of the photograph; the relationship between the photograph and other photographs in the same series or body of work; use of

Contexts of presentation

text; other external factors, such as topicality, a curator's or editor's selection process; geographical placing of the photograph; and the cultural understanding and experience audiences can bring to the photograph. This chapter explores the external context of the photograph, and its influence on audience understanding.

Terry Barrett refers to *external context* as 'the situation in which a photograph is presented or found' (1990: 99). He adds that photographs are usually encountered in 'very controlled situations: books, galleries, museums, newspapers, magazines, billboards and classrooms' (Barrett 1990: 99). How and where a photograph is presented or seen can significantly affect its meaning. Every context carries with it a set of assumed values and perceptions; for example, a press photograph in a newspaper connotes a truth value and its documentary status as part of a news story, whereas images in a family album convey a sense of close, personal significance. Images on an official government website or the BBC website, for example, may be regarded differently if they were encountered on social media or on a blog belonging to a citizen journalist. Roland Barthes, in his essay 'The Photographic Message', referred to the 'channel of transmission' (1977: 15) of a photograph; this is the mode through which a photograph is received by its audience. Using the example of a newspaper, he highlighted the fact that image-text relationships on the page, as well as the use of titles, captions, layout, and even the name of the paper ('this name represents a knowledge that can heavily orientate the reading of the message' [Barthes 1977: 15]) can influence photographic interpretation. As John Walker also states, 'With each shift of location the photograph is recontextualised and as the context changes so does the meaning' (Walker 1997: 54).

3

Traditions and labels associated with the history of photography are being blurred, questioned or subverted. It is therefore not uncommon today to find individuals such as Pieter Hugo, Alec Soth and Mikhael Subotzky amongst others who produce artworks through a documentary photography format and who exhibit their socially conscious works in galleries. Indeed, much photography that is presented in museums and galleries today were not necessarily made to be exhibited in the museum context in the first place; these include documentary photography, architectural studies, domestic or personal imagery, ethnographic or scientific archival imagery, studio portraiture, fashion photography – exemplified through the works of photographers such as Joachim Schmid, Seydou Keïta, Mario Testino and recent exhibitions such as *Burden of Proof: The Construction of Visual Evidence* (2015), and *Black Chronicles: Photographic Portraits 1862–1948* (2016).

Luc Delahaye is a French photographer who began his career as a photojournalist, specifically a war photographer during conflicts, such as in Afghanistan, Yugoslavia, Rwanda, Chechnya, and has won numerous awards for his reportage photography. He joined the Magnum agency in 1993, and he left it in 2004 when he declared that he was no longer a photojournalist but an artist. He won the Deutsche Börse prize for groundbreaking contemporary photography in 2005 and is well known to the contemporary art world. Whilst he retained his interest in theatres of war and his concern for politically charged subjects and social issues, he shifted his approach to produce large-scale (normally 8x4 feet in size) highly detailed images using a large format camera, exhibiting his work in galleries internationally (and charging 'art world prices'). He comments in an interview with Bill Sullivan: 'Photojournalism is neither photography or journalism. It has its function but it's not where I see myself: the press is for me just a means for photographing, for material, not for telling the truth. In magazines, the images are vulgar, reality is reduced to a symbolic or simplistic function' (Sullivan 2003).

In an interview for the *Guardian*, Luc Delahaye discussed the importance of scale to his images and how they could be differentiated from other press photography. When asked what he considered the essential characteristics of a 'tableau' photograph, he commented, 'It is something that has to have a certain dimension. . . . Size is important: the physical rapport creates a relationship between you and the history of art. There is a harmony, a mystery, that takes you and resists you at the same time' (Lennon 2004). Indeed, the scale of Delahaye's images from his 'History' series are crucial to its visual impact; the Getty Museum proposes that, 'Their nearly life-size dimensions and their narrative power evoke the tradition of 18th- and 19th-century European painting' ('Recent History' 2007). Referring to the work of artists such as Jeff Wall and Andreas Gursky, Michael Fried, in his book *Why Photography Matters as Art as Never Before* (2008), regards the use of the tableau form as an important development in contemporary art photography.

'The photograph, as it stands alone, presents merely the possibil of meaning. Only by its embeddedness in a concrete discourse situation can the photograph yield a clear semantic outcome.'

Allan Sekula, 1984: 7

Title: *US Bombing on Taliban Positions*, c. 2001

Photographer: Luc Delahaye

Upon reading the title of the image, this photograph showing a dark, floating cloud in the background of a wide, barren landscape reveals itself to be a plume of smoke caused by American bombardment on suspected Taliban footholds. The stillness of this image presents a detached eloquence far removed from the conventions of action-filled war imagery. Delahaye comments, 'It is just true that there are beautiful landscapes in Afghanistan where there is also death. To not show this complexity? Reporters in the press see the Afghan landscape but they don't show it, they are not asked to. All my efforts have been to be as neutral as possible, and to take in as much as possible, and allow an image to return to the mystery of reality' (Sullivan 2003).

'Such pictures make us question our ability to comprehend the image, and images in general. Ultimately, the cool lyricism of Delahaye's photographs urges us to reflect upon the relationships among art, history, and information.'

J. Paul Getty Museum, 2007 ('Recent History' 2007)

William J. Mitchell coined the term *post-photography* in his book *The Reconfigured Eye* (1992), where he critically explored the shift in the nature and use of photography with advents in digital technology, its veracity in an age of digital manipulation, as well as its ethical implications. The growth of the digital realm has presented a range of possibilities for artists who utilize the Internet for source material. While there are artists today who produce 'traditional' forms of photography (for example, illustrative and nonreflexive content and approaches), the works of many contemporary art photographers are characterized by large-scale displays, involving forms of construction, or performance, combined with cinematic modes or as part of an installation. Stephen Clarke (2014) states that the term *post-photography* is 'seemingly an adjunct to this ending of classic modernist practices that aimed for purity of method and form'. He cites the art historian George Baker's reference to 'photography's expanded field' which drew from a model by Rosalind Krauss to establish the broad arena of contemporary photographic practice involving other media such as film, video and performance (Baker 2005). The contexts of presentation of photography have also expanded to incorporate virtual galleries on the Internet, a burgeoning book publishing industry, and modes of display have evolved into more dynamic interplays with other art forms and mixed media practices.

'Given the abundance of pre-existing visual material in our hyper-documented world, it's unsurprising that an increasing amount of photographic art begins with someone else's pictures. There's nothing new about appropriating found imagery for fine-art purposes. But the sources, methods, and goals are fast-evolving. If digital culture has transformed photographic practice—that is, how pictures are taken and displayed—it has had no less profound an impact on how found materials are sought and then manipulated.'

Robert Shore, 2014: 13

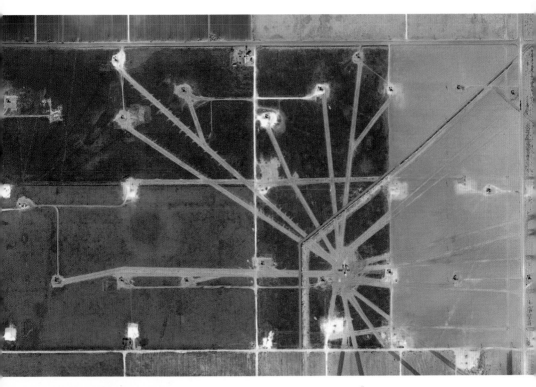

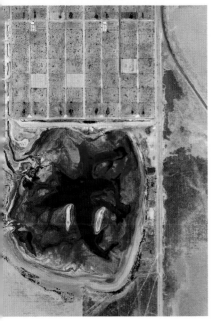

Title: *Levelland Oil Field #2, Hockley County, Texas*, 2013
and *Coronado Feeders, Dalhart, Texas*, 2013

Artist: Mishka Henner

Mishka Henner is a Belgian-born artist who works with appropriated material from the Internet. He has used the surveillance capabilities of satellite imaging and Google Earth in order to reflect on the omnipresent nature of surveillance technology and the ways in which it alters visual experience. His aerial surveys of flattened physical landscapes, that are often hidden from public view at ground level, resemble abstract paintings, for example, in his series 'The Fields' (2013), where he focuses on American oil fields in Texas. In another series 'Feedlots' (2012–2013), he charts areas where livestock is fattened up at an industrial scale; 'Coronado Feeders' (2012–2013) depicts cattle waste transformed into an expressionist abstraction from a perspective high above. The finished images are detailed, large-scale, wall-size outcomes that are the result of the stitching together of hundreds of individual screen shots. Quentin Bajac, chief curator of photography at the Museum of Modern Art, comments: 'His work is at the crossroads of many different genres or practices,' and considers it 'part of a strategy of neo-appropriation that you find in contemporary photography today with the Internet' (Gefter 2015).

Found photography

There has been a widespread use of 'found' imagery in the works of artists using photography, where essentially, the photographers themselves do not take the actual photographs but instead collects or archives vernacular imagery (i.e. photographs that were not created within traditionally 'authored' genres) from a variety of sources ranging from flea markets, magazines, newspapers, to the Internet. Artworks based on found photography entails the re-using of images for a new purpose and context, and in the creation of these archives, it raises questions around ownership and authorship, as well as creating and collecting. According to Mark Godfrey, the use of found photography 'marks the culmination of the de-skilling of photography' where 'de-skilling is taken to be a process in which artists separated their anti-aesthetic use of photography from the photographer's "fine art" ambitions for the medium' (2005: 96–97). He also comments on the significance of found imagery to the construction of archives (for example, Gerhard Richter's *Atlas*), to practices of appropriation, as well as to test the veracity of the photograph as document (for example, Christian Boltanski's *Tout ce que je sais d'une femme qui est morte et que je n'ai pas connue* [1970] and Zoe Leonard's and Cheryl Dunye's project *The Fae Richards Photo Archive* [1996]).

'In the context of the museum and art magazine (as opposed to the mantelpiece) we are forced to approach them differently. . . . Nixon's Brown sisters and Duchamp's urinal equally undermine the canons of "high" art by revealing the aesthetic power of the vernacular. At the same time they reveal just how powerful our taste-making institutions have become by revealing that it is quite possibly their appearance in the art context *alone* that makes them art.'

Henry Sayre, 1989: 38

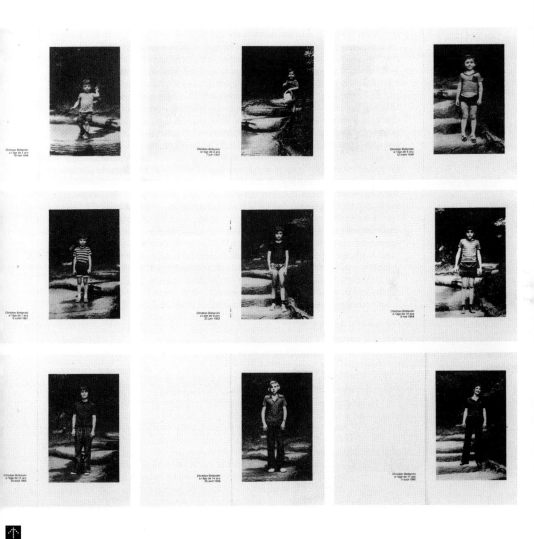

Title: *10 Portraits Photographiques de Christian Boltanski*, 1945–1964

Artist: Christian Boltanski

Christian Boltanski challenged our assumptions around the truth of photographic archives when he created his own fictional history by assembling a series of random photographs of young boys and titling them with captions that appear to be statements of fact, such as 'Christian Boltanski, Aged 7, 6 July 1951'.

Found photographs are unique media artifacts since they were not originally created as anonymous images to be viewed by a multitude of strangers, and they are dislocated from the original contexts that anchored their meaning. The surrealists were keen to exploit this function and frequently employed the use of found images and objects in their publications and artwork. Joachim Schmid is a Berlin artist, whose extended project *Bilder von der Straße* (*Pictures from the Street*) (1982–2012), entailed the collecting and repurposing of anonymous, discarded images of everyday life into collections that are exhibited internationally in museums and galleries. His recent project, *Other People's Photographs* (2008–2011), consists of a series of ninety-six books exploring the themes and patterns of amateur photography online. His personal website mentions that the images have been assembled from his trawls through photo-sharing sites on the Internet in order to create 'a library of contemporary vernacular photography in the age of digital technology and online photo hosting.' Indeed, the stripping of metadata by websites such as Flickr and Facebook allows images to be easily circulated without the context of the original maker.

**Title: *Afsaneh Box III –
A selection of identification
documents belonging to
Afsaneh Mobasser (1957–2013)
from age 7 to 55***

Artist: Ali Mobasser

Ali Mobasser is an Iranian photographer based in London. His work is informed by his own sense of displacement and his connections with ideas of his homeland. In this series, Mobasser rephotographs identification images of Afsaneh Mobasser, who was born in Iran, and exiled, in order to trace her life's journey. He recounts her story in a 2014 interview: 'For "Afsaneh Box III", almost all the IDs were found in a box when we were clearing out Afsaneh's belongings after she had passed. It did not need me to do much as the story was already in front of me. I just had to gather them and set the order. I did not see the items as photos but as Identifications, hence the surrounding areas (the context) being just as important as the photo itself' (Mobasser 2014).

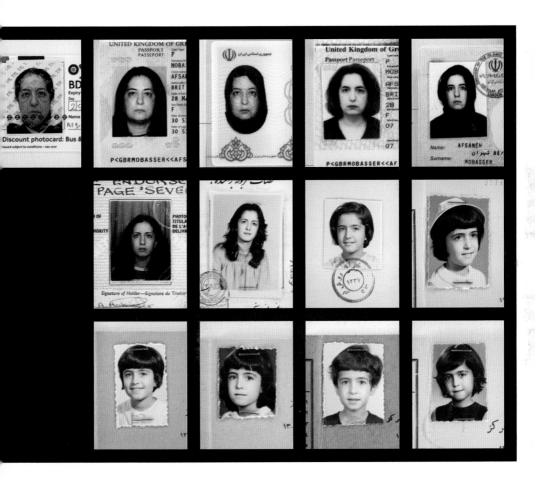

It has been argued that the shift in context of photographs, particularly those that serve documentary functions, is problematic. Documentary images often depict the suffering of others, and their consumption in an art context, perhaps even encouraging a voyeuristic fascination for images of trauma, raises ethical concerns, especially when taken out of context. Furthermore, the photographer may not have immediate control over how an image is used or 'misplaced'.

A good example of how context can affect meaning occurred when artist Joy Garnett used a portion of a photograph by Magnum photographer Susan Meiselas as the basis for her painting *Molotov Man* (2004). Meiselas's original photograph showed a member of the Sandinista National Liberation Front in Nicaragua throwing a bomb at one of the last remaining Somoza national guard garrisons. The photograph was taken on 16 July 1979, the day before the dictator Anastasio Somoza Debayle fled Nicaragua. Meiselas presented the photograph within a larger body of work that shows many aspects of the situation that are politically, socially, culturally and now historically relevant to the subject's actions.

In Garnett's painting, the subject is seen as a random rioter expressing anger. The recontextualizing of Meiselas's photograph in Garnett's painting could be seen to be not just disrespectful of the significance of the subject's actions and intents but also disregarding what was, for those involved, a serious and long drawn-out battle for what they believed was justice.

Both Garnett and Meiselas discussed the subject in *Harper's Magazine* in 2007. Meiselas states:

> There is no denying in this digital age that images are increasingly dislocated and far more easily decontextualized. Technology allows us to do many things, but that does not mean we must do them. Indeed, it seems to me that if history is working against context, then we must, as artists, work all the harder to reclaim that context. We owe this debt of specificity not just to one another but to our subjects, with whom we have an implicit contract. (2007: 58)

She is focused on protecting her subject's integrity and motivations and what could be described as a level of historical accuracy and broader understanding. As this incident demonstrates, it is vital for photographers to recognize both the practical and ethical implications of context and develop their own sense of ethical boundaries and a professional code of practice.

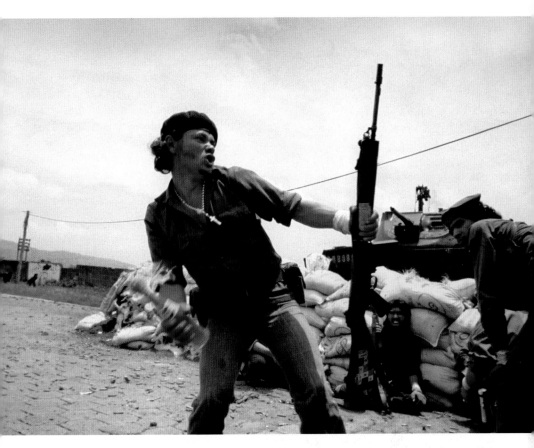

Title: *Sandinistas at the Walls of the Esteli National Guard Headquarters*, 1979

Photographer: Susan Meiselas

Susan Meiselas explains: 'It is important to me – in fact, it is central to my work – that I do what I can to respect the individuality of the people I photograph, all of whom exist in specific times and places. So here is some context: I took the picture above in Nicaragua, which had been ruled by the Somoza family since before World War II. The FSLN, popularly known as the Sandinistas, had opposed that regime since the early 1960s. . . .

I made the image in question on July 16, 1979, the eve of the day that Somoza would flee Nicaragua forever. What is happening is anything but a 'riot'. In fact, the man is throwing his bomb at a Somoza national guard garrison, one of the last such garrisons remaining in Somoza's hands. It was an important moment in the history of Nicaragua – the Sandinistas would soon take power and hold that power.' (Meiselas 2007: 56–7)

Supporting text

In the previous chapter, we looked at visual approaches to the conceptualization of creative work and the importance of the photographer recognizing their intentions behind photographic communication. A significant aspect of this communication is to understand the function of the work, which can inform critical choices before, during and after the undertaking of a project. Text (in the form of titles, captions or words accompanying images in an article) plays a significant role in audiences' interpretations, reflecting the viewpoint of its author, whether it is the photographer, editor, curator or writer.

In his book *Vietnam Inc.* (1971), Magnum photographer Philip Jones Griffiths captioned his images to reveal their original context – for example, in the image entitled 'Quang Ngai Province, Vietnam, 1967': 'Mother and Child, shortly before being killed. A unit of the American Division operating in Quang Ngai Province six months before My Lai. The resentment was already there: this woman's husband, together with the other men left in the village, had been killed a few moments earlier because he was hiding in a tunnel. After blowing up all tunnels and bunkers where people could take refuge, GIs withdrew and called in artillery fire on the defenseless inhabitants' (1971: 59).

Rick Poynor describes being troubled by the discovery, on reading the caption, that the husband of the female subject in the photograph had been killed moments before, and that she and her child would also soon be killed. Jones Griffiths highlighted the plight of innocent victims: 'Analysis is exactly what Jones Griffiths provides in his pictures and writing in *Vietnam Inc.* His findings have a depth of experience and a moral authority that comes from taking risks and personally bearing witness. It may suit some photographers to deny this now, but the viewer still sees it' (Poynor 2015).

Statement of intent

Statements of intent should clearly communicate the rationale of the work, for example, the 'Shootback' project (1999), involved giving teenagers from Mathare, one of Africa's largest slums in Nairobi, plastic point-and-shoot cameras to document their daily lives. The introduction in the publication edited by Lana Wong (2000) clarifies the scope of the project – these are photographs made by the teenagers accompanied by their written descriptions of when and how they took each picture. It also includes a statement from the United Nations about how these images present a different reality to the front-page stories about youths in East Africa, largely linked to mob violence, AIDS deaths, drug use etc. A further statement from the Mathare Youth Sports Association adds to a clear outline of the ambitions for the project. The book also includes a portrait and brief autobiography for each one of the participating teenagers.

With clear information, audiences can understand their function and purpose within a clearly defined context. A critical reflection and evaluation of your work should illuminate major aspects of the context within and surrounding the photograph and contribute to your development of an effective visual language.

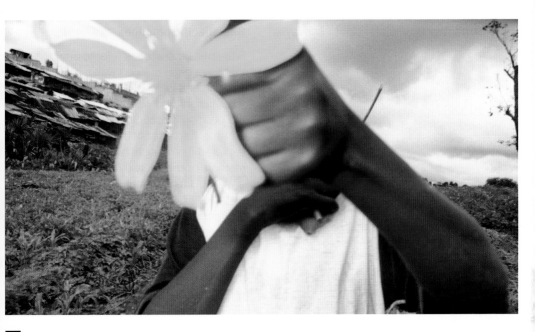

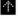

Title: from 'Shootback'

Photographer: Saidi Hamisi

It is significant that teenagers who live in the environment that they are photographing made these images. From the perspective of the audience, this authorship implies a sense of honesty that could not be appreciated in the same way if a visiting photographer had made the photographs. 'Shootback' is a community project has positive social impact. Hamisi comments: 'My ambition in the future is to become a good journalist' (Wong 2000).

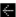

Title: from 'Shootback'

Photographer: Peter Ndolo

Peter says of his Shootback experience: 'I thank God and Shootback because I could have been in the street borrowing money, snatching women's bags or sniffing glue, but now I know how to take pictures, how to process film and about the Internet' (Wong 2000).

While photographers can aim to convey an intention or expression, it is not possible to accurately predict the response of the viewer. However, the viewer's response can be informed by the photographer's visual language and the clarity of their intention. In his essay 'Context as a Determinant of Photographic Meaning', John Walker (1997) refers to a 'mental context' within reception theory, which focuses on the reading rather than the making of a photograph and is concerned with the impact of works of art on viewers. As well as the more immediate context of the required output and destination of the photograph, it is also important to consider the cultural and social context that the final image will be viewed in. For example, will the photograph be making any direct references to topical events, or will it take on a new meaning or further dimensions because of cultural beliefs, current events or viewers' experiences? Likewise, will the work have particular resonance if it was displayed in a particular context?

Site-specific practices

Site-specific practices refer to artworks that have been created within a particular location and which holds or develops a relationship between the artwork and the position it occupies. Shimon Attie, an American artist of Jewish heritage, explored the relationship between place, memory and identity through photography and installation. His project 'The Writing on the Wall' (1991–1992) entailed a search for traces of Jewish culture in Berlin, a community which was destroyed during the Second World War. He converted historic photographs taken sixty years earlier in the Scheunenviertel (the former Jewish quarter in East Berlin) into slides, and he projected portions of them directly onto the original sites of these photographs wherever possible. He then photographed the scenes with the projections, re-animating these sites with their lost histories and memories.

Making progress

- Obtain feedback from tutors and peers through tutorials and group critiques.

- Portfolio reviews are often organized at gallery events. Share your work-in-progress at a portfolio review session; this would be more beneficial than attending with a finished body of work.

- Use portfolio review sessions as a valuable opportunity to share work with other photographers and to build collaborative networks.

- Be able to clearly communicate your concept and intentions, both verbally and in written form.

Title: *Mulackstrasse 37: Slide projection of former Jewish residents, ca. 1932, Berlin*, 1992 and *Almstadtstrasse 43 (formerly Grenadierstrasse 7): Slide projection of former Hebrew bookstore, 1930, Berlin*, 1992

Photographer: Shimon Attie

Erwin Leiser in the *Independent* explains: This image 'shows two little boys who probably died during the war; some graffiti, recently sprayed on the house, reads, "What the war has spared . . ."' (Leiser 1994).

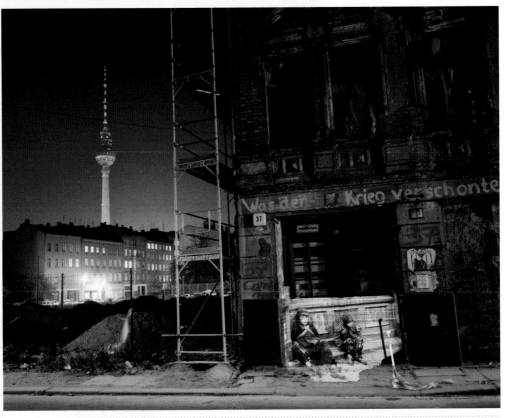

Presentation

Drawing from the work of photographers such as Alfred Stieglitz, Minor White, Josef Sudek, Lewis Baltz, Nicholas Nixon and Sian Bonnell as examples, it is worth noting that the presentation of work as a series or in sequences creates dialogue among the individual images. It is therefore important to consider how photographs can relate to one another within a body of work. Order, size, shape and placement on the wall, page or screen can all work together to inform how photographs are seen and read. The contribution of these elements in constructing a narrative will be further explored in the second part of this book, but here it is important to ask whether the presentation echoes, informs or works as part of the concept. Does the method of presentation work in accord with the conceptual approach?

The way in which an image is presented is an important aspect of the context in which it is seen and therefore interpreted. Size, shape and ordering of images are the main ingredients that inform how a series of images relate to each other or highlight the significance of a single image.

Typology sets, or series, are a simple but effective way of enabling the viewer to compare the detail within a group of photographs. Typology is simply the study of types. Photography can be used in a consistent manner to produce a set of related images, as with Jamie Sinclair's images, and illuminate aspects of either the subject or conceptual approach. The presentation of the typology group, such as in a grid formation, can be integral to the interpretation and also an exercise in considering how viewers understand the relationships between one image and another within the exhibition space. The German artists Bernd and Hilla Becher photographed industrial buildings for over forty years, starting in 1959, and made black-and-white photographs of types of industrial structures using a large format camera, often exhibited in grid format. They employed a rigorously consistent way of working – each structure was photographed from a similar angle and under similar lighting conditions. In relation to their presentation, Michael Collins (2002) explains in *Tate Magazine*: 'By placing photographs of similar subjects alongside each other, the individual differences emerge, making the fine details in each picture more noticeable, more distinct. Drawing on this, they began exhibiting the pictures as typologies . . . the typology was the work . . . a symphony of industrial structures.' Presenting their work in a grid, as mentioned in chapter 1, 'The Photograph', was one of the methods the Bechers employed to draw attention away from documentary and toward form. In other bodies of work, such as Lalage Snow's, noticing the 'fine details' is integral to the documentary function of the work.

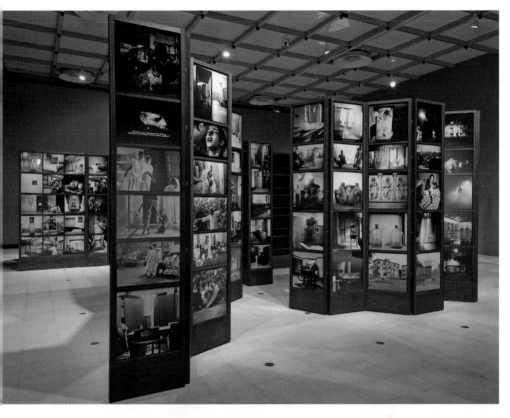

Title: Installation view, *Dayanita Singh: Go Away Closer*, Hayward Gallery, London 8 October–15 December 2013

Photographer: Stephen White

Dayanita Singh is an Indian artist who presents her work in a variety of formats: publishing photobooks of poetic quality and creating portable museums, the latter consisting of wooden structures with movable panels that house photographs of particular themes. This display format allows the viewer to make connections among the images, and the layout (which Singh reconfigures according to each exhibition space) invites the viewer to move around the physical exhibits, stimulating engagement with her visual stories. She comments in *The Hindu*: 'My museums are like photo-sculptures, photo-architecture' (Tripathi 2015). Ruth Rosengarten points out that Singh's interest in the archive and visual storytelling and her flexible and intuitive approach to display is significant: 'The re-editing and re-purposing of photographs, allowing them to wander from one context (book, display, museum) to another hyperbolises the notion of impermanence and re-contextualisation' (2013).

Title: from 'Constricted Reality'

Photographer: Jamie Sinclair

In these portraits, which are aesthetically coherent as a series, Sinclair drew upon his feelings of a loss of control over his body due to asthma. To reflect these feelings, Sinclair devised a method of photographing while his subjects were upside down and holding their breath. By doing so, he was able to capture the involuntary responses of the body.

Title: *We are The Not Dead, Returning by the Road We Came*

Photographer: Lalage Snow

Lalage Snow photographed a series of portraits of British soldiers over a seven-month period; before, during and after their deployment to Afghanistan on Op Herrick 12. Each image in the series is captioned with the thoughts and feelings of the individual. Their presentation as a triptych (a set of three images displayed together) effectively contextualizes their experiences over time.

Ideas for exhibition or presentation

- Consider the possible contexts of presentation of your work, such as exhibiting in a gallery, in a public space (e.g. in a converted shopfront, offices, café or any physical space as part of a community project), publishing a photobook, part of a magazine spread, screen-based or online, or even a digital presentation to an audience. Evaluate the appropriateness of specific sites of display to your work.

- Create opportunities for yourself by actively thinking about possible projects that could be linked to particular locations. For example, a series of portraits of football or rugby team players to be displayed within their club premises. Relevant parties can then be approached for permissions and possibly funding.

- Conversely, having created a body of work for a university project, it would be useful to consider what other applications or sites of display your work could have beyond its submission as 'coursework'. For example, a student who undertook a project documenting a broad range of individuals suffering with depression and other mental illnesses approached Mind Charity (UK) to organize an exhibition at one of their sites in conjunction with a larger conference event they had organized.

- Photographers are not necessarily designers. Approach peers or colleagues who may be better equipped to advise on book design.

- If using text, consider how much is needed (e.g. title of project or individual captions) and how to present text with images.

- When ordering and positioning photographs, think through ways of creating specific relationships among images – for example, as a series, grid, diptych or triptych.

- Within the gallery context, in addition to mounting or framing photographs or placing them in light boxes, consider projections as well as the use of film and moving images or creating an installation. How would you introduce audio recordings (perhaps of interviews), other sounds (ensure you have license to use recordings), objects or other material to make connections with particular events or environments?

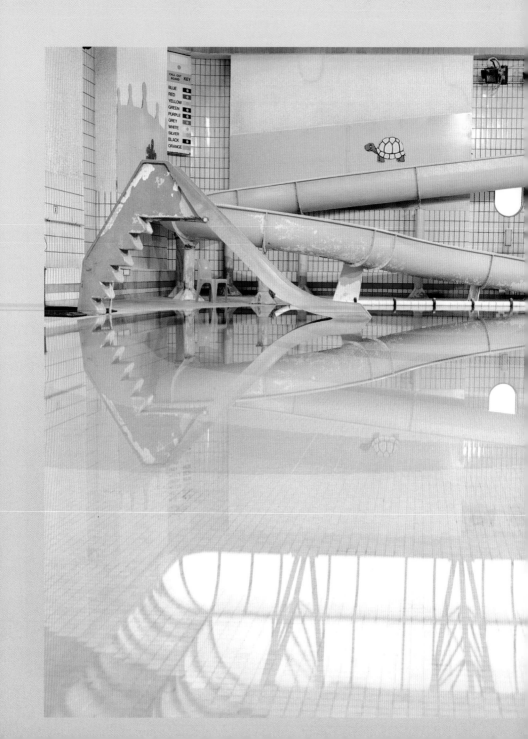

Case study 1

The decaying King Alfred leisure centre on Hove seafront in the south of England, UK, opened during the 1930s. Having served the public for over seventy years, the site has been earmarked for redevelopment. A Frank Gehry designed structure, incorporating a sports complex and 754 apartments, at an estimated cost of £290 million ($470 million), have been proposed for the site. The new landmark redevelopment will soon erase the memory of the outdated, existing leisure centre.

Local photographer Simon Carruthers decided to capture the atmosphere of the original complex before it is permanently erased from the landscape and people's memories. Using a Bronica ETRS 6x6 camera and Kodak VC160 film, Carruthers used only available light to convey a sense of the atmosphere of the building. Even in the darker rooms, lit from man-made overhead lighting, one can feel the presence of the strong light reflected from the sea and the flat, open surrounding space of Hove seafront.

Carruthers describes the original context of the work, his attraction to the building and the intention behind his photographs:

> I was drawn to The King Alfred because . . . I am intrigued by the process of decay, especially regarding the man-made. Possibly this has something to do with the gradual processes of nature reclaiming human territory. I am very aware of waste and the effect our disposable society has upon the planet. I think I could probably sense an element of wastefulness in our attitude toward this old building, which has served the community for so long. (Carruthers, pers. comm. 2010)

Title: from 'The King Alfred'

Photographer: Simon Carruthers

Setting his lens to the smallest aperture, Carruthers' technical precision can be appreciated through the detail and atmosphere rendered in the images.

But Carruthers is also conscious of the impact of the context in which the images are shown, and the importance of the audience in achieving the desired result.

> My ideal audience is the general public, as I see my work as informative. The last thing that I want is that my work becomes exclusive and is only understood by people who have studied the Arts. My work is conceptual – it has to be – but only to a point. If only ten per cent of the people who see it are able to make sense of it, then it has failed. My aim is to produce striking images to grab the attention but once I have your attention then it is time for the meaning of the work to come through. If the work is not striking then I won't get your attention in the first place and the work has failed. There has to be a balance – aesthetic and concept or meaning. If the work is purely aesthetic, I have little interest and if the work is too conceptual it can become self-centered or exclusive and then risks alienating its audience. (Carruthers, pers. comm. 2010)

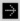

Title: from 'The King Alfred'

Photographer: Simon Carruthers

Setting his lens to the smallest aperture, Carruthers' technical precision can be appreciated through the detail and atmosphere rendered in the images.

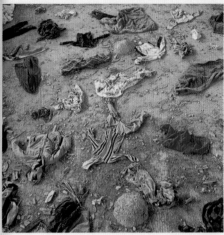

ABANDONED SWIMMING POOL COMPLEX
LAMPEDUSA, ITALY, MAY 2015

(This page)
ABANDONED SWIMMING POOL COMPLEX
LAMPEDUSA, ITALY, MAY 2015

(Next Page)
LAMPEDUSA, ITALY, MAY 2015

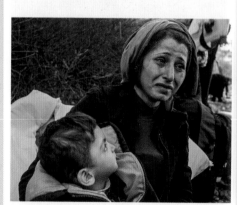

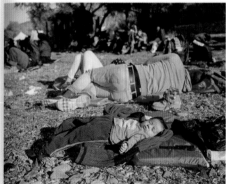

LESBOS, GREECE, NOVEMBER 2015

LESBOS, GREECE, NOVEMBER 2015

Case study 2

The photobook has served for many years to showcase and disseminate a range of different photographic practices. Its format allows it to reach wider audiences and, as a physical object, it possesses a permanence that offers longevity in contrast to a temporary photographic exhibition in a gallery or museum. Gerry Badger and Martin Parr, in *The Photobook* highlight the important role that the photobook plays within the history of photography: 'It resides at a vital interstice between the art and the mass medium, between the journeyman and the artist, between the aesthetic and the contextual' (2004: 11). They cited the Dutch photography critic Ralph Prins in describing the photobook as 'an autonomous art form, comparable with a piece of sculpture, a play or a film' (Badger and Parr 2004: 7). Indeed, the photobook has provided a platform for photographers to innovate and experiment with their visual language; take for example, the creations of Daido Moriyama or Alec Soth. In recent years, there has been a flourish in photobook publishing, as well as a proliferation of photobook awards, one of the most well-known of which is the Aperture Photobook Awards, which 'celebrates the book's contribution to the evolving narrative of photography.' In addition to the use of social media for advertising, Liz Jobey (2015) attributes the booming photobook industry to the 'advances that digital technology has made to the design and production of visual publishing'.

The John Radcliffe Studio is the creative partnership of Daniel Castro Garcia and Thomas Saxby. Their project, *Foreigner: Migration into Europe 2015–2016* (2016), is a self-published photobook project which documented the plight of refugees and migrants from Africa and the Middle East around 'hot-spots' in Europe over an eight-month period. In 2016–2017, they commented on the use of the book as their primary format of choice, and why it was important to the project:

> The book itself serves as a perfect vessel to encapsulate the situation in each of the places we visited. Although it is a macro project, the focus is on the people suffering the consequences of this humanitarian crisis. From a photography point of view,

Title: page spread from
***Foreigner*, images entitled**
'Abandoned Swimming Pool
Complex, Lampedusa, Italy,
May 2015' and 'Lesbos, Greece,
November 2015'

Photographer: Daniel Castro Garcia

there is a proximity and intimacy to the work that conveys (and allows for) a different interpretation of the story and provides an alternative visual to what is used by the media. By considering each person individually we felt there was an opportunity to create a body of work that humanises the subject and removes the complex geopolitical aspects of the crisis. . . . Furthermore, the book serves as a document with a historical value, and potentially an educative one also. The design elements are particularly important in delivering this idea. We wanted to create a sobering and thoughtful reflection rather than a sensationalist and voyeuristic experience. In addition, the consumption of images is almost relentless these days. The Internet and social media has shortened attention spans and changed the way we look at the world. By placing the work into a book we felt there was an opportunity to slow down this interaction with images and effectively prolong their life-span. (Saxby and Garcia, pers. comm. 2016–2017)

All images are captioned with location information, and sometimes explain the context of the photograph; for example, 'Šentilj, Slovenia, November 2015: A queue of refugees wait for food and water after being held in no-man's land for eight hours'. The book is also interspersed with brief contextual narratives about individual experiences: 'Sometimes people were interviewed but generally this project was more about spending time with people and talking, getting to know one another and exchanging thoughts and experiences. The caption work in the book is very simple. . . . Despite their brevity, they offer precision and are free of sentimentality or misinterpretation' (Saxby and Garcia, pers. comm. 2016–2017).

As Saxby and Garcia state on their website: 'The book serves as an alternative to the imagery used by the mainstream media to depict Europe's refugee and migrant crisis. We wanted to approach the subject from a calmer perspective, using photography as a means of meeting the people at the centre the crisis face to face – and of learning something about their lives.' They add that the project 'attempts to capture individual stories and to use photography as a peaceful and empowering tool, rather than one of judgement. . . . When journalism and public discourse move into the sphere of inflammatory language and misinformation, so often the real victims are forgotten' (2016, n.p.).

Saxby and Garcia commented on the design of the book, which was a process that entailed consideration of placement and structure of the images. They had six chapters defined by geographical location, and the sequence they eventually arrived at aimed to present several different journeys. They describe the book in the first instance as one which depicts the migrant's journey – 'early chapters dealing with boat crossing

and arrival in Europe, the middle section dealing with travelling across the Balkans, and the final chapters covering the informal migrant camps where many people find themselves trapped.' They also add that 'the book is chronological; the first chapter on Lampedusa being the first trip we made and the final one in Idomeni being the last (it was an attempt to make the book as up to date as possible and the photos were in fact taken just a couple of weeks before we sent files to print)' (Saxby and Garcia, pers. comm. 2016–2017). They also describe the chronological aspect of the book as akin to their own 'journey of understanding' in its making. Whilst their first chapter in Lampedusa is devoid of people, this relationship between photographer and subject developed over time:

> As the book progresses, so does the proximity to the subjects – emotionally and physically – and it's not until half way through the book that you get some of the diptychs and stories of some of the people we met. This progressive proximity reaches its climax with the final image - our friend Aly Gadiaga dressed in a red robe. This image was the result of the deepest relationship we made with anyone in the book, and is the only portrait that tries to represent things from within the sitter's psyche. (Saxby and Garcia, pers. comm. 2016–2017)

Foreigner was exhibited at TJ Boulting Gallery in London in March 2017, and it presented an opportunity for Garcia and Saxby 'to experiment with how the subject is explored visually, placing it into a different environment' to the book format (Saxby and Garcia, pers. comm. 2016–2017).

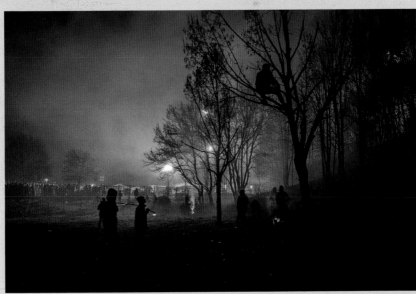

Title: *Šentilj, Slovenia*, November 2015. After hours of waiting, groups of people move into a nearby field and use tree branches to make fires and keep warm

Photographer: Daniel Castro Garcia

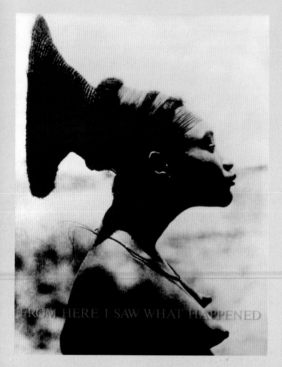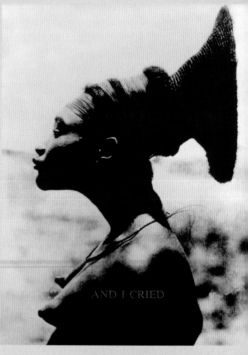

FROM HERE I SAW WHAT HAPPENED

AND I CRIED

Title: *From Here I Saw What Happened and I Cried*, 1995

Artist: Carrie Mae Weems,

Maren Stange explains: 'The exhibition *From Here I Saw What Happened and I Cried*, "starts" with a large blue-tinted profile portrait of a woman in West-African head-dress – the Mangbetu woman Nobosodru, photographed in 1925, looking to the right. . . . At the end of the 32-image sequence, the same portrait flipped to look left, reappears with text reading "And I Cried"' (2005: 279).

Case study 3

Carrie Mae Weems in an influential American artist well known for her explorations of race, power, identity and history through personal, cultural and historical perspectives. Her multimedia installations often integrate photographs, text, video and sound, creating audio-visual environments that engage the viewer through her narrating of events. In a 2014 review for *The New York Times*, Holland Cotter refers to Weems's work entitled *Family Pictures and Stories* (1978-1984), where she compiled a family album of images of relatives who are migrant sharecroppers who moved from Mississippi to Oregon in the 1950s and combined them with 'interviews and anecdotes to express and define a familial history' (Kirsh and Sterling, 1993: 11-13). Weems subverts the reading of African American portraits in her series, *From Here I Saw What Happened and I Cried*, through the re-use and recontextualizing of historical images. She rephotographed and enlarged the images, reprinting them in blood red. Weems placed the prints behind glass, and sand-blasted captions that read 'A Negroid Type' or 'Others Said "Only Thing A Niggah Could Do Was Shine My Shoes"'.

Appropriation has been a strategy employed by artists since the late 1970s, and contemporary non-European artists have utilized such approaches to articulate their identities in relation to the ways in which particular races have been represented (largely Black stereotypes based on physiological differences) in ethnographic and anthropological archives. Artists including Dave Lewis, Glenn Ligon, Lorna Simpson and Carrie Mae Weems draw from historical images made by Western anthropologists, scientists and other official recorders of racial types in order to challenge the legitimacy of these practices and to question power relations. Weems was commissioned in 1995 by the J. Paul Getty Museum in Los Angeles to create a response to their earlier exhibition entitled *Hidden Witness* (1992) on African Americans in

photography, which consisted of the Getty Museum's and a private collection of mid-nineteenth century photographs of Africans and African Americans individuals archived largely as 'nameless slaves' (Golden, 1998: 29-30). In *From Here I Saw What Happened and I Cried* (1995), she appropriated daguerreotypes from a study conducted by Swiss naturalist, Louis Agassiz. Weems's critique and deconstruction of African stereotypes provokes a questioning of the audience's own reading and understanding of Black history, as well as a contemplation of power and race relations. In an audio interview for the Museum of Modern Art in 2000, she states, 'When we're looking at these images, we're looking at the ways in which Anglo America—white America—saw itself in relationship to the black subject. I wanted to intervene in that by giving a voice to a subject that historically has had no voice' (Weems 2000).

'So there's three narratives that are working simultaneously, and then the individual photographs for the most part stand alone as individual units. A narrative like you became a scientific profile, a Negroid type, an anthropological debate, a photographic subject. They're all of these sort of singular moments that go on to make a more complex story. . . . It doesn't have a single note, but it has many. It has notes of complication and duplicity and complicity. I love the rhythm of the text that's created that allows for the image to be amplified.'
Weems n.d.

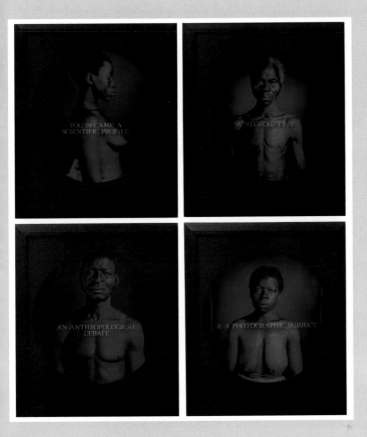

Title: *From Here I Saw What Happened and I Cried*, 1995

Artist: Carrie Mae Weems

Exercises: Considering contexts and meanings

→ Prior to visiting an exhibition, look at the work online or in a book. Note your response and then compare it with your response when viewing the work at exhibition. How does viewing the work in a gallery alter or influence your reading of it?

→ Take time to write down your observations and reflect upon the link between the photographer's statement, the work and your response. Take shots of the exhibition space if you are allowed to, and review the work's concept in relation to presentation methods. Having researched the wider context in which the work was made, how does this influence your interpretation?

→ Within a group of peers, each person could collect ten to twelve images of different subject matter derived from a range of sources – for example, photographs depicting fashion, or documentary subjects, portraits of celebrities, family photographs. First conceal their sources and contribute to a discussion on what the images are about and in what context they could have been used. Then divulge original contextual information and evaluate your responses.

→ Try printing one photograph in several different ways; for example, as a large print, a small print and on different paper types. If possible, position your test prints within the exhibition space beforehand to clearly recognize the size of the print in relation to the characteristics of the space (e.g. height of the walls, lighting etc.). Discuss the impact of print size in relation to your concept with your peers.

→ Produce a body of work around a theme of your choice, aiming to produce around fifteen to twenty images. Through a selection and editing process, consider what choices you will make if you were to (1) exhibit a work on a gallery wall; (2) create a photobook; or (3) produce screen-based outcomes, for example, your own website or a virtual gallery. Decisions relating to the actual content, the number of images, the size and technical resolution of the outputs, the sequencing and arrangement of the work, the use of text etc. will highlight the fact that different approaches are necessary when applying your work within various formats of presentation.

Title: *Sunday New York Times*, 1982

Photographer: Tina Barney

Tina Barney, alongside Gregory Crewdson, Jeff Wall, Stan Douglas, Adi Nes, Erwin Olaf and Max Pinckers, to mention just a few, is known for her narrative images. The narrative qualities of her images can be attributed to their detail and the clarity of their composition, as well as the provision of theatrical and melodramatic scenes that invite interpretation. For the production of her images, Barney has been using an 8x10 large format camera that allows the presentation of the image in large scale so as to absorb the viewer in the detail. A large part of her work presents domestic scenes, drawn from the affluent everyday life of her friends and family. To enhance the legibility of the scenes, Barney also often uses additional lighting and directs her subjects. The images often seem to be stiff and unnatural, adding an existential dimension to the work that seems to address the alienation characterizing contemporary society. She claims: 'When people say that there is a distance, a stiffness in my photographs, that the people look like they do not connect, my answer is that this is the best we can do. This inability to show physical affection is in our heritage.' (Bussard 2006: 72)

Visual narrativity

In the previous chapters, we discussed how audiences use frames of reference and context in order to interpret the images they see. Even though, as will be explained in the next section of this chapter, the notion of a narrative can only marginally be applied to photographs, visual narrative techniques are often used to depict or create these frames of reference and context: they can define the content of the images and highlight photography's inherent characteristics, communicate the photographer's intentions, and be employed to recontextualize the work in a process of producing new narratives.

Ultimately, the aim of using narrative techniques in photography is to provide meaning, coherence and, where appropriate, a sense of rhythm to an image or sequence of images. These techniques can be seen as a kind of visual punctuation that can offer a sense of organization to attract and immerse the viewer in a representational universe, fictional or actual, or as a stylistic intervention through which photographers affirm their identity as authorial subjects. In this chapter we will explore notions of visual narrativity and the significance of narrative techniques in single and multiple images.

4

Narratives have been analysed mainly in literary/film theory and criticism, but they are used in many fields of endeavour where giving the audience a thread to follow or a concept to grasp can be helpful in conveying or examining information in a particular context, such as sharing experience to enhance knowledge or instigate change.

In simple terms, a narrative is described as a story. Images are frequently used to illustrate a story, as happens for example in newspapers, where photojournalistic images are used to draw the reader's attention, to humanize the story or to provide a visual reference for the account of events illustrated in the text. The use of images alongside text will be further explored in chapter 6, 'Image and Text'. Also, as we shall see in chapter 5, 'Photographic Discourse', because of its mechanical nature and reference to the world, photography has increased narrative potential. However, unless we accept the statement that all images narrate, a general definition of a narrative that equates narratives to stories does not allow for the processing of the variety of methods in which images narrate, nor of the difference between narrative and description.

In his 2008 essay 'Narrative, Narrativeness, Narrativity, Narratability', drawing on narratology (the science devoted to the study of narratives), Gerald Prince provides a more precise definition of a narrative that allows acknowledgment of the complexity of the term and the plurality of its expressions. Prince defines a *narrative* as 'the logically consistent representation of at least two asynchronous [i.e. non-simultaneous] events that do not presuppose or imply each other' (Prince 2008: 19). But Prince also acknowledges that the degree to which an object can be a narrative can vary. He claims: 'Some objects are narratives; some are quasi-narratives; and some are not narratives. Some narratives are more narrative than others; some non-narratives are more narrative than others' (Prince 2008: 22). As such, *narrative* can signify both an entity and a quality of being narrative to a varying degree. The latter quality will be referred to as *narrativity* in the rest of the text.

It is often said that 'an image is worth a thousand words', but the narrativity of different photographs too can vary greatly. Because of its lack of duration, photography's capacity to represent asynchronous events is limited. Further, images are less precise than words in narrating events – for example, in explaining what happened first and what followed, or characters' thoughts and motivations; hence the incorporation of written text that can guide the viewer's interpretation. Photographs can overcome such difficulties when they are presented in a series or when they include more than one instance of an event, as happens in polyphase images, which include more than one instance of an action. Further, with the use of narrative devices, images can call for a narrative to be completed by the viewer. Narrative techniques can increase an image's narrative potential, or its narrativity, but some photographs can be best described as merely an instance within a narrative, and some photographs are not narrative at all.

The following sections provide a list of techniques and devices that introduce degrees of narrativity to the photographic image and enhance its communicational possibilities.

Linear storytelling

Linear storytelling is a key feature of realist narratives, where events are presented in a sequence that has a clear beginning, middle, and end. A realist narrative, in Robert Alter's words, 'seeks to maintain a relatively consistent illustration of reality' (Alter 1984: 12). In a series of images, the viewer is invited to fill the gaps between narrative fragments, which in the case of linear storytelling are as small as possible. The reading of this narrative can be stimulated with the provision of visual continuity and a sense of progression.

In 'Trashumantes' (2009), José Navarro documented a three-week journey in November, during which a flock of 5,000 sheep were walked across 250 miles of the Spanish landscape by their seminomadic shepherds. The journey saw the flock leave the exhausted summer pastures of their native Serrania de Albarracin for the green winter hillsides in Andalucia. They walked the old drovers' tracks as part of a 1,000-year-old tradition of seasonal livestock migration (trashumancia) that is both cost-efficient and an environmentally friendly alternative to road transportation.

The photographs convey the enormity of the journey as the audience follows the flock through the landscape and towns. This is an example of a linear and sequential story with a clear beginning, middle and end. The natural flow and rhythm are dictated by the event itself. As the majority of the audience viewing the images would be unfamiliar with the exact details and landmarks of the route, the order of the photographs may have been shuffled to produce a more fluid visual sequencing. Using the same camera format and tonal quality of black and white throughout enhances the level of continuity.

Points to consider in relation to linear narration:

- How many images would you need to illustrate your narrative?

- How much control do you have over the order in which the pictures will be viewed?

- Will the audience see all the pictures at once?

- Will the audience follow an identified sequence?

- Will some pictures take greater prominence than others?

- Do you need a 'lead' picture – one that sums up the intention?

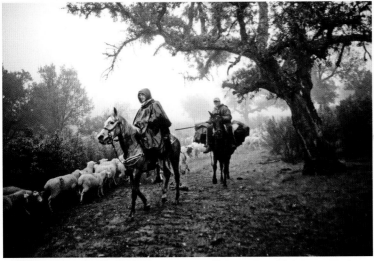

Title: from 'Trashumantes', 2009

Photographer: José Navarro

'During the journey, I felt the pervading sense of camaraderie amongst them and witnessed how the activity completely defines who they are. They are Trashumantes and could not, would not, be otherwise. Sadly, they're often seen as an anachronism in our technological society. However, for the Trashumantes, the journey is not an exercise in nostalgia but a cost-efficient and environmentally friendly alternative to road transport: they save money by walking the sheep instead of taking them in lorries. The activity is unquestionably rooted in a modern market economy.' (Navarro)

Non-linear narratives

In visual communication a narrative does not need to work in a linear sense. It can be cyclical, operate as a series of embedded stories or make cross references that, when brought together over repeated readings, inform the viewer's overall understanding or interpretation of the photographer's intentions.

An interesting example of narratives created with the photographic medium is what Jan Baetens calls the 'experimental photonarrative' (Baetens, 2001). This is similar to the photo-roman, the photographic equivalent of the graphic novel, but, for Beatens, experimental photonarratives differ from the photo-roman in the richness and complexity of their content and in that language is not the dominating element. He regards the work of Duane Michals, as well as Marie-Françoise Plissart's book-length photonarrative *Right of Inspection* (1985), published alongside an essay by Jacques Derrida, and Lawrence Levy's *Going to Heaven: A Photo-Narrative* (1976), as paradigmatic for the genre because of the complexity of their structure and the sense that the text is reduced to the title.

The experimental photonarrative emerged in the 1970s inspired by self-conscious fiction and Oulipo authors, such as Italo Calvino, who set themselves against the conventions of realist fiction that, with a few exceptions, had dominated the novel until then. By subverting conventions of linearity, objectivity, and logic, such narratives can prove more difficult to piece together but can also encourage a more active engagement.

It is worth mentioning that there are a number of similarities in Michals's, Plissart's and Levy's works, such as their black-and-white format and use of cinematographic sequencing. All three photographers also make effective use of the photographic medium and employ the breaks between images to introduce new elements, double-expose their images or transition to different photographic realities through embedding. The complexity of their structure invites repeated reading and allows the gradual enrichment of the viewer's impressions.

'The "decisive moment" is a very important category in photography but I just did the moment before and the moment after that. What I did was to stretch the moment, to give me more space. Rather than just depending on the one photograph, I had some room to develop an idea and tell a story. It liberated me.'

Duane Michals, 2014 (Lemoine 2014)

THINGS ARE QUEER

 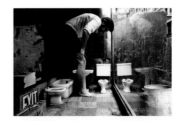

Title: 'Things Are Queer', 1973

Photographer: Duane Michals

Michals's narratives, however minimal in comparison to Plissart's and Levy's book-length narratives, invite the viewer into a fictional universe that is immersive both in narrative and conceptual terms. 'Things Are Queer' is an example of a circular narrative structure that is achieved through embedding. The series provides a set of illusory transitions between photographic realities and perceived actual realities, with every image challenging the impressions received from the previous ones. Experimental photonarratives, such as this one, emphasize the importance of storytelling techniques over that of the story being told.

Visual continuity and uniformity, for example, in size, quality, colour and representation of space, across a set or series of images do not necessarily lead to a narrative. However, they can offer a sense of rhythm and coherence, and they can operate as a bonding element between images, with the method of production and the manner of presentation giving the audience subtle visual clues that inform the reading.

Jill Cole's project 'Birds' operates as a chapter within a larger body of work that explores an army garrison in North Yorkshire. Each chapter in this work is defined by uniform series of images. The underlying significance of 'Birds' comes through the manner in which Cole photographed her subject. Cole frames her subjects so that there is a strong level of visual continuity between each image. The continuity can also be seen in the lighting, colour and tonal range of the images. The images, therefore, despite appearing quite disturbing at times, are 'easy on the eye'; there is a sense of fragility. The photographs are compelling and draw the audience in further to explore their content.

Clare Grafik, curator at The Photographer's Gallery, London, UK, writing for 2008 Graduate Photography Online for *Source* magazine, describes Cole's work: 'Jill has a very accomplished visual sensibility, which enables her to combine a number of different elements into this coherent and striking series of work' (Grafik, 2008).

So far we have looked at several specific narrative techniques across a set or series of images. Another point to consider is the relevance of the size and the shape of the images. If you are producing a sequential set of images, it can be possible to achieve a certain pace in the series by using a particular size or shape of image at a key point in the sequence, either as a recurring theme or a one-off. This is the kind of technique that one could describe as a form of visual punctuation.

Another technique is the production of triptychs and so forth; images that work as small sets within a larger body. Juxtaposing different images can also help present an argument or raise a question; the tension between negative and positive being one obvious example, and indoor versus outdoor another.

It is also worth questioning the eye of the camera in relation to narrative. Is the camera a fourth wall, the eye of the viewer or the 'eye' of the subject? You may wish to extend this question and think of other perspectives that the eye of the camera could represent. It may also be helpful to look at other forms of visual communication and think how this use of perspective helps the rhythm and interpretation of the images.

There are several key points here for the photographer to bear in mind during production, both in planning the presentation of their work, and in thinking about how the audience will see the images or how context should inform the choices the photographer makes.

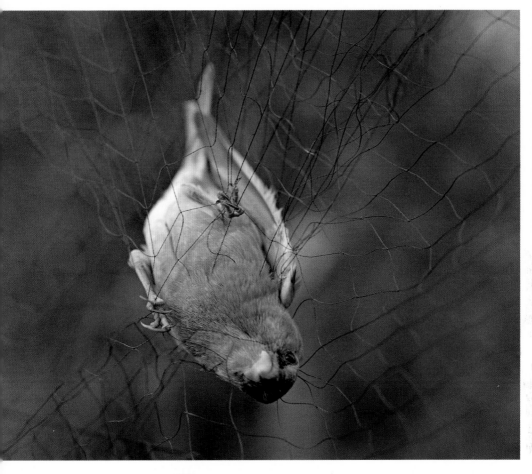

Image: from 'Birds', 2007–2008

Photographer: Jill Cole

On her website Cole describes her work as follows: 'Created over eighteen months on British military land, this series shows birds captured for scientific and conservation research on a nature reserve within an army garrison in North Yorkshire. As part of a national bird ringing programme birds are caught during flight in fine nets erected between poles. Trained ringers maintain high levels of welfare throughout the process of capture, data collection, ringing and release. By allocating each with a unique number the birds are identified as individuals whilst contributing to a broader understanding of the movement and population changes of their species as a whole. [. . .] Through this work, by referencing the interrelationship between conflict, beauty and renewal, the aim has been to locate our own, distanced realities within an ongoing presence of war' (Cole n.d.).

Different options in developing a series of images

- Photo essays often depend upon an ordered sequence with each picture showing an aspect of the story that builds to show a level of development or to create an overall impression. The order does not have to be chronological.

- Visual continuity and uniformity in a set of photographs offers coherence and allows the viewer to perceive each image as part of a larger argument.

- A set of photographs can work as stand-alone images but can also take on greater relevance when presented together by encouraging the viewer to associations between images.

- Creating a typology, as discussed in chapter 3, 'Contexts of Presentation', promotes comparisons between photographs.

- An installation often requires a level of interactivity from the audience and 'scene setting' on your part to encourage this.

'One morning I noticed the shapes the covers made after I had got up and was intrigued how that related to the sleep I just emerged from. I am interested in the psychological space between sleep and consciousness, and how the change that occurs within that space is recorded by the bedding. That space is where the story lives, and the beds in this collection, even the unslept-in ones, have a story to tell.'

Barbara Taylor, 2010: 3

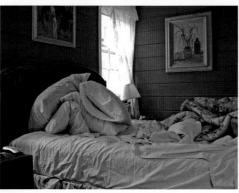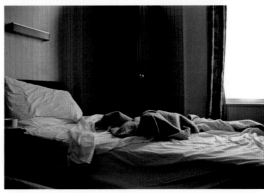

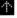

Images: (3) from 'Beds', 2002–2009

Photographer: Barbara Taylor

Barbara Taylor's 'Beds' were produced using different camera formats over a period of time, which was largely dictated by using whichever camera she happened to have with her. What holds the project together from a narrative perspective is the subject matter; the unmade beds in hotel rooms and the variety of light.

Similar to other image types, photography can overcome difficulties of representing asynchronous events when presented in a series. However, questions like 'Can a single photograph constitute a narrative?', or 'Is there a photographic narrative at all?' remain a subject of debate.

In his essay on 'Pictorial Narrativity' in the *Routledge Encyclopedia of Narrative Theory* – an ambitious work summarizing narrative theory to date – Werner Wolf denies the status of a narrative to a single image. In his words, 'a single picture can never actually represent a narrative but at best metonymically *point to* a story' (Wolf 2005: 433).

An exception to this, in his opinion, is what he calls the 'polyphase image'. In opposition to a 'monophase image', a 'polyphase image' represents more than one phase of a story, as happens for example, in Hieronymus Bosch's *The Haywagon* (1516), which represents a number of different episodes from the book of Genesis. Wolf argues that polyphase images, despite their increased narrative potency, have gradually been abandoned in Western art due to the rise of illusionist aesthetics according to which: 'a picture should imitate only what could be perceived from one point of view and point in time' (Wolf 2005: 431). The composition of polyphase scenes in photography can be achieved through multiple exposures and combination printing in post-production. These techniques are avoided in some uses of the medium, for instance, in social documentary, because they challenge transparency, authenticity, and ultimately the immediacy of the work, but are popular in various other applications and works that prioritize the narrative potential of the work.

A type of polyphase image achieved with the use of multiple exposures would be Étienne-Jules Marey's 'chronophotography' from the second half of the nineteenth century. The images, similarly to Eadweard Muybridge's studies of motion, were made with a scientific framework in mind. Irrespective of the duration of the actions taking place, each image represents a number of phases of this action: its beginning, middle and end. Known as 'sequential photography', this technique has become increasingly popular with the advent of digital modes of postproduction and is common, for example, in sports photography and scientific research.

Combination printing has been popular since the dawn of photography. A relevantly early example that contains a complex sense of narrativity is Oscar Gustave Rejlander's *Rejlander Introduces Rejlander the Volunteer* (c. 1865). In this image Rejlander seems to reflect upon his professional choices. Rejlander started out as a painter before taking up photography. His career in photography brought him remarkable success, especially around the end of his life, with his collaboration with Darwin on the illustration of his 1872 book *The Expression of the Emotions in Man and Animals*. One of the images featured in Darwin's study,

the *Ginx's Baby*, became the most widely publically distributed image of this era. However, his work in photography also brought a clash with the art establishment. His composite print *Two Ways of Life* (1855) brought hostile reactions by critics, who saw it as an arrogant assertion that photography could match the scope of art. In his apology letter, Rejlander defended his choices, but also confessed: 'I positively dare not now make a composition photograph, even if I thought that it might be very perfect' (Rejlander 1863: 145), perhaps leading to his autobiographical work *Rejlander Introduces Rejlander the Volunteer*.

Title: *Rejlander Introduces Rejlander the Volunteer*, c. 1865

Photographer: Oscar Gustave Rejlander

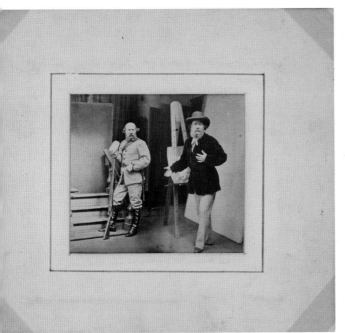

Title: *Pole Vault, chronophotography*, 1887

Photographer: Étienne-Jules Marey

In this double self-portrait the photographer presents himself in his studio dressed up as an artist and as a military volunteer, a role he had assumed after the 38th Middlesex (Artists') Rifle Volunteer Corps regiment was formed in 1860. On the easel and between the two characters is *Ginx's Baby*. These two roles in the image occur concurrently, as happened in his life outside fiction during that period. Rejlander the volunteer looks back down at Rejlander the artist who is over-performing in front of the viewer, perhaps alluding to the fact that in his military career he received more honour than he would have expected to receive as a photography artist. The image invites a variety of interpretations relevant to the photographer's biography.

Combination printing and the repetition of characters to enrich an image's narrative complexity is incorporated into the work of a few contemporary photographers who employ digital compositing tools to create multiple versions of themselves, as happens in the work of Anthony Goicolea and Tomoko Sawada.

In 2007, within the framework of a practice-based research project on photographic narrativity, Elisavet Kalpaxi embarked on the creation of a series of composite images. The images were intended as a form of critique on current socio-political issues and were taken in a variety of settings, mainly in the UK and Greece. To create the images, the artist used an analogue 6x6 camera and then scanned the images to bring them together digitally. The starting point for the images was the setting, as one of the early decisions made was to photograph wide and open spaces offering a clear, yet detached perspective to the scenes. To enhance the clarity and detail of the images she took several shots of the location and combined them (some pages from her sketchbook have been included in chapter 1, 'The Photograph'). She then emptied the scenes of all human characters and repopulated them according to her vision. The multiplication of characters in this series operates in a double-way. In some parts of the images it operates in a similar way to sequential photography, introducing a sense of progression; in others, it draws on the mythic theme of bilocation, the imaginary capacity to occupy different spaces at the same time. In either case, the inclusion of many characters and events encourages a gradual reading of the image, adding a sense of temporality to the viewing.

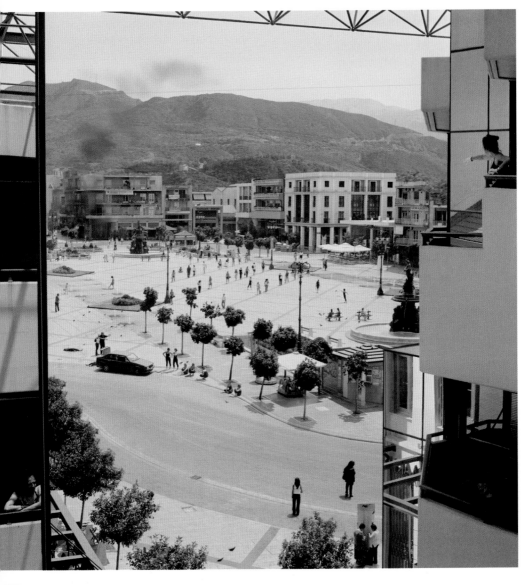

Title: *Patras, September 2008,*
A Hometown Overview, 2008.

Photographer: Elisavet Kalpaxi

Monophase images and narrative devices

Even though Werner Wolf does not recognize the capacity of single monophase images to tell a story, in a similar way to Gerald Prince (2008), he explains that single monophase images can realize various degrees of narrativity. This can be achieved with the use of narrative devices, which are here grouped together into categories for clarity:

- Representationality, or the realistic representation of objects and scenes

- 'Tell-tale' objects, such as atmosphere, light, texture and spatial relations

- Objects and situations that create expectations and imply temporality and chronology, like Lessing's 'pregnant moments' (i.e. the visual representation of climactic moments)

- References that activate the beholder's general knowledge; for example, scenes of well-known stories or allegories

- Self-conscious devices, such as *mise en abyme* (pictures within pictures) and ironic mirroring

- A 'syntax', through the use of many characters, emotionally charged expressions, gestures, symbols and text that provide clues and introduce causality

These devices can be found in images produced in various contexts – artistic and commercial. Considering that monophase images present only one moment in time and that the events preceding or following the actions taking place are subject to the viewer's imagination, the narratives tend to be incomplete or much more ambiguous than the ones achieved in series of images. Rather than producing a complete narrative, the aim of using narrative devices is to enhance communication, create a mood or instigate a process of narrativization.

The following three sections discuss different types of work that employ and often combine some of the abovementioned narrative devices. Even though narrative devices apply to both image series and individual images, the emphasis will be on single monophase images. All works explored in the following sections include objects and scenes that are reproduced in a realistic manner. Nevertheless, the notion of 'representationality', which according to Wolf "is a major characteristic of narratives", will be discussed further in chapter 5, 'Photographic Discourse'. Representationality, or the realistic representation of objects and scenes, can be seen as an inherent characteristic of photography. As such, it requires further attention.

Cinematic images

Photographers working with staged scenes often employ gestures, lighting and atmosphere as vehicles of narrativity. The American photographer Gregory Crewdson produces expensive and elaborately staged surreal scenes of American homes and neighbourhoods. In an interview with Antonio Lopez at SITE Santa Fe in February 2001, Crewdson says: 'I've always been interested in wanting to construct the world in photographs . . . whether or not it's in my studio or out on location. I think one of the things we can get from photography is this establishment of a world' (López 2001).

When making his images, Crewdson operates like a film director. His images involve large production teams and budgets, actors, and a camera operator – he is not taking the images himself. His sets are entirely artificial and constructed with painstaking attention to every detail. However, unlike film directors, Crewdson produces frozen moments that suggest a number of different narratives that resist resolution:

Since a photograph is frozen and mute, since there is no before and after, I don't want there to be a conscious awareness of any kind of literal narrative. And that's why I really try not to pump up motivation or plot or anything like that. I want to privilege the moment. That way, the viewer is more likely to project their own narrative onto the picture. (Loh and Vescovi 2013)

The input of the audience is extremely important in the construction of the narrative, but by literally constructing his images, Gregory Crewdson is clearly thinking about what he is showing his audience, how and, to a certain extent, why he is doing so. Space, composition, artificial lighting, atmosphere and texture achieved through special effects, such as smoke and rain, as well as his actors' expressions and gestures enable the photographer to create a film-like scene and encourage the viewer to perceive it as a fragment that conveys a larger narrative.

'I have always been fascinated by the poetic condition of twilight. By its transformative quality. Its power of turning the ordinary into something magical and otherworldly. My wish is for the narrative in the pictures to work within that circumstance. It is that sense of in-between-ness that interests me.'

Gregory Crewdson, 2006

← Visual continuity and uniformity | **Polyphase images** | Authorial intent →

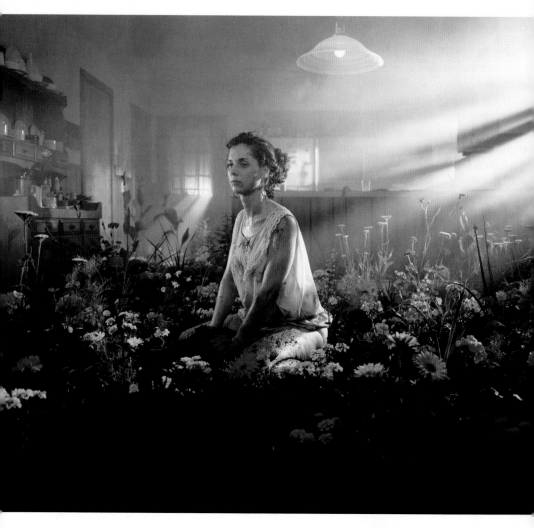

Title: *Untitled*, 1998–2002

Photographer: Gregory Crewdson

In this image, the 'magical and otherworldly' that Crewdson seeks is achieved not just through the unusual combination of garden and kitchen but by the manner in which the set is lit and the relationship among the key aspects of the picture; not just *what* he is photographing but *how*.

References (well-known stories, allegories, symbols)

Many filmic and artistic influences can be referenced within Crewdson's work, such as David Lynch's and Alfred Hitchcock's films, or Edward Hopper's paintings, but the images are not directly associated with one particular work or story. Other photographers, though, employ existing work or stories as a starting point of their narrative images and the recognition of these references is a crucial part of their work's interpretation.

For example, much of Tom Hunter's work is based on existing paintings, such as Vermeer's or Millais's. His images rework these original paintings to create contemporary equivalents. Hunter's work addresses current socio-political issues, relevant to unemployment, homelessness and class stereotyping. His focus is mainly on his local area, the council of Hackney in London and the major changes that have been inflicted in the social landscape and his community over the last two decades.

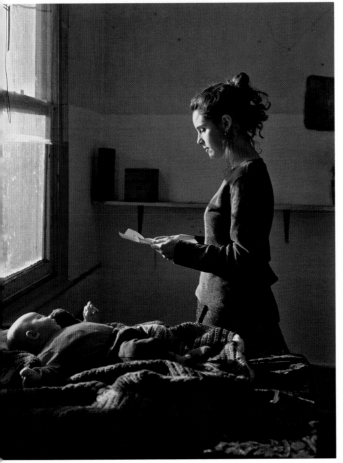

Title: *Woman Reading a Possession Order*, 2000

Photographer: Tom Hunter

Hunter's image reworks Vermeer's *Eviction Letter* (1659) and was made in response to a local drama that unfolded in the late 1990s, when the squatting community he was living with in Hackney for more than fifteen years was threatened with eviction. Hunter claims: 'Often these subjects are pictured by a window. As evidenced by Friedrich's fascination with window-as-motif (which later influenced Rothko) a window in art is often a symbolic entry/closure to/from the vastness of the Cosmos. In other words, it's a peephole through which one may sense "the sublime": the odd, simultaneous, twin sensation of insignificance when one acknowledges the vastness of nature coupled with the realisation that one is still part of this universe. Of course, these subjects are used to the sensation of insignificance in a world which doesn't care; which requires certain rules are followed, whether it be submission to an eviction order, or numerous other points which are tantamount to "taking part" on "official" terms alone.' (Hunter n.d.)

Although presented as a series of images, Yinka Shonibare's series 'Dorian Gray' (2001) is also relevant here. His series reworks Oscar Wilde's story, providing a set of events or climactic moments from the book, but it also diverts from it. According to Kathleen Edwards:

> Shonibare suggests that he does not believe, as Wilde did, that art should merely serve the cause of beauty, but rather that art should also reveal and expose societal and cultural transgression. *Dorian Gray* also refers to Britain's myriad racialized imperial ideologies. Shonibare highlights the excess of the aristocracy at the expense of the colonized, exposing nineteenth-century England's leisured elite. (Edwards 2005: 52)

Such images invite the viewer to base their interpretations on the references contained in the work, but at the same time, through the provision of contemporary equivalents or additional elements and considerations, they also instigate comparisons. As the recognition of these original references is an important part of reading the images, recognition precedes interpretation and, in a similar way to reading a book, viewers' impressions are enriched gradually and through a back-and-forth movement between the representation and their perceptions and knowledge about the original work.

Visual Referencing

Imitating an existing work is a good exercise in control. It is also important to think about:

- What is the essence of the original work?

- Which elements must be reproduced to evoke a link?

- If the original is presented in a different medium, for example painting or a piece of literature, how could you translate elements such as painterly textures or literary style into pictures?

- Would you choose a climactic moment or an event of lesser significance?

- How could you avoid the literal and bring relevance to the present?

Self-conscious devices and clues

Various devices that are employed in the 'experimental photonarrative', such as embedding (or *mise-en-abyme*), which was discussed in an earlier section of this chapter, as well as ironic mirroring, are also employed in single monophase images.

For example, Robert Doisneau's *La cheminée de Madame Lucienne* (1953), presents a moment of domestic life in a Parisian apartment through the mirror installed over the fireplace of the family's dining room.

Amongst other signs of domesticity, the front plane includes a wedding photograph, encouraging a link between the couple in the picture and the figures presented through the mirror. Past and present are here presented side by side for comparison, while the couple continues their everyday activities, with Madame Lucienne reading and her husband listening to the radio. As also happens in image series, blending actual and representational realities operates as a form of embedding, with the past still being echoed in the couple's daily life.

Another image of the same environment, made from a different angle possibly a bit later the same day (judging from the time on the chiming wall clock), presents the couple again in the same positions, with Madame Lucienne embroidering and her husband still listening to the radio. This image includes an additional character, a little girl (possibly their granddaughter?). Whereas pretty much everything else has remained the same, the wedding picture from the previous image has now been moved and has replaced the frame that was previously standing over the radio. This intervention presents this wedding picture as significant for the story told. The wedding picture here operates as a clue or as an additional event to add a sense of chronology and increase the narrative complexity of the image.

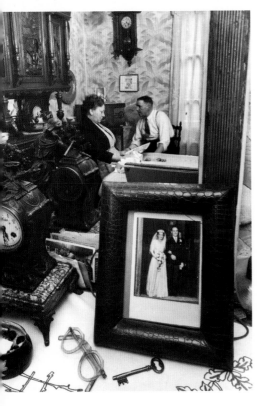

Title: *La Cheminée de Madame Lucienne*, 1953

Photographer: Robert Doisneau

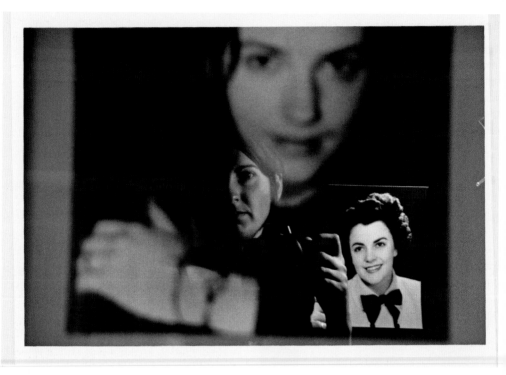

Title: *Mháithreacha agus Iníonacha (Mothers and Daughters)*

Photographer: Laura Mukabaa

Laura Mukabaa layered three generations of women into this one photograph in order to convey mother-daughter relationships in a single frame.

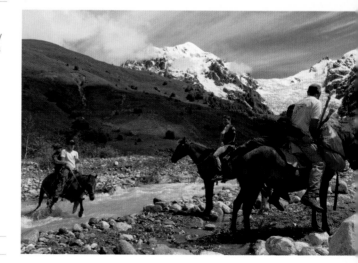

Title: *Torrent Crossing*

Photographer: Andrea Cavallini

Volume of information and chronology

With the use of narrative devices photographers can add a narrative dimension to their images. However, as is also evident in the previous section, images do not have to be constructed to communicate a narrative. Some editorial and photojournalistic images too contain narrative qualities. This is often achieved through the selection and presentation of situations that include many characters and imply chronology.

Andrea Cavallini is an editorial photographer with a particular interest in visual storytelling. His image *Torrent Crossing* presents a group of local cowboys helping hikers to cross a river on their journey from Adishi to Iprari in Georgia. The hikers with their camping equipment are loaded on horses to cross the river for a small fee. The image presents a number of elements to be decoded by the viewer. It is divided into micro scenes that also illustrate different phases of the events taking place: loading, crossing, unloading and return. Regardless of its complexity, the scene is made legible through the careful consideration of angle and camera settings. The light conditions also help give plasticity to the objects and emphasis to the scene against the background that is in shade.

Controlling the Outcome

As a photographer becomes more experienced in this process, it is possible to anticipate:

- How much blur a slower shutter speed will record

- At what angle and place in the frame movement will be frozen

- What will be sharp and what will not with a shallow depth of field

- How and where light is falling

- Whether to expose for highlights or lowlights

- How many frames it will take before a moving subject is in exactly the right spot

- Where to move oneself, or how much to shift the camera, in order to compose the photograph as they wish

'A good image is created by a state of grace. Grace expresses itself when it has been freed from conventions, free like a child in his early discovery of reality. The game is then to organize the rectangle.'

Sergio Larrain (n.d.)

Contemporary theories on visual narrativity tend to agree that the term *narrative* better describes a series of images and that the single image could at best illustrate a condensed description of events or a compressed dramatic scene that suggests a narrative.

So, what exactly is a visual narrative in photography, and how does a photographer work to convey or create it? The narrative can be conveyed through the provision of a number of events that are linked together to present different phases of a story, or it could be drawn by the viewer from all components of the picture and the dynamic or tension both of and between those components. It may be that the photograph conveys the turmoil and confusion of a moment or it may reference an existing story; whatever the photograph conveys, the narrative is drawn from how the basic components appear at the moment of photographing.

'The purely descriptive or informative is almost as great a threat to the art in photography as the purely formal or abstract. The photograph has to tell a story if it is to work as art. And it is in choosing and accosting his story, or subject, that the artist-photographer makes the decisions crucial to his art.'

Clement Greenberg, 1964: 183

The questions raised by the appearance of these components of the photograph could go something along the lines of: What is the picture of? What is happening? What is the relevance of the empty space/dark sky/colour of the carpet? This may sound very simple, but breaking down the various components can help the photographer to think about what they are showing their audience, how and why. This implies an understanding of the medium, the story and the context in which it will be circulated.

Photographic meaning, as discussed in chapter 3, 'Contexts of Presentation', is subject to the context in which it is found. Narrative techniques can help the photographer control the meanings of their images. The point here is that it is important to be prepared and clear about one's intention for each photographic project. It is vital to be aware of narrative devices and their implications, while at the same time being open to unexpected elements contributing to the photograph. Ultimately, the aim of narrative technique is to provide or anchor meaning and coherence for the image and its audience.

Title: from 'Full Circle', 1992

Photographer: Susan Derges

Photograms of frog spawn hatching into tadpoles act as a visual metaphor for the scientific gaze.

Title: (2) from 'Full Circle', 1992

Photographer: Susan Derges

The specific concerns of 'Full Circle' are natural life cycles and the relationship between the frogspawn, tadpoles and frogs, and the water they inhabit.

Case study 1

Susan Derges is a French photographer who is best known for her consistent interest in water, its various forms and expressions as rendered by the photographic medium.

Derges frequently uses photograms and other methods of producing cameraless images. Speaking of the relationship between ideas and her process, Derges says:

> Working directly, without the camera, with just paper, subject matter and light, offers an opportunity to bridge the divide between self and other – or what is being explored. There is a contact with the materiality of things that allows a different kind of conversation to happen. One is changed and in turn changes – a kind of dialogue between inside and outside unfolds. (Barnes 2010: 98)

Her work 'Full Circle' shows tadpoles hatching from frogspawn and developing into frogs. This sequence literally depicts the growth of life in a linear manner. Looking at the images, the viewer can begin to read and make sense of what the images are 'of' because of the visual continuity found in the colour, size of subject within the print and the angle of perspective. Generally speaking, because the images maintain this level of continuity, the viewer can take an overall look and see that there is a progression from one image to another. Upon closer inspection of the detail of the subject, the viewer can then realize what the prints are of, how the subject develops and begin an interpretation.

The thread of information is provided as we see the steady growth from spawn to tadpole to frog. However, this literal depiction is created and presented in a way that allows a broader interpretation of the images. This literal metamorphosis, combined with the beauty in the detail and sequencing of the images, can lead the audience to use the imagery as an allegory or visual metaphor.

Speaking of her work, Derges says:

> Water has been the focus of my photographic work for the past 27 years. I first became aware of the fragility and preciousness of this element when I lived in Japan in the early 1980s, while simultaneously seeing its potential to operate as a metaphor for a holistic approach to the natural world that includes our creative participation (Prix Pictet 2008: 102).

So, as in previous chapters, we read once again of the artist citing their method of production as an essential ingredient in conveying their intention. We can imagine here, in relation to 'Full Circle', Derges connecting with her subject over a period of time as she made the images, during which time both the spawn and herself metamorphosed. This metamorphosis provides the project with a continually growing and evolving subject, lending itself to a narrative.

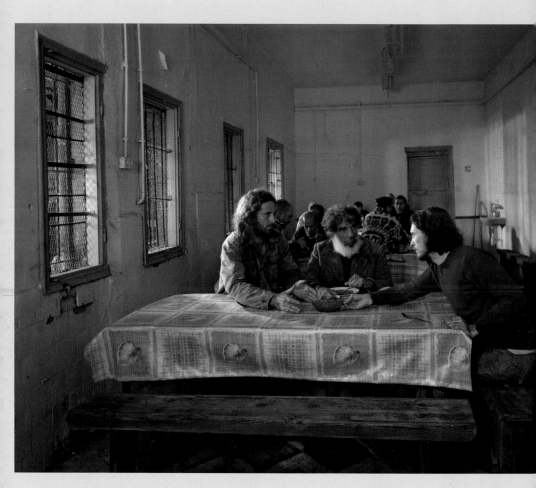

**Title: *Untitled (Jacob and Esaù),*
from the series 'Biblical Stories',
2006**

Photographer: Adi Nes

The series recreates biblical
scenes, played out by homeless
people.

Case study 2

Unlike documentary or photojournalistic images, staged photographs, because of their evident signs of the photographer's interventions, are most likely to be perceived as subjective and constructed. What happens, though, when the photographer takes on the responsibility to present crucial and controversial issues relevant to social and political realities? 'This is my mission as an artist', Adi Nes claims, 'to cast the net and raise issues' (Ahronot 2012: 4).

Adi Nes is an Israeli photographer whose images draw on autobiographical references. His images provide a complex account of the Israeli identity fused with narratives of religion, history and conflict. Some themes that he has chosen to confront in his series include the mandatory military service, heroic masculinity, homelessness, sexual identity, the 'Zionist dream', and the Israeli Palestinian conflict. In a similar way to Gregory Crewdson, Nes is staging the scenes. Everything, from actors and costumes to settings and compositions, is planned ahead with meticulous attention to detail, and during the shootings he is also surrounded by a large support team.

Similar to many contemporary art photographers, he is working with series of images, but the images are not bound to the series they belong to for their legibility and coherence and can be presented separately as autonomous pieces. This may also be attributed to their large size and their narrative qualities, i.e. their dramatic lighting, clues and expressive gestures, as well as references to existing stories, such as stories from the Bible, and references to existing images across the history of art and photography.

To narrate, for Nes, is to affect reality. He claims:

> Acts of many creative people eventually lead to changing public opinion, and that change leads to political change. This happened in the Gay community. A large amount of the change which occurred was due to acts by individuals: a film maker who creates a film, a poet who writes a poem, an author who writes a book, a photographer who has an exhibition. These things are expressed in the press, in public opinion and in politics. Artists shouldn't be drafted to create art, yet literature and art create culture, and for a lot of people this leads to understanding their identity. When a person knows his or her identity, then s/he can know the identities of others so that together we can create a healthier society. (Ahronot 2012: 4)

Title: *Untitled*, from the series 'The Prisoners', 2003

Photographer: Adi Nes

Nes served as a guard in a Palestinian detention house. This series was inspired by his claustrophobic and conflicting experience, where as a guard, he befriended one of the prisoners. The prison for Nes, imprisons prisoners and guards alike.

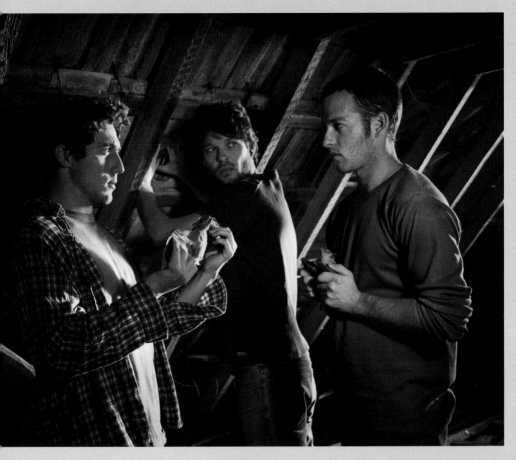

Title: *Untitled*, from the series 'The Village', 2008

Photographer: Adi Nes

'The Village' is a series based on the 'Zionist Dream'. The series was shot in the Jezreel Valley, where he now lives with his partner and their four children. Nes claims: 'Even now, after many years, it's clear that the dream is one thing, and reality another, and that the occupation bore fruits of despair for both sides' ('Israeli Artist Adi Nes' 2012). Nevertheless, he still believes in the 'dream', a dream that incorporates empathy for 'the place', the 'minorities who live amongst us' and 'the peoples who live around us' (Ahronot 2012: 4).

Exercises: Deconstructing the narrative

⇢ With your peers, take turns editing each others' work. Rearrange and regroup a set of 10–15 prints each. Observe how, with a different arrangement, the prints can convey a variety of narratives dependent upon the sequencing and their relationships to each other.

⇢ Choose a body of work from any photographer and describe in around 1,500 words how each image informs your overall interpretation. State the context in which you view the size, shape, colour and tonal quality. Make links between the 'facts' of what you see in terms of what is actually there, how you interpret the relationships between images and what impact, if any, that has upon your reading.

→ With a peer, choose a Tina Barney or Annie Leibovitz photograph. Look carefully at the picture and write 1,000 words each about the image. Draw upon the content, composition, lighting and dynamics within the image to describe the narrative and your response. Do not discuss the image until after you have written your reflective response. Read each other's writing and then discuss similarities and differences in your interpretation. Try to develop the discussion by exploring the reasoning behind your responses.

→ In a group, shoot three images each with a particular story in mind. The story could be fictional or it could draw on current news, existing literature, fairy tales, etc. Avoid any direct references, e.g. taking a picture of a book, or including the printed names of the ones involved in a newspaper. Do not tell anyone what your story is about. Project the images on the wall or pin them up in groupings, and allow time for everyone to write down what they think the stories are about. After all members of the group have completed their accounts, you can reveal what the stories are. Discuss and reflect on the similarities and differences in your interpretations.

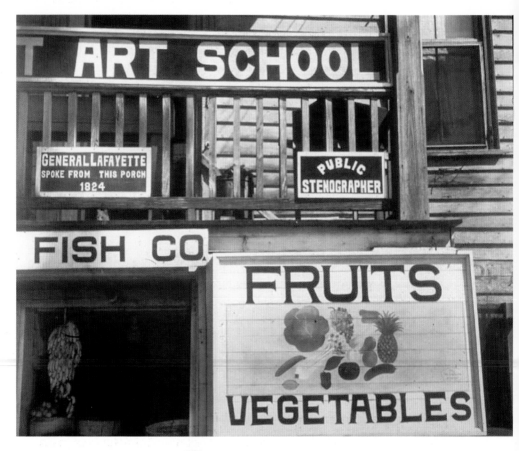

Title: *Fruit Sign, Beaufort, South Carolina*, 1936

Photographer: Walker Evans

Evans was obsessed throughout his career with signage in modern America. He photographed anything from hand-painted signs, advertising billboards, road signs to graffiti. This image shows one of several photographs he made of the signs adorning the porch and front of the building housing the Beaufort Art School in South Carolina. It is a clear example of his interest in signage, as well as his perceptive and playful eye. Here, he appears to encapsulate a range of approaches to communication; the signifier and signified are juxtaposed in the painted drawing of fruit and vegetables, and bunches of bananas hanging in the greengrocer's, with the text providing anchorage. There is a historic sign stating that General Lafayette spoke from that porch in 1824, as well as another sign advertising the services of a stenographer (one who transcribes speeches in shorthand), as though the stenographer was there to record the General's speech. Forms of visual, oral and written communication are referenced in this photograph. Furthermore, Evans included another amusing element to this particular image, where a cat in the balcony appears to be peering over the word 'FISH'.

Photographic discourse

5

In a similar way to other image types, such as painting and drawing, photographs narrate through the use of narrative techniques, such as the ones explored in the previous chapter of this book. However, in photography the strategies employed for narrativity are often concealed behind the images' immediacy and mechanical means of production.

In *The Photograph* (1997) Graham Clarke states that reading a photograph requires us 'to enter into a series of relationships which are "hidden"', and that 'we need not only to see the image, but also to read it as the active play of a visual language' (29). He cites Victor Burgin's discussion in relation to the complexities of photographic discourse, where meaning within a photograph is generated through 'the social and psychic formations of the author/reader' (Burgin 1982: 144); and as such, social and ideological assumptions are often at play when reading an image. The process of encoding or decoding is rooted in social knowledge. Therefore, how a person reads an image is determined by his or her social and cultural conditioning. At the same time, the photographer's ideology, which determines their choice of subjects and approach, is also influenced by the ideology of his or her culture.

Processes of signification are integral to how photographs and images become meaningful. Signs and symbols are part of our everyday lives – from street signs, food packaging, to advertising imagery. Semiotics refers to the study of signs and can be applied to many fields of endeavour, including linguistics, the sciences and visual arts. Semiotics can be used to interpret visual language in an interesting, applicable and socially relevant manner. Signs and symbols can be constructed and predetermined or incorporated as part of the visual language of the work. It is the context in which symbolic visual language is used and interpreted that is significant to photographers and their audiences. This chapter will explore the representational power of photography and its propensity for narrativity.

Key figures in the field of semiosis (processes of signification) are the Swiss linguist Ferdinand de Saussure and the American philosopher Charles Sanders Peirce. Their models are frequently referred to when interpreting images; Saussure proposed a dyadic model, whereas Peirce proposed a triadic one.

Saussure proposed that the combined aspects of signifier and signified constitutes the sign. Take, for example, a top-of-the-range Mercedes Benz, which is used to signify 'wealth', where the car is the signifier and wealth is the signified. The relationship between the two is what produces the third term, the car as a sign. However, note the important difference between the signifier (the actual vehicle), which is 'empty', whereas as a sign, it is 'full'. What has filled it with signification is societies' conventional modes, which has developed consequent connotations surrounding cars.

Icon, Index, Symbol

Peirce proposed three fundamental classes of sign: the icon, index or symbols are nonlinguistic signs inherent in language. In icons, the signifier is perceived as physically resembling or imitating the signified, such as a portrait, a cartoon, a scale-model, metaphors, sound effects and imitative gestures. An indexical signifier is causally linked to the signified. This link can be observed or inferred. For example, signs include smoke (indicating fire or heat), lightning (indicating a storm) and footprints or a knock on the door (indicating human presence). Similarly, physical symptoms such as pain, a rash or a raised heartbeat can all be signs of a related medical problem. A symbol refers to a process of signification in which the signifier is bound to the referent by social convention. In this instance, the signifier does not resemble the signified but is dependent upon a cultural system of meaning. The relationship must be learnt. For example, the American flag can symbolize a range of meanings and attributes depending on particular cultural or political contexts.

'Photographs are *texts* inscribed in terms of what we may call 'photographic discourse', but this discourse, like any other, engages discourses beyond itself, the 'photographic text', like any other, is the site of a complex 'intertextuality', an overlapping series of previous texts 'taken for granted' at a particular cultural and historical conjuncture.'

Victor Burgin, 1982: 144

Indexicality, as defined by Peirce, is particularly pertinent to photography simply because a photograph is a literal 'trace' of its original subject; objects or events that existed in the real world at the moment of exposure. This indexical link between subject and image generates complex critical analyses and debates around photography (see also chapter 1, 'The Photograph').

Photographic theory is often connected to a consideration of the photograph's mechanical means of production and its assumed status as a reproduction of 'the real'. Roland Barthes, the French literary theorist, philosopher, critic and semiotician, in his essay entitled 'The Photographic Message' (1977) describes photography as the 'perfect analogon', representing the literal reality. Proposing that the photograph is a 'message without a code'; it is the channel of transmission and audience's reception which gives it its meaning. A person's response to an image is rooted in social knowledge, which is directly related to a culture's abstract language system, presenting the individual with their own 'coded' reality. Hence, signs are only meaningful in context, and a sign can be a complex structure that combines forms and materials of representation. While he suggests that a photograph cannot mean anything outside of language, in *Camera Lucida*, a seminal work in photography that is also discussed in chapter 1, 'The Photograph', Barthes states that 'looking at certain photographs, I wanted to be a primitive, without culture' (1980: 7), asserting a duality, a 'co-presence' in the photograph, drawing a distinction between the culturally coded aspect of the photograph, 'studium' (which he defines as a general enthusiastic response), and another aspect that

transcends culture and language, 'punctum' (a 'sting' which disturbs the viewer). As a result of studium, one can decode the photograph, whereas the punctum is never coded, never a part of culture: 'What I can name cannot really prick me. The incapacity to name is a good symptom of disturbance' (Barthes 1980: 51). Hence, Barthes presents two approaches towards the photographic image: a structuralist reading in 'The Photographic Message' on the one hand, and on the other, a more meditative, philosophical, personal response in *Camera Lucida*. Our relationship with the photograph may hover between these theoretical and personal nonideological positions.

Negotiating signs and symbols

How does a photographer negotiate the use of signs and symbols in their work? Many photographers say that they respond intuitively to the moment, situation or event, while simultaneously being mindful of their intention and narrative they intend to communicate, and engaging their own personalized sense of visual language. Others may consciously and carefully construct an image, either before, during or after the event of the act of photographing.

For example, a photojournalist producing reportage will be faced with on-the-spot decisions. If the photographer is clear as to the function, intention and context of the assignment, these decisions are easier. The photojournalist may have one attempt at making a particular image, so decisions relating to the symbolic components that could be included may be more crucial than when there is an opportunity to make a series of differing compositions. The appearance of particular signs and symbols may be the result of a considered

decision to use them as narrative devices in a specific manner in one image or a series or set of images, or it may be a looser inclusion that ranges across a series of images as the photographer responds to individual locations and subject matter (for example, the American flag or the jukebox in Robert Frank's *The Americans*).

Constructed photography

The appearance of a sign or symbol in a photograph may or may not have been a predetermined and orchestrated consideration of the photographer. A photographer working on a carefully constructed set will have the time to consider and bring in signs and symbols. This may be particularly relevant to constructed photography and studio-based practice where the outcomes are previsualized to convey a narrative, as happens to a few of the examples presented in the previous chapter of this book.

The indexical nature of the medium has raised questions challenging photography's capacity for fictionality and the telling of stories. Contemporary photography, however, lays less emphasis on the photograph as fact; instead, it establishes the photograph as sites of fiction and drama. In his 1976 essay entitled 'The Directorial Mode', A. D. Coleman explores the developing area of constructed or 'directed' photography, a practice which undermines the purism of the medium in relation to its ability to represent 'reality' objectively. As Louise Neri comments:

> In the photographic process, settings literally become frames, stages or real contexts charged with narrative potential; and players become archetypes, complex models who function largely as

ciphers of the photographer's artistic intention rather than possessing any independent reality of their own. Subject to this transformative process, which produces a tension between what is real and what is constructed, incidental details take on greater significance, characters and settings assume greater symbolic power; the subjects are suspended in a state of becoming. (Neri 2001)

From the late 1970s onwards, constructed photography took on enhanced theatrical and cinematic qualities. Ranging from the complex theatrical staging of photographs (such as in the work of Philip-Lorca diCorcia, Cindy Sherman or Gregory Crewdson) to the manipulation of images digitally or in the darkroom, such constructed imagery offers an extension of the possibilities of ways of seeing and expands our perception of reality.

Quoting Lefebvre:

> In order to be intelligible, fictional or imaginary universes have to be related to the world. An embodied sign, for instance a work of fiction or a painting, that is totally disconnected from—or better yet, 'unconnectable' to—our world is not only an impossibility but also would be beyond intelligibility. In this sense the ultimate object of our representations, including fiction, can only be reality (the one and only). (Lefebvre 2007: 233)

Jens Schröter (2013) states that it is precisely photography's indexical potential that gives it its power and authenticity to be used effectively in the construction of elaborate fictions since the images appear all the more convincing.

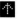

Title: *Mary and Babe*, 1982

Photographer: Philip-Lorca diCorcia

Philip-Lorca diCorcia comments, 'The more specific the interpretation suggested by a picture, the less happy I am with it' (1995: 6). diCorcia's photographs are carefully stage-managed and lit in a sophisticated way, presenting a suspended moment in an unfolding narrative. Since only a fragment is offered, the viewer has to use their own imagination to fill the stories in. Peter Galassi observes, 'After looking at a few of them the viewer develops the vaguely troubling impression that the artist has tampered with the unspoken contract between documentary photography and its audience. . . . What makes diCorcia's work powerful (and original) is that the contaminant of fiction, instead of causing us to reject the picture as false, draws us further into its drama' (Galassi 1991: 16).

'The world is too elusive to pin down in a photograph. The image has to create its own world, hopefully self-contained, an analog of reality, not a mirror of it.'

Philip-Lorca diCorcia, 2015

The representation of time or, as mentioned in chapter 4, 'Visual Narrativity', the representation of a number of 'asynchronous events' is crucial to narrativity, and in this sense, the photograph is understood to be an extraction from a flow of events, a moment in time. As John Szarkowski proposes in *The Photographer's Eye* (1966), the narrative capacity of photography has been called into question since it was assumed that its static quality renders it incapable of telling a story. Henri Cartier-Bresson's famous 'decisive moment' reflects photography's ability to arrest time in an image in visually dynamic ways; but Szarkowski has argued that 'the thing that happens at the decisive moment is not a dramatic climax but a visual one. The result is not a story but a picture' (1966: 10).

In contrast to this preservation of a moment, the moving filmic image is often likened to the very unfolding of time. In comparison to the time that is represented in film that appears continuous, the photograph is temporally limited. As Manuel Alvarado notes (2001), while it is easy to critically analyse the explicit narrative in a feature film or a novel, a photograph's narrative exists only as a trace. As the single still photograph is capable only of opening up a limited narrative space and the time inscribed in it is of a short duration, photographers have developed narratives out of montage, through a sequence of

Title: *Breath on Piano*, 1993, and *Extension of Reflection*, 1992

Artist: Gabriel Orozco

Gabriel Orozco is a Mexican artist working with drawing, photography and sculpture. These works capture the beauty and fragility of fleeting moments through photography – in one image, his condensed breath, an index of life, disappearing from the shiny surface of a piano; and in the other, traces made by tire tracks that pass through puddles of water creating a series of circles on the road. The photographs exist as temporal markers, capturing and freezing in time the moments of their making, even though the marks of condensation or indeed the puddles and tracks have long disappeared. Orozco reflects on simple things that surround us, drawing attention to ephemeral traces whose presence in the photograph simultaneously reminds us of their absence.

'To understand a narrative is not merely to follow the unfolding of the story, it is also to recognise its construction in "stories". . . . Meaning is not 'at the end' of the narrative, it runs across it.'

Roland Barthes, 1983: 259

photographs or other strategies that expand the moment captured. As the camera only gives access to only one moment in time, Ansel Adams, for example, extends this single moment in his 'Surf Sequence' (1940), consisting of a series of five photographs of waves lapping the rocks on a stretch of beach, in which the formal elements of each frame are kept constant and the patterns of the waves in each image are the only aspects of change. As a series, this work makes reference to a larger geological time and the cycles of nature. The multiplication of images in a sequence (imitating the cinematic experience) is a rendering of time's passage. Regardless of photography's limited capacity to represent time, reading must be seen as a temporal, sequential activity. It is also worth remembering that the indexical nature of photography imbues it with a special relationship to time; it represents a moment extracted from a continuum.

The analysis of 'off-screen' space is a strand developed in film theory; that is, in the determining of what is not represented within a photograph. From the choice of subject matter to the lens and camera angle, position and distance from the subject, elements in a particular scene can be included or excluded. Max Kozloff in his essay, 'Through the Narrative Portal' (1986), relates the success of Cindy Sherman's 'film stills' in engaging the viewer and inferring an event to the eye-line of Sherman herself, where she is often looking into an 'off-frame' space, suggesting another's presence. In contrast to narrative cinema that attempts largely to represent real time, Manuel Alvarado states that 'the photograph takes on its significance precisely through its temporal exclusions', and the meaning of the still image is determined 'through the very absence of temporal movement' (2000: 154). The arresting of still images (even within the context of a sequence, or a photo-story) interrupts the flow of the narrative, inserting a 'pause' between one image and the next. In Duane Michals's photostories that are discussed in chapter 4, 'Visual Narrativity', for example, meaning is also produced in the gaps between one frame and the next, at these interstices which evoke the viewer's anticipation and imagination. The photograph is an isolated image, which invites its placement within temporality and history.

John Sunderland is an artist with a background in archaeological photography. His project entitled 'In Flux: Land, Photography and Temporality' (2015), examines our experience of particular natural environments as they evolve over time and is a prime example of how photographers have sought to expand the duration represented in a single photographic frame. For this work, he applied a series of images taken over time at a particular site into a digital compositing process, a 'black box' technology that relies on a designed algorithmic computation that is automated. It operates by finding similarities in single images and combining them in a random way. The user of the programme has no control over how this is achieved. Sunderland regards it as a significant part of the process for him to show the 'errors' (evident in the breaks and distortions of the images), as it alludes to the temporal nature of perception and how we visualize the environment as we encounter it in a flow of time. The titles of his pieces also reveal the actual time and duration of each shoot.

Title: *Shrine # 1 2:59 pm - 3:39 pm (40 minutes)*

Photographer: John Sunderland

Sunderland explains: 'This is an example of what is known in Ireland as a rag tree. This is a tradition of placing rags on certain trees that are often near holy wells or running water (as is the case with this one, there is a stream to the right of the tree). The process is that if someone is ill or has a problem then a rag is tied to a tree and by the time the rag has rotted away, then the illness or problem will also have been cured or gone away. Although the tradition is associated with Catholicism, it is often mentioned that it has pagan, Celtic resonances, and in recent times more objects such as rosary beads, coins, jewellery and other trinkets, including religious icons such as small Buddha figures referring to other faiths can be found' (Sunderland, pers. comm. 2016).

Symbolic meaning

Robert Frank's *The Americans* (1958) is a body of work that is frequently referenced when exploring symbolic meaning within the photograph, and is widely recognized as challenging American post-war identity. A Swiss photographer, Frank was awarded a Guggenheim Fellowship to undertake his project documenting American life. Whilst his work contains the realism of documentary photography, he approached his subject through a critical, subjective eye of an observer looking in. As such, he presented an alienating and melancholic view of American society, racially divided and distinct from the stereotypically optimistic visions of the 'American dream'.

Frank employed particular methods to develop a recognizable visual language – his images were often taken on the move, sometimes 'from the hip' without looking through the viewfinder. His images were therefore blurred at times and cropped in radical ways to complicate the relationships between foreground and background. Frank also utilized the symbols of political power (displayed through rallies and parades that he photographed) in order to subvert them.

Sarah Greenough, Senior Curator of Photographs at the National Gallery of Art in Washington, DC, comments in relation to a photograph entitled 'Political Rally, Chicago 1956': 'Notice the way the tuba has completely obscured the face of the person behind it, as if to suggest these symbols of American democracy; the marching band and the bunting above it has drowned out the voice of the average American who stands behind it' (Greenough and Alexander 2009). It is evident from Greenough's reading of the image how aspects of a scene can be framed within an image to convey a meaning that goes beyond the mere recording of a scene.

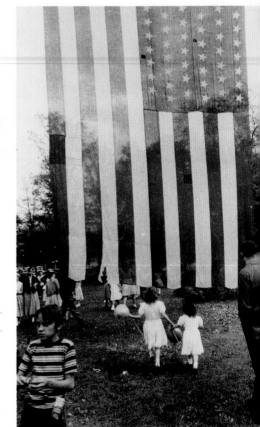

Title: *Fourth of July, Jay, New York*, 1956

Photographer: Robert Frank

Images of American flags appear throughout *The Americans*; here, a worn-out American flag has been patched over, with a bored and discontented young boy in the foreground of the photograph, captured during the Independence Day celebrations.

Ways of remembering

John Berger, in his essay 'Ways of Remembering' (1978), proposes that it was the faculty of memory that served the function of photography before its invention, since the photograph is not a reconstitution of an event but a *trace* of that event. The photographic recording system operates much like memory in that how we remember is more often a reconstruction rather than an exact copy. Hence, it is often the case that the meaning and significance of one photograph can alter over time and with every change in context, in terms of the way it is interpreted and appreciated. Since there is a gap between the point at which a photograph is made and later viewed, this inherent separation of meaning from an original context (and therefore from its meaning) results in the image being used and interpreted in a variety of ways.

The photograph, a trace of the 'real' in reduced physical dimensions, is a souvenir of the past made even more significant because of the narratives it is able to generate around and in it. This silence of the photograph creates the potential for visual intimacy and in turn encourages the telling of its story. As Susan Stewart notes, 'the narration of the photograph will itself become an object of nostalgia' (1993: 138). The following examples by Nikol Parajová and Jorma Puranen employ the representational power of photography in exploring the past. While Puranen investigates the history and dislocation of a particular community, student photographer Parajová develops a personal narrative around memories of her great-grandmother, Anna, who was born in the Czech Republic. She recounts Anna's life and her relationship with her great-grandfather based on stories told to her by her mother, speaking of a life filled with strife during the Second World War, as well as a deep affinity Anna had with her husband and family.

Contemporary Finnish photographer Jorma Puranen explored the history, identity and dislocation of the minority Sámi people, evoking a 'metaphorical return' for them in his series 'Imaginary Homecoming'. Puranen found the source images for his work, which consisted of Lapp portraits on glass negatives, in the ethnographic archives of the Musée de l'Homme in Paris. These photographs were taken by French photographer G. Roche who was employed by the Prince Roland Bonaparte on an expedition to Lapland in 1884.

Puranen states that 'Imaginary Homecoming' attempts 'a dialogue between the past and the present; between two landscapes and historical moments, but also between two cultures' (1999). It was important for him to try to return those old, found photographs to their source in a symbolic gesture of returning these people to their homeland. Photographed within ethnographic conventions (i.e. full-frontal profiles to determine 'racial types'), the identities of the persons photographed were indicated on the archival images, something which was important to Puranen, who recognized that the sitters were ancestors of people he knew in Lapland, having worked there for two decades. He therefore constructed an imaginary homecoming for the portraits and restored them (albeit temporarily) to their original landscape. He rephotographed the portraits and printed them on film, then attached these transparencies onto acrylic sheets

Title: *Memory of Young Anna*

Title: *Anna Grown Old*

Title: *Time-beaten*

Title: *Rosary and Cross*

Title: **'Nostalgic Recollections', 2016**

Photographer: Nikol Parajová

These photographs were taken in Anna's house in a small village in Slovakia – the place where she raised her children and grew old with her husband. The furniture in the house was left untouched after she passed away. Parajová comments, 'My passion for exploring old buildings and the beauty of their antiquity was fulfilled when visiting her house, particularly because it had a poignancy relevant to my own history and identity. The spaces marked by the ravage of time are significant, including the cracks on the wall, furniture covered by dust, as they are symbolic of the time she spent in the house. The rosary on the table represents her beliefs. As a Christian, she was a strong believer who did not miss out any Mass. My mother mentioned how they used to spend every Sunday morning in the church. The dried plants signify the time which has passed and condition of the house after she passed away. These objects and environment symbolise the absence of my great-grandmother and a life once lived' (Parajová, pers. comm. 2016).

and transformed them into photographic installations in the fells of the province of Finnmarken in Norway. He chose this environment 'for its historical and active significance: the migration routes of the reindeer-herding Sámi have traversed these very fells for centuries' (Puranen 1999). Since it is impossible to trace the origins of these archival photographs to specific locations, these migration routes became symbols of homecoming. Puranen sought to understand Lapland in relation to the Sámi people who have inhabited and shaped the land, and he recognized the significance of the narratives and histories this landscape contains. References to the past formed an integral part of his work; and in 'returning them home', their images are integrated into their land, buried within and projected into the snow, or hovering within the woodlands.

Title: *Imaginary Homecoming 10*, 1992, and *Imaginary Homecoming 1*, 1992

Photographer: Jorma Puranen

Puranen comments: 'The past is a figment of the imagination. This remains true regardless what documents we use to approach it. For the explorer of the past, old photographs serve as "the vehicles of fantasy or dreaming", just as maps once aided explorers. Even at best, photographs only serve to conjure up feelings and images. Instead of representing reality, they construct it. This book is called *Imaginary Homecoming* precisely because a real homecoming is impossible. The photographs only supply us with fragments of the past. To see the completed image, we need to use our imagination' (Puranen 1999).

Investing meaning

As a photographer develops their project or response to a brief, they may find that they are highlighting certain aspects of their subject by photographing under specific conditions; such as, choosing to photograph a building at night, a landscape during a storm or a garden during the changing of the seasons. Particularly if the photographer is producing a series or set of images, it may transpire that the particular conditions under which they are photographing might give rise to signs or symbols – or, indeed, the conditions themselves may become symbolic.

For example, Risaku Suzuki photographed cherry blossoms during the Japanese Sakura Celebration that takes place every year in early spring and has inspired artists since the reign of the Emperor Saga in the eighth century. The blooming of the trees after winter symbolizes hope and strength, while the falling petals express the fragility of beauty and life itself. Signs and symbols can influence the dynamics of the image itself and the audience's reading of it. They can provide a coherent structure for a body of work; they can denote pacing, sequencing, raise questions, incorporate a visual subtext and, overall, add meaning to the subject and its place within the image.

'I see that an image has several authors: there is yourself; there is the camera (because I think that photography through each camera speaks in a different way); there is reality, because reality speaks very forcefully through photography; and then there is the viewer, which is a person who looks at the image, makes his own interpretation of what's happening. And I do think that photography is very much "open text," where half of the text is in the reader. So for me to go anywhere with a preconceived notion of what it is that I'm going to do, what it is that I'm going to say, and what it is that I'm going to tell you, would be a fairly delusional, self-defeating project.'

Gilles Peress, 1997 (*Conversations with History* 1997)

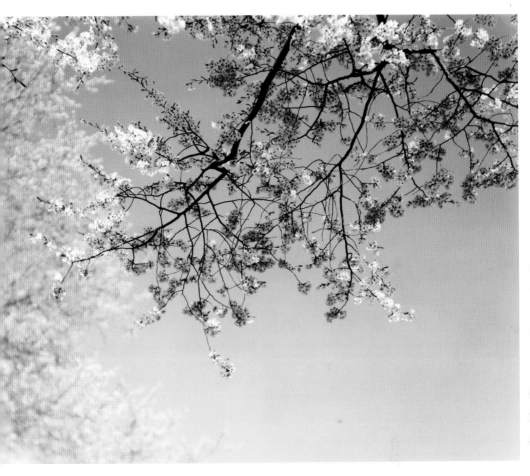

Title: from 'Sakura (Cherry Blossom)', Sakura N-24

Photographer: Risaku Suzuki

In his essay on the work of Suzuki 'The Photographer as Pendulum', curator Harumi Niwa explores the idea of: capturing life, which cannot be captured, in a photograph and leaving a record of its being. Photographs, which are chemical traces of the path of light, eventually fade, their images disappear, only the blank white of the paper they are printed on remaining. But even then, Kumano, snow and cherry blossoms will continue to exist, as the seasons shift and change in their unending cycle. The photographer accepts this and creates his photographs out of the relationship of everything he photographs – time, place, existence itself – to himself (Niwa 2009: 92–94).

Enigmas and truths

Some photographers speak of making images within contexts where they have no real understanding of the event or the subject they are documenting. This was the case with some of the images captured by the 'Bang-Bang Club', who were a group of photographers committed to covering the reality of apartheid in South Africa. Their name was given to them in a magazine article and referred to the collective work of photographers Kevin Carter, Greg Marinovich, Ken Oosterbroek and Joao Silva.

On 18 April 1994, during gunfire between the National Peacekeeping Force and African National Congress supporters in the Tokoza township, Oosterbroek was killed in crossfire and Marinovich was seriously injured. In July 1994 Carter committed suicide. In 2000 Marinovich and Silva published the book *The Bang-Bang Club*, which documents their experiences.

Reporting for the *Guardian* newspaper in September 2009, David Smith explains how Silva and Marinovich are unaware of the full story behind two of their images:

> Silva stood before a photo he had taken of a mob beating a woman with sticks, while a passerby grinned at the camera. He did not know why they had set upon the victim. 'It's one of those things you never get an answer for,' he said. The picture remains an enigma.
>
> Marinovich showed a beautiful black-and white image he took inside a Soweto hostel before a police raid in 1992. There, he had come across a Zulu man wearing a dress and behaving like a woman. He has never been able to work out why. (Smith 2009)

Marinovich puts this 'not knowing' into context by explaining that: 'Writing and researching the book took us a long time and we really challenged ourselves to get to the truths, our truths more especially. Other people's truths are actually easier to get to, but digging into what you have put up as your version of reality, then digging into it more and more and challenging yourself about your perception of what really happened was quite something' (Smith 2009).

Signs and symbols: Points to consider

- Consider the function of signs or symbols in your work. Do they reinforce an existing message or communicate an opinion that challenges traditional assumptions?

- Consider how you can communicate the meanings of signs or symbols. Are you expecting the audience to have pre-existing knowledge of particular meanings?

- Does the symbol work like a recurring motif, signifying a particular mood or point to note?

- How are you framing the 'context' of your use of signs and symbols?

- Are you using any dynamics of relationships, such as juxtaposition?

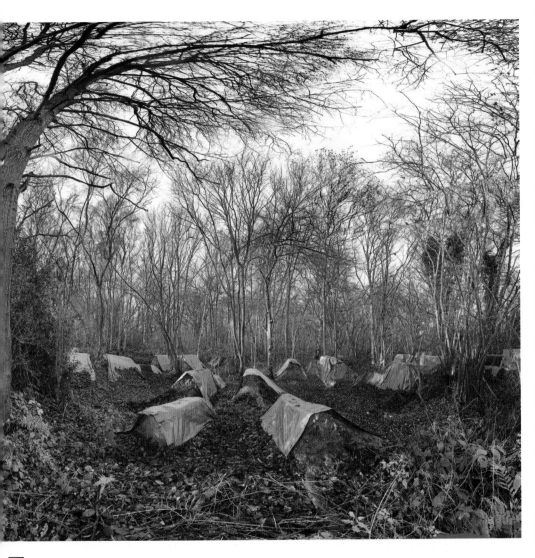

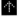

Title: *Blue Land # 3 11:38 am–12:13 pm (32 minutes)*

Photographer: John Sunderland

Sunderland states: 'This time, the reason for all the effort to construct these mounds and cover them in tarpaulins and carpets remains to this day unclear to me. While others have suggested this could be a BMX racing track, or a site for cultivating bluebells, none of these speculations have been accurate. The enigmatic nature of the site serves to enhance and highlight the ambiguities in reading photographs; interpretations can be multiple and inconclusive especially when actually visiting the site and moving around it does not solve the mystery' (pers. comm. 2016).

Symbolic meaning can be introduced through practical techniques, such as the control of aperture and shutter speed in relation to film speed, subject and lighting conditions. One example of this is Paul Fusco's series of photographs of the funeral of Robert F. Kennedy. On the 8 June 1968 Fusco, then a photographer for *Look* magazine, was a passenger aboard the train carrying Robert F. Kennedy's coffin between New York City and Washington. He had been told by his editor to 'get on the train' which was the extent of his brief, so Fusco did.

In a production for the *New York Times*, entitled 'The Fallen', published 1 June 2008, Fusco explains that he was mostly focused on what was going to happen at the cemetery. As the train pulled out of New York, he was stunned to see hundreds of people lining the platforms. He responded instinctively and photographed what was happening from the window of the moving train throughout the eight-hour duration of the journey. He described the process as 'a constant flood of emotion'. Fusco explains that he could not change his viewpoint or perspective; he just had 'to grab it when I could, if I could, I hoped I could' (Fusco 2008).

Technique as emotional device

Fusco describes one particular image; he could see a family standing at the side of the tracks, they had nothing with them, no trucks, cars or bikes. He had one opportunity to get the picture. Afterward, when he saw the image, he saw it as: 'real strong confirmation, to me personally, the singular powerful statement of the commitment, the effect this one man had on people and the hope he gave them' (Fusco 2008).

Fusco was using slow film which, on a moving platform, shooting moving people in sometimes low light conditions, could pose technical problems. Visually, this translated into the motion being captured on a slow shutter speed. Speaking of the movement in the frames Fusco says: 'The motion that appears in a lot of the photographs, emphasized, for me, the breaking up of a world, the breaking up of a society; emotionally. Everyone was there, America came out to mourn, to weep, to show their respect and love for a leader, someone they believed in, someone who promised a better future and they saw hope pass by, in a train' (Fusco 2008).

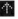

Title: *Robert Kennedy Funeral Train*, **1968**

Photographer: Paul Fusco

Fusco describes the motion as emphasizing 'the breaking up of a world, the breaking up of a society; emotionally' (Fusco 2008).

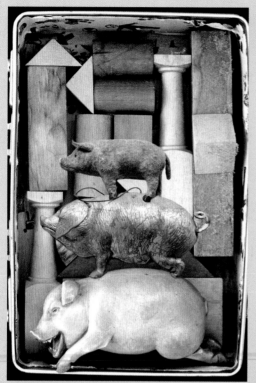

Title: *The Three Little Pigs*, 'Tales From a Little Suitcase', 2002

Artist: Mari Mahr

'I was born in Chile to Hungarian parents. When I was eight they decided to move back to Hungary and I carried a little suitcase with all my toys. When I moved to Britain my daughter brought all her toys in this little suitcase. I made this series, 'Tales From a Little Suitcase' (2002), using toys that belonged to different generations of our family, to retell traditional children's tales and fables. This is from *The Three Little Pigs*. Interestingly, each pig is from a different country: Germany, France and Hungary from bottom to top. The blocks on the background are from my childhood but belonged in fact to my mother before me.' ('Photographer Mari Mahr' 2014)

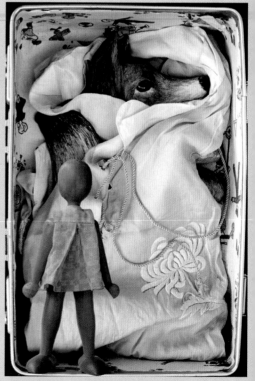

Title: *Little Red Riding Hood*, 'Tales From a Little Suitcase', 2002

Artist: Mari Mahr

'This is the tale of Little Red Riding Hood. Here the wolf is disguised; wrapped in my grandmother's beautiful blouse. My images are quite simple and straightforward, but there are some little messages: I wanted Little Red Riding Hood to stand upright, very brave, hence her posture.' (Photographer Mari Mahr 2014)

Case study 1

Mari Mahr is a London-based artist who was born in Chile and later lived in Hungary. The diversity of her origins and experience is reflected in the range of evocative objects that she selects for her work that explores her personal and cultural history, identity, memory and relationships. Her works, appearing in small series of black-and-white photographs, are part memory, part imagination. Mahr makes photo-constructions by combining photographs and objects and rephotographing them into constructed narratives built of dreams, memories, emotions.

Richard West (1998) discusses the challenges faced when trying to represent personal memories since they would likely become 'decontextualised fragments of the archaeology of our past experience'. In order to overcome this, Mahr uses photographs in a highly constructed way, where images and objects are collaged together and come to resemble theatrical stage sets that constitute visual narratives evoking the sensibility of a particular time or place. In relation to a series created for her daughter, entitled 'My daughter, my darling . . .', the artist states in her website: 'The stage us set against a Chilean landscape. . . . I feel I am here passing on to my daughter all that has been passed on to me by my mother' (Mahr n.d.). In this story being told, she used pressed leaves to reflect the time of the year and also to symbolize the passing of her relatives. Indeed, her relationships with her mother, grandmother and daughter offer stability and anchorage within the displaced life of an émigré.

'In this suitcase a number of traditional stories are presented by dolls and toys from many generations of our family. It is as if every time the suitcase is opened another tale is being played-out by those within.'

Mari Mahr, 2002

Mahr's work introduces a different dimension to photography, challenging the idea of historical fact where personal memory and cultural history are interwoven through myth and fantasy. Her technique of incorporating and assembling objects and images into unique compositions enables her to distort and play with our perceptions of scale and perspective. She rephotographs her physical assemblages, flattening their depth, hence 'making strange' our understanding of recognizable objects.

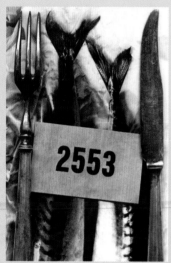 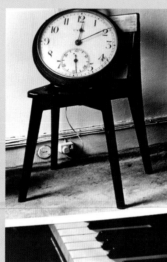

Title: *13 Clues to a Fictitious Crime, c. 1941* **(1983)**

Artist: Mari Mahr

This is a small selection of images from a larger series where the viewer is drawn into a perceived mystery, each image providing a fragment of a clue to be deciphered. A variety of objects have been placed on a base layer of photographs that have then been rephotographed, cropped in ways which present these clues as cryptic and abstract. There is no precise narrative, and Mahr states: 'No real crime has been committed. The recurring face is that of my mother – youthful in a way I only knew her from early photographs. The objects also come from my family – I brought them all with me from Hungary' (Mahr n.d.).

West (1998) comments that Mahr's photographs are:

> imitations of remembrances and completely artificial. This is
> clear in her use of old photographs, they have the feeling of
> age about them like the contents of a museum display cabinet
> but they are also part of the elaborate stage machinery of her
> theatre. A photograph vies with our memories because it is so
> close to the way we remember. . . . Mahr uses photographs in her
> compositions as if they were the dreams of her theatre director
> and therefore destined to become part of a larger memory.

In 'Tales from Within a Small Suitcase' (2002), Mahr arranges
dolls and toys belonging to several generations of her family
inside her daughter's old suitcase to depict traditional fables.

**Title: from the series 'A Few
Days in Geneva', 1985**

Artist: Mari Mahr

Stories of journeys that combine
the real and imagined feature in
Mahr's work: 'I only have to cross
the Channel to the Continent and
see those familiar cobblestones
and rooftops to make my childhood
memories flood back. This record
of a short trip to Geneva is about
just such a time' *A Few Days in
Geneva* (n.d.).

Title: from the series 'Something Is Missing', 1997

Artist: Jean-Marc Bustamante

Akin to William Eggleston's vision of the 'Democratic Forest', Bustamante's images depict a kind of no man's land in the form of streets, walls, trees, shadows, or scrubland, leaving the viewer to 'occupy' these spaces through their own knowledge, memory, fantasy or imagination.

'I try to produce a precise, accurate picture of the world and also to create a distance from the viewer in the hope that he will make the work his own, interpret what initially appears to be a rather fragile work in his own way. It is fragile because it does not demonstrate anything.'

Bustamante, 2000

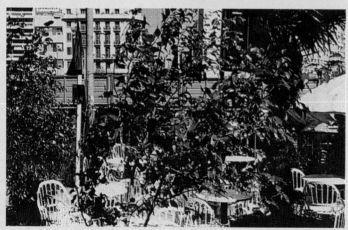

Case study 2

Jean-Marc Bustamante is a French artist working with sculpture, painting and photography. His interest lies in an exploration of how the eye works in relation to 'a mental or psychological perception of the world' ('Jean-Marc Bustamante: Biography', n.d.). His first major photographic series, 'Tableaux', presented a series of images of seemingly banal and characterless sites around Barcelona, nondescript locations identified largely by trees on hillsides, paths and buildings. Using a large format camera, the resulting large-scale colour photographs and classical composition bears resemblance to painting. Rather than search for distinctive elements in his environment, he attempts to perceive his surroundings through a democratic eye. He comments in Volume 2 of *Contacts*, a video documentary about his work:

> When you look at a landscape with your eyes, you tend to focus on one thing. The interesting thing about taking a photograph with a large format camera is that the camera does not select. It embraces, it frames, and if you proceed in a certain way and photograph a landscape in a certain type of light, and use a particular depth of field, then none of your subjects in the image, none of the elements forming the image stands out. They cancel each other out and should represent the world. Ideally, these images which constitute the world would be a sort of idea, an object of thought representing the world as a whole. (Bustamante 2000)

Bustamante describes his series 'Something is Missing' as 'a walk through the world' consisting of photographs taken in cities throughout the world which have a personal relevance or significance to him. Catherine Kinley (n.d.) states that 'the title, *Something is Missing* refers to the artist's continuing search for material, indicating the open-ended nature of his approach; it also suggests that his photographs, though highly detailed, must inevitably remain a provisional or incomplete account of the places where they were taken'. Indeed, Bustamante does not reveal the specific locations or chronology of his images. Therefore, the viewer is forced to decipher any visual clues present, and to rely on their own analysis in order to interpret and find their own meaning in the work. As a body of work, 'the photographs are intended to suggest an alternative space beyond narrative or documentary' (Kinley n.d.)

Exercises: Variations on a theme

→ Take a walk around your home observing how many different kinds of signs and symbols you come across. Take twenty minutes to write them down and put them into categories as detailed in the section on 'Icon, Index, Symbol'.

→ Conduct the exercise described above on a familiar route, perhaps during your journey to work, college or visiting a friend.

→ Analyse the work of a photographer of your choice in relation to their use of signs and symbols.

→ Watch Cameron Crowe's *Vanilla Sky* (2001). Note how images are used to build memory and convey notions of happiness.

→ Undertake a short project using a visual metaphor to convey a simple idea, such as growth or decay.

⇢ Try juxtaposing basic themes such as indoors and outdoors, hot and cold. Incorporate the passing of time.

⇢ Explore weather conditions. Incorporate a 'fixed' element into the image to give the weather conditions something to bounce off or illuminate, for example: 'the garden shed' or 'through a train window'.

⇢ Using a combination of things and images gathered from the past and present, construct a collaged portrait of yourself that tells a story about one or more significant aspects of your life. Try experimenting with physical methods of photomontage, creating photograms or create digital constructions.

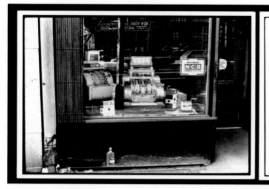

```
                                              stewed

                                              boiled

                                              potted

                                              corned

                                              pickled

                                              preserved

                                              canned

                                              fried to the hat
```

```
hard drinker

funnel

drinkitite

emperor

bingo boy, bingo mort

dipsomaniac
```

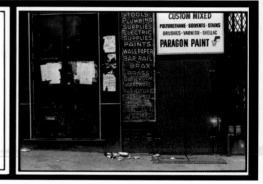

'A photograph, when it stands on its own, without text, potentially has multi-layered meanings. . . . Combined with texts or text fragments, various possible meanings contained in a photograph can be oriented to divergent discursive directions.'

Van Gelder and Westgeest, 2011: 165

Image
and text

Title: *The Bowery in two
inadequate descriptive systems*,
1974–1975

Photographer: Martha Rosler

Consisting of a grid of twenty-
one image-text diptychs, Martha
Rosler's *The Bowery in two
inadequate descriptive systems*
presents a critique of documentary
photography as a means of
representation. In this work, which
portrays dilapidated storefronts
within the Bowery district
juxtaposed with images of type-
written text of words associated
with drunkenness, she criticizes
'victim photography' and the way
that poor and marginalized human
subjects are often presented in a
degraded form in documentary
images. Rosler's images of the
Bowery, which was a run-down
neighbourhood in the Lower East
side of Manhattan, are deliberately
devoid of human beings and
instead capture the remnants
of human presence (e.g. empty
alcohol bottles). The 'inadequacy'
in her title refers to the limitations
of photography or language to
address complex social problems.

6

As we have seen in various examples in the preceding
chapters, captions, titles, essays and accompanying
editorial text will help the viewer place an image. Text,
therefore, is directly related to the context in which an
image is encountered and influences how an image
is read. As Roland Barthes notes in 'The Rhetoric of
the Image', images are polysemous (that is, they can
carry a range of different meanings), and societies
use 'the linguistic message' to 'fix the floating chain of
signifieds . . . to counter the terror of uncertain signs'
(1964: 39). The relationship between image and text is
an important one, and how a photographer responds
to it depends on the intentions of the work and its
subsequent applications. For example, a photographer
may be commissioned to produce a series of editorial
images to accompany a piece of text. The photographer
will then need to consider and clarify whether the
images are required to illustrate (or follow) the text or
whether they can stand independently from the text
and work in a more evocative manner. Alternatively, the
photographer may approach, or be approached by, a
commissioning editor to produce images that will form
the lead story with the text serving an explanatory or
questioning purpose. Words and images communicate
in different ways, and their relationship is often dynamic
and complementary. This chapter will explore a variety
of methods used to combine image and text based on
the underlying intentions of the photographer, their
conceptual approach and functions of the photograph.

Whilst it may not be unusual for a photographer, whose main intention is to communicate visually, to be tentative when it comes to using text and adopt the stance of 'letting the art speak for itself', the inclusion of text can often serve to enhance the work or engage the viewer in different ways.

Take a minute to reflect upon the photographs we experience around us and think about the role of text in relation to the photograph and vice versa. An advertising campaign may take a lengthy period to reach the point where an audience can recognize a brand through the style and subject of images alone; for example, the black-and-white images in a Calvin Klein advert. Advertisers therefore use logos, slogans, captions, and titles to offer recognizability and to direct the viewer to a particular reading.

Roland Barthes, in his essay 'The Rhetoric of the Image' (1977) analyses the reading and interpretation of images and how they promote particular ideologies. He utilizes a commercial advertising image (the Panzani advertisement) in his analysis, because in advertising the signified or the intended message is clear. Barthes states that there are three parts in signification: the linguistic message, the coded iconic message and the noncoded iconic message. The linguistic message comprises the caption and the labels on the packaging, which operates at two levels: the denoted message which refers directly to the name of the company 'Panzani', and the connoted message which signifies what Barthes refers to as 'Italianicity'. This has two possible functions: anchorage and relay. Since images are open to multiple meanings and interpretations, anchorage refers to the process of text being used to focus on a particular meaning, that is, directing the viewer to a specific reading: 'the text directs the reader through the signifieds of the image . . . remote-control[ing] him towards a meaning chosen in advance' (1977: 40). He states that anchorage is the most frequent function of the linguistic message and is commonly found in press photographs and advertising. In a system of relay, the image-text relationship is complementary; the text adds meaning to the work, and both text and image work together to convey an intended meaning, e.g. a comic strip. Most signification systems are a combination of anchorage and relay, and image-text relationships exist in many forms of photographic work. There are occasions when a simple explanatory sentence will help the audience understand what is going on in the photograph in a way that adds to the picture rather than negating or reducing the power of the image.

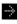

Title: from Zoo, Bremerhaven 1993

Photographer: Britta Jaschinski

Through using a factual title and being clear about her underlying intention, Jaschinski has allowed the images to speak for themselves, thereby affording the audience the opportunity to reflect upon their own thoughts surrounding the captivity of animals. The simplicity of the main title *Zoo* and each individual title, combined with the sequencing, technical and creative approach, raises questions for the audience to reflect upon.

Shades of interpretation

In her book *Zoo* (1996), comprised of seventy-four black-and-white photographs of animals in zoos, Britta Jaschinski includes a short piece of prose, interestingly at the back of the book as a postscript. In it she writes:

> The uneasy paradoxes inherent in zoos have led me to discover aspects of myself, the animals and of a society that feels a need to confine. A stream of emotive, social and psychological associations has swept through my lens and it is precisely because of the complexities that I would never wish my images to be didactic or even complete. They cannot illustrate but do seem to embody those strains of unease, which I – and perhaps many of us – feel. The intention is to allow shades of interpretation, so that if any of my feelings, impressions and ways of seeing reflect some truth, it will be recognized by the viewer. (Jaschinski 1996)

Each photograph is simply captioned with its plate number, the place and year (e.g. '70. San Diego 1995'). The simplicity of each caption allows the viewer to work with the profundity of each image at a personal and emotive level. The merely informative and factual caption could be said to help prevent any 'didactic' intention as to the audience's interpretation; in this way the photographer is encouraging the audience to respond to the content and visual language alone.

Literary influences

In addition to the text in the postscript
and simple captions offering context to
the images, Jaschinski also explains how
she has drawn upon literary and artistic
influences: 'I guess you could say German
literature and Eastern European art by
Friedrich Nietzsche, Fyodor Dostoevsky,
Josef Koudelka and László Moholy-
Nagy hold a certain darkness and have
impacted on my "style"' (Armstrong 2010).

Many photographers will draw upon
literature as part of their research. This
background reading can inform the project,
inform the photographer's approach
and give rise to new ideas or avenues to
explore. Student Ashleigh Vella responded
to a photographic brief on identity
through the visual exploration of a poem
or a piece of literature of their choice. He
developed a project around the subject of
hedonism and the images were made in
locations related to his own past hedonistic
behaviours, captured around sites where
these experiences were played out. He was
influenced by Allen Ginsberg's poem *Howl*
(1955), finding links between the subject of
the poem (such as imagery of death) and
his own experience. He attempted to create
a visual equivalent to a poem through the
use visual motifs and rhythms, stating that
'the wonder of the poem really comes with
the rhythm when read or recited, the way
the words are arranged and relate to one
another. When thinking of ways to interpret
these devices, it became clear that the
images would also need to have a rhythm
or motif connecting them together, such
as strips of light that translated into visual
beats' (Vella, pers. comm 2016). In order to
emphasize the poetic influence, the images,
when displayed in an exhibition, were
arranged to reflect the improvisational spirit
of jazz. An audio reading of this poem also
accompanied the images in the exhibition.

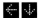

Title: *Untitled*, 2016

Photographer: Ashleigh Vella

Vella produced a series of images in significant locations to visually explore the subject of hedonism in relation to his own past experiences. The work was influenced by Allen Ginsberg's poem, *Howl*.

Telling tales

Lucy Soutter offers an analysis of paratexts and parafictions in relation to contemporary narrative photography. She cites Gérard Genette's (1997) term *paratext* to describe the external elements that accompany a published text that contribute to our reception or interpretation of it, such as the name of the author, title and jacket design etc. Soutter states that we cannot help but be informed by textual information such as 'the photographer's name, the work's title . . . framing, wall labels, and gallery press releases.' (2016: 44) She regards Alec Soth's 'Broken Manual' (2006–2010) as 'a prime example of a photographic project with paratexts dispersed across several sites' (Soutter 2016: 44) When exhibited, the work presents different aspects of the project in various forms, including large photographs, artefacts produced and even portions of survivalist handbooks. Indeed, Soth's exhibitions present photographs on the wall, as well as glass vitrines containing notes, sketches and love letters, for example, in his 'Niagara' series – a furnishing of documents to ground these narratives. Soutter expresses some doubt about the reliability of Soth's stories and cites art historian Carrie-Beatty's description of a parafiction: 'Unlike historical fiction's fact-based and imagined worlds, in parafiction real and/or imaginary personages and stories interact with the world as it is being lived' (Soutter 2016: 54). In other words, the possibility that the story is told might have been true and believable gives the work an additional impact. Soutter states, 'An unreliable narrator, an unreliable narrative, can still teach us a great deal about ourselves. It is important to its efficacy that fiction offer both recognisable scenarios and unforeseen outcomes' (Soutter 2016: 45)

Mary Frey explores narrative possibilities of everyday situations in her constructed photographic series entitled 'Real Life Dramas' (1984–1987). Each image is framed with white space around it, reminiscent of the Polaroid SX-70 format, heightening its sense of spontaneity and authenticity as a physical artefact. Bearing the characteristics of domestic snapshots as well as involving the complex theatrical crafting of scenes, Frey states that the appearance of these images 'is meant to hover somewhere between reality and soap opera' (Boothroyd 2015). The accompanying captions are photographically generated and printed within the white space of the image – its language and content appropriated from popular fiction or pulp romances. Frey states that the text 'is chiefly meant to be a fulcrum around which to operate a series of ideas' (Boothroyd 2015). As such, the artificiality of these words undermines the assumed realism of the image and. at the same time, provides the images with narrative potential.

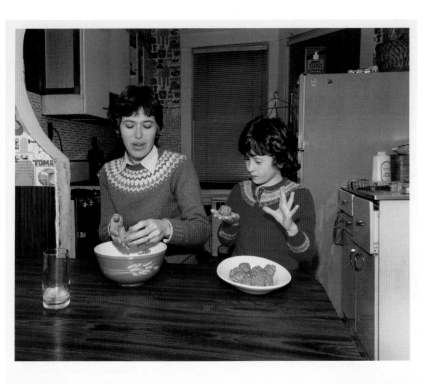

"But how can you be certain?" she asked.

"You never can," was her reply.

Title: from 'Real Life Dramas', 1984–1987

Photographer: Mary Frey

Frey comments, 'When I began 'Real Life Dramas' I merely wanted to see what my pictures could mean in color. I approached my subjects in a similar way to the earlier B&W work, but switched to a medium format camera. This allowed me to shoot off-tripod changing the look and feel of the images. While working in people's homes during the day, I noticed that their television sets were always on, often tuned to soap operas. Thinking about how popular culture permeates (mediates) our lives, I began to wonder how words could affect the meaning of my images. I read mass-market paperback novels, and appropriated the feel of their language creating phrases I would pair with the photographs. Often overblown and pretentious, these words would shift and/or change the reading of the photographs, injecting humour into sober moments. The text looks like a caption, but operates against the description of the scene depicted, opening up possibilities for new interpretations and bringing into question the "truth" of the photographic image' (Boothroyd 2015).

Another way in which text can be used as a structure for a set of photographs is as an explicitly articulated and meaningful part of the project of which the audience is aware. A good example of this is Mark Power's 'The Shipping Forecast' (1993–1996). The Shipping Forecast is a daily radio broadcast, first transmitted in 1922, which informs sailors of the weather conditions around the coast and seas of the UK.

As Power describes:

> The forecast was very much a part of my childhood, drifting gently across our living room from the mahogany radio gramophone in the corner, near the wicker chair which hung from the ceiling by a chain. Back then, when the choice of stations was limited, most people would listen to the [BBC] Home Service. . . . Its strange, rhythmic, esoteric language is clearly romantic, forming an image of our island nation buffeted by wind and heavy seas, which explains why everyone's favourite place to listen is from a nice, warm, safe bed. (Power 2005)

Power visited and photographed each of the places mentioned in the forecast, such as Cromarty, Fisher, German Bight and so on, that had become familiar to generations of listeners across the UK. The text with each picture gives the 6 am forecast on the day the picture was made.

A multidimensional experience

When the work was exhibited, a sound installation of recordings of the forecast were sampled and randomly played through Roberts radios scattered around the exhibition. It was significant that Roberts, an established brand of radios, was used, as they are as much an institution as the stations they played. As exemplified here, both the written and spoken word can be complementary and their relationship forming the core concept of a photographic body of work.

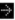

Title: *GB. England. Scarborough. Tyne. Sunday 25 July 1993. West or southwest 3 or 4 increasing 5 or 6. Showers. Good.* from 'The Shipping Forecast', 1993–1996

Photographer: Mark Power

Mark Power describes these 'extraordinary' moments: 'The beauty of working like this, a method which is – essentially – street photography, is that you can never be sure what will happen next. When at my lowest ebb, when it felt that I haven't taken a decent picture for three or four days, something extraordinary would appear from nowhere . . . a middle-aged man in a three-piece suit with a rolled umbrella and a fob watch playing football, while an elderly couple makes sandcastles in the foreground' (Power 2005).

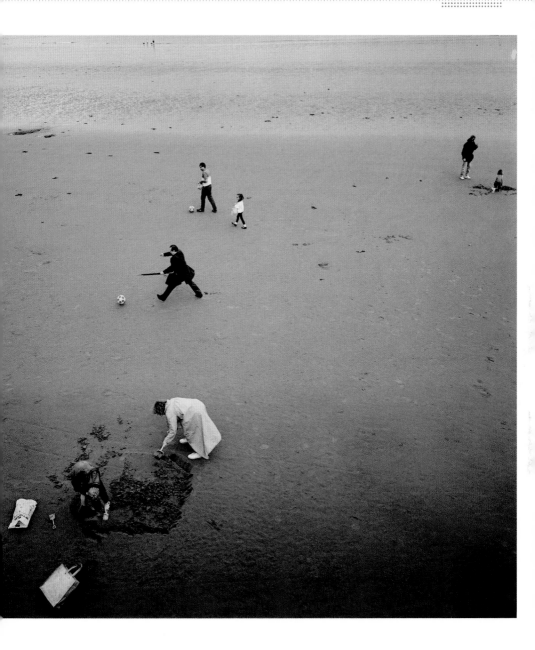

Multiple Voices

Magnum photographer Jim Goldberg undertook his project entitled 'Raised by Wolves' between 1987 and 1993 photographing and interviewing adolescents on the streets of California, as well as social workers and the police. He used both text and images to speak directly to audiences, where the photographs in the book are accompanied by handwritten testimonies of the subjects. This strategy was an extension of his earlier work 'Rich and Poor' (1979) where he allowed the subjects to have a voice, asking them to write their feelings about the photographs he had made of them – a technique similar to ethnographic photo-elicitation, a method of interview in visual sociology practice that elicits responses and comments from participants through photographs. More recently, Goldberg utlized a similar approach in his 'Open See' project which told the stories of immigrants and refugees travelling into Europe.

In participatory, community-based or collaborative arts practices, the voices of a range of participants or contributors become significant. For example, in community-based oral history projects (such as *Minding Histories*, 2010), the individual stories being told contribute to a larger archive of material to understand events or human experiences better. In 2014, Ashoka U and California-based Photowings supported a participatory photography project Sri-Kartini Leet devised around the use of photography to visualize ideas of home. The notion of home occupies a complex and rather indeterminate space, which will hold subjective meanings for individuals. It could be anything from one's

Title: *I'm Dave*, from the series 'Raised by Wolves', 1989

Photographer: Jim Goldberg

Goldberg comments, 'At the time, a lot of documentary and photojournalism was from the outside looking in. And I was interested in something else – letting people describe experiences in their own words, from the inside, with pictures that sometimes supported, and sometimes perhaps undercut, what they were saying. . . . I wanted to open up the picture, open up the discussion, to more complicated and sometimes contradictory discussions than economics or photojournalism would allow' (Goldberg 2015).

Title: *Friedemann Schaber, Black Forest, Germany, 2014*

Photographer: Sri-Kartini Leet

'Coming from a family line of wood workers, I grew up in the Blackforest and near to where the writer Hermann Hesse was born. To me, the set of photos taken by my late aunt with her post-war camera depict the crystalline snow, sky, tree and path that Hesse wrote about. . . *"When we are stricken and cannot bear our lives any longer, then a tree has something to say to us: Be still! Be still! Look at me! Life is not easy, life is not difficult. Those are childish thoughts. Let God speak within you, and your thoughts will grow silent. You are anxious because your path leads away from mother and home. But every step and every day lead you back again to the mother. Home is neither here nor there. Home is within you, or home is nowhere at all"* [Hermann Hesse, Bäume. Betrachtungen und Gedichte (1984)].' (Schaber, pers. comm, n.d.)

Title: *Jumai Ewu, On the Road to Lokoja, Nigeria, 2014*

Photographer: Sri-Kartini Leet

'With regards to the photograph, I think I chose it because it embodies a lot of memories and different emotions. Lokoja was the town that my parents retired to at the end of their working life. As a child, I grew up hearing stories about the town whenever my dad visited the place. I never got to know the place until my parents retired there. (It is a beautiful town, of historical value to Nigeria and lots of economic potential as well). It quickly became the seat of the family, with my immediate eldest sister and her family choosing to work and live there. The landscape between Abuja (the federal capital of Nigeria) is dotted with rolling hills, woodland and savannah grassland. I never fail to marvel at the beauty of it all, whatever the weather. Sadly, between 2001 and 2011, I lost both parents and my sister. I also lost one of my other younger sisters who used to live and work in Lagos with her family. All four are buried in Lokoja' (Ewu, pers. comm., n.d.).

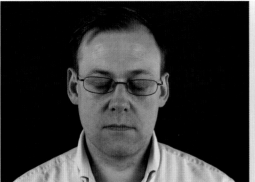

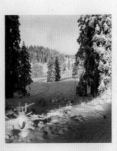

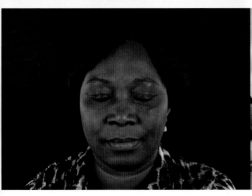

country of birth, or a place of escape or dreams. It is a concept that extends beyond physical boundaries and can signal a range of emotional and psychological attachments within our lives, reflecting past experience, memory and a sense of the familiar. For this project entitled 'I Dream of Home' (2014), Leet photographed almost one hundred participants in the studio, and asked them to each contribute a photograph, either made by them or belonging to their family, which symbolized 'home'. The images were presented as diptychs and supplemented by text. Due to the limitations of photography in its ability to capture the intangible, the participants were asked to contribute a short piece of writing to explain their connection with the photograph, providing some insight for the viewer to understand its significance.

The diary format

It is common practice for artists and photographers to create sketchbooks or journals to record their ideas and experiences, as well as their personal responses towards situations or locations. Often, the routines and experiences of everyday life become source material for their artwork; for example, in the works of Nan Goldin or Corrine Day. Jo Spence, too, explored her personal history in 'Putting Myself in the Picture' (1986). Others record their travels through environments using text, photographs and maps. Hamish Fulton, for example, regards himself as a 'walking artist', making landscape photographs and writing poetic diary entries of physical sites he walks through.

Similarly, where experiential process forms part of the strategy of an artwork, the use of written text in the diary format becomes particularly effective in engaging and placing the viewer into the context of the work. Sophie Calle is an artist who uses photography to develop projects around ideas of surveillance, voyeurism and notions of privacy. In 1980, her first major project entitled 'Suite Vénitienne' involved her following a man she had met at a party to Venice over a two-week period. 'L'Hôtel' was undertaken in 1981, when Calle worked as a chambermaid in a hotel in Venice, in order to pry into the personal lives and possessions of its guests. In addition to photographing rooms when they were unoccupied (including beds, the contents of suitcases, items left around), she rummaged through their belongings, read their letters and postcards and even used their perfume. Her photographs were published within the diaristic reports of her observations, each entry dated with descriptions of the rooms and their contents, as well as personal insights into information she has discovered about the room's occupants. Giuseppe Merlino notes, 'The intimacies she recounts, with texts and images, are not the result of encounters, attractions or affinities, but of an accumulation of observed details, from the programmed obsessiveness of a collector-voyeur' (2008: 24). Calle often utilizes the aesthetics of 'documentation', producing evidential photographic records of particular objects, events and experiences. The accompanying text serves to reinforce the authenticity of the image; however, the reality of the stories she tells remains ambiguous and uncertain.

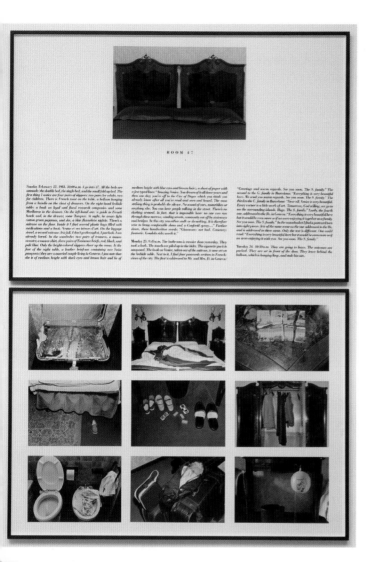

Title: *The Hotel, Room 47*, 1981

Photographer: Sophie Calle

Calle's work for 'The Hotel' series consists of diptychs presenting text and images. In this example, the occupants of Room 47 are described as a family of four from Geneva, and Calle uncovers possible problems in the marriage through her reading of their postcards. As Susanne Holschbach (n.d.) notes, 'Calle turns the viewer or reader into an accomplice of her voyeurism – filling them, too, with the urge to move unobserved through another's private sphere. Like with many of Sophie Calle's works, photographs and texts exist in a circular self-referring structure: the objects that Calle mentions in the text are found again in the photographs, but their role as evidence is first established through the telling of the story, whose believability lies solely in the hands of the artist.'

Journal entries

Some projects lend themselves to including text in the form of a complementary journal. For example, Mike Fearey kept a written diary to accompany his year-long study of the Tenantry Down Road allotments. Using a Pentax 6x7 and black-and-white film, Fearey photographed the allotments from 1990–1991 on a regular basis and documented, amongst other things, the slow change of the seasons. The diary recounts in a minimal manner each visit he made and points of change, development and incidents that impacted on the allotments.

The pictures are explanatory without the use of text. However, by incorporating the diary, the text adds a further dimension and includes the element of human relationships, which are inferred by, but not literally depicted, in the photographs.

Two entries read:

Wednesday, 21 November, 1990. Time 11.00 am Shooting 1/125th sec. F5.6 – f8.

Bright, cloudy day. More people about today. Not spoken to anybody today. Carry on shooting sheds.

Saturday, 12th January, 1991. Time 2.48 pm Shooting: 1/125th sec. F16.

First visit to Tenantry Down Road in 1991. Beautiful sunny day; no clouds but with a northerly wind. Not many people around at the present time. Everything looking very dormant. Horse manure brought to the site on New Year's Day. Met Caroline. I talked to a young chap who has a plot near to his father's on the upper slope. Had all the glass on his shed broken but the vandals could not break down his metal inner door – nothing was taken. (pers. comm., n.d.)

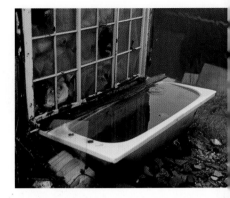

Title: from 'Tenantry Down Road Allotments'

Photographer: Mike Fearey

Fearey's simple and practical approach takes the viewer on a journey through the allotments. The difference in viewpoint of each image suggests that it is not so much the structures and pieces of land that should be compared or examined in detail but rather how the land and its inhabitants together work as a changing, seasonal and rhythmic whole.

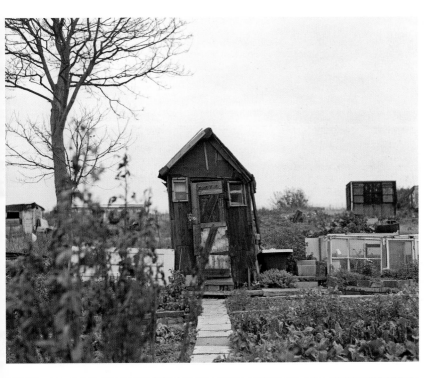

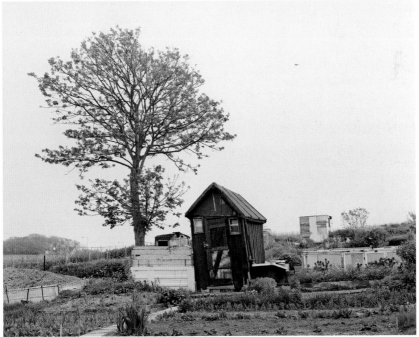

Using text in your work

- Consider the extent to which you want to incorporate text into your photographic work. For example, does the work require individual captions, or will an overall title for the entire body of work or an artist's statement provide sufficient information? Would it work better if there were fewer or no words?

- Text provides further contextual information, particularly in documentary applications. Can you think of other ways text can be used in your work; for example, to challenge and complicate the reading of the work?

- Consider ways that you can amalgamate text into the photographs themselves, either through a layering process (both analogue or digital) or by writing or scratching directly onto the surface of your photographs.

- Analyse the different ways photographers caption their images and the subsequent readings they may provoke; for example, the use of text in John Hilliard's 'Cause of Death?' (1974), or the descriptive vocabulary used in Diane Arbus's titles.

- Think, in conceptual, aesthetic and design terms, about your choice of font, or, if you intend to handwrite your text. Provide a clear justification for your decision in your sketchbook. Also consider the scale of the text in relation to the size of your photographs and the dimensions of the exhibition space.

- Consider the practicalities of how text will be presented with your work in an exhibition. For example, will there be typed and mounted titles/captions underneath or next to each photograph? Will the text be incorporated (i.e. printed) at the bottom right of the photographic print? Will captions or titles be printed and mounted on a single sheet and displayed alongside a series of photographs? Are you allowed to write on the exhibition walls? Consider printing vinyl text and applying directly to the walls to provide a smart, professional finish.

- Apply the same considerations if you were creating a photobook. How will text be placed?

Documentary contexts

In chapter 3, 'Contexts of Presentation', the importance of supporting text was discussed, particularly in the context of documentary photography, where it is essential for audiences to understand the context of the images. Since photography is temporally limited and can only represent a moment in time, the addition of writing provides further narrative meaning. John Berger states in his book *Another Way of Telling*, that words fill the gaps in meaning that photography leaves, and photographs provide specific authenticity that words lack, and the relationship between the two is a powerful one.

Title: *Palestinian children cry at the funeral of their father, a Fatah fighter killed during an Israeli incursion, Gaza, 2006*

Photographer: Alexandra Boulat

Alexandra Boulat was one of the founding members of VII Photo Agency. She photographed many areas of conflict during her career as a photojournalist and was particularly focused on the plight of the dispossessed, the innocent victims of war. She commented, 'You can show a war without showing a gun . . . and that's interesting—in only one photograph' (Martin 2005). Boulat's captions, such as in this example, provide the viewer with an explanation of the context of the image's making.

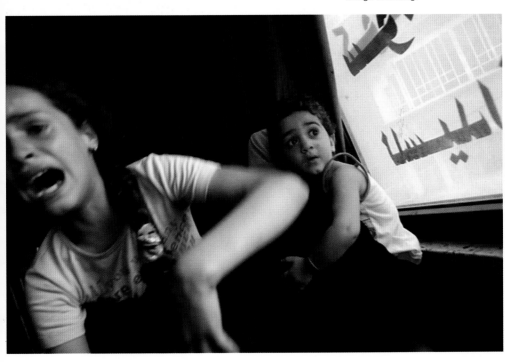

New documentary modes

Gilles Peress, a Magnum photographer, utilized text in a radical way in his book, *Telex Iran: In the Name of Revolution* (1983). He recorded the events of the 1979/1980 seizure of the American Embassy in Tehran and published his photographic work alongside telexed textual communications with various people, mainly lab technicians and his associates at Magnum in New York and Paris. Instead of captions in the form of titles (image titles were placed at the end of the book), the images on each page are accompanied by a parallel narrative of communications to and from Peress that present a behind-the-scenes story to the making of the work. By embedding his photographs with chosen fragments of text, he creates a dialogue between visual and written communication and elicits active engagement and questioning from the viewer.

The dislocated, chaotic style of his photographs highlights a fragmented and nonlinear narrative rather than a documentary study, while the text opens up a new dimension to these images; the telexed communications function as a constant reminder of all the other external forces that dictate the 'value' of a documentary photograph, and it draws attention to the process of production and post-production. As Fred Ritchin (1989: 439) comments, 'In this context the photographs are asserted as questions rather than answers, a strategy in keeping with a growing disbelief that it's possible to present conclusions without involving the reader in the photographer's attempt to understand. The revelation of the image is located in the telling, not just the evidence of what has been told.'

Title: Page extract from *Telex Iran: In the Name of Revolution*, 1983. Title of image: *Arms Market, Kurdistan*

Photographer: Gilles Peress

Here, the telexed message from Peress to the Magnum agency reveals he was weary and out of money, two of his cameras had 'gone dead', and 'nothing's happening' (Telex Iran, 1983: 66). His desire to leave the country was met with clear instructions in a reply from Magnum to stay in Iran. *Telex Iran* opens with a statement by Peress: 'These photographs, made during a five-week period from December 1979 to January 1980, do not represent a complete picture of Iran or a final record of that time' (n.p.). Peress's approach to his subject presents us with a kind of deconstructive documentary, a mode that does not seek to speak a unified truth and provide distinct answers, but one that is self-reflexive, questioning traditional approaches.

PRO DOMINIQUE
NOTHINGS HAPPENINTG. AM TIRED . OUT OF MONEY. TWO CAMERAS WENT
DEAD IN BEHESHTEZARA CEMETERY. WILL PROBABLY RETURN MONDAY PLANE
PLS ADVISE IF ANY PROBLEMS LOVE GILLES
◇
MAGNUM UI
212549 PARK IR
◇◇◇◇◇◇◇◇◇◇◇◇◇◇◇◇◇◇

PRO GILLES PERESS
██████████████████████ URGENT
IMPOSSIBLE YOU LEAVE. RUMOR HOSTAGE WILL BE FREED NEX T THURSDAY
ALSO LIFE INTERESTED... PLS STICK IT OUT.
BISES DOMINIQUE

The significance of titles

In his photograph *The Critic*, photographer Weegee is reported to have set up the image in order to accentuate the divide between rich and poor. According to his assistant Louie Liotta, Weegee requested Liotta go to a bar in the Bowery district and buy drinks for one of the regulars and then bring the intoxicated woman to the opening of the Metropolitan Opera just as the limousines were discharging their high society passengers. The two well-dressed women in this photograph are well-known generous benefactors to cultural institutions. Weegee claimed to have only noticed the woman observing the opera patrons after he had printed from the negative.

The image first appeared in *Life* magazine on 6 December 1943 and was titled *The Fashionable People*; it was first retitled *The Critic* in Weegee's own book *Naked City* (1945). By using the title *The Critic*, Weegee encourages the audience to see the relationship between the two well-dressed women and the woman he reportedly set-up to appear in the image, the 'critic' who is apparently making a judgment about the rich-poor divide. As Miles Barth (1988: 26–27) comments, 'This contrast of images, the rich with the jewels, and the well-mannered "plain people" was exactly what Weegee was striving for in all of his photography. The incongruence of life, between the rich and poor, the victims and the rescued, the murdered and the living – his photographs had the ability to make us all eyewitnesses and voyeurs.'

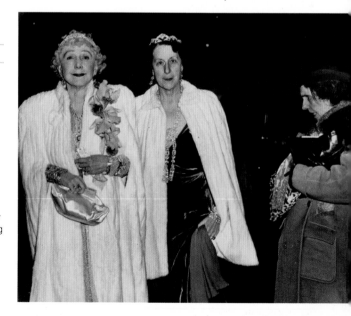

Title: *The Critic*, 1943

Photographer: Weegee

When first published in *Life* on 6 December 1943, the caption of the image read: 'The fashionable people were laden with jewels. Most bejewelled was Mrs. George W. Kavanaugh and Lady Decies whose entry was viewed with distaste by spectator' (n.p.). Weegee claimed that he only noticed the dynamics of this image during printing; however his assistant of the time, Louie Liotta, states that Weegee carefully prepared the moment. By changing the title from *The Fashionable People* to *The Critic*, he effectively shifts the audience's attention from the central figures to the woman observing them.

Loaded with meaning

In her work *An American Index of the Hidden and Unfamiliar* (2008) photographer Taryn Simon has used accompanying text with each photograph. The text is placed very precisely on the page under each image. The overall format alludes to the 'index' of the title. Flicking through the pages of the book, the reader experiences a sense of images being 'documented' in that it is reminiscent of a filing system where each image is stored, labeled and catalogued. The text itself describes the content and location of each photograph in a detailed and factual manner.

Geoffrey Batchen (2008) observes in an interview with Simon:

> Viewing one of these works involves looking briefly at the image, then looking away to read the text, and then looking anew at the image, lingering on it, drinking it in fully once it is loaded with meaning. By that point, it is practically a hybrid of text and photograph: it is charged. Simon's brand of social realism is thus also, perhaps primarily, a form of critical practice that calls into question its own medium.

The viewer derives understanding from the combination of image and text. Without the depth of information in the accompanying text, the image fails to communicate its full meaning and vice versa.

The accompanying text to the Taryn Simon image reads:

> African cane rats infested with maggots, African yams (dioscorea), Andean potatoes, Bangladeshi cucurbit plants, bush meat, cherimoya fruit, curry leaves (murraya), dried orange peels, fresh eggs, giant African snail, impala skull cap, jackfruit seeds, June plum, kola nuts, mango, okra, passion fruit, pig nose, pig mouths, pork, raw poultry (chicken), South American pig heads, South American tree tomatoes, South Asian lime infected with citrus canker, sugar cane (poaceae), uncooked meats, unidentified subtropical plant in soil.

> All items in the photograph were seized from the baggage of passengers arriving in the US at JFK Terminal 4 from abroad over a 48-hour period. The JFK handles the highest number of international arrivals into the nation's airports and processes more international passengers than any other airport in the United States.

> Prohibited agricultural items can harbour foreign animal and plant pests and diseases that could damage US crops, livestock, pets, the environment and the economy. Before entering the country, passengers are required to declare fruits, vegetables, plants, seeds, meats, birds or animal products that they may be carrying. The CBP agriculture specialists determine if items meet US entry requirements. The US requires permits for animals and plants in order to safeguard against highly infectious diseases, such as foot-and-mouth disease and avian influenza. All seized items are identified, dissected, and then either ground up or incinerated. (Simon, 2008)

Title: *U.S. Customs and Border Protection, Contraband Room. John F. Kennedy International Airport, Queens, New York*

Photographer: Taryn Simon

The relationship between the plain, factual text and the clinical image alludes to the nature of the photograph as evidence. This simple approach throughout the work, combined with Simon's choice of location and also, importantly, those locations acknowledged that did not agree to participate, creates a portrait in keeping with the title *An American Index of the Hidden and Unfamiliar.*

Text within the image

Many photographers make use of text appearing in the photographs themselves. For example, in Paul Reas' work *I Can Help* (1988), the photograph of what appears to be a queue outside an out-of-town superstore contains the letters 'que' in the centre background. Another of his images, from the same body of work, is a Christmas scene showing two customers waiting to be served at an empty counter with a banner in the background reading 'Season's Greetings'. The two customers not being served, whether seasonally or otherwise, and laden down with shopping, creates an ironic tension to the image that questions the orientation of values and consumerism.

Similarly, Robert Frank's *Sick of Goodby's* (1978) is a powerful black-and-white image with his hand-scrawled text on a mirror. Liz Jobey (2004) analyses the shift in Frank's approach when he returned to photography in the 1970s, where he had abandoned the formal compositions of the single image and was orientated towards a filmic aesthetic instead:

> The physical appearance of his pictures was radically changed: there were few single images, instead there were composites and serial frames, taped and spliced together with words scratched on the negative or scrawled in dripping paint on the picture itself. He had destroyed the photograph's superficial descriptive powers and used it as a surface on which to etch his emotional shape: gnomic phrases, half-articulated thoughts, sometimes the words barely decipherable, and yet they described, in a way that photography had not done so powerfully before, intense, painful, personal emotion.

The personality of handwritten text

It is worth bearing in mind the difference between handwritten and printed text; handwritten text can bring a sense of the person and their life condition at the time of writing to the image in a way that printed text cannot. For example, Keith Arnatt's 'Notes from Jo' (1990–1994) comprises a series of messages penned by his wife and photographed by Arnatt after her death in 1996. The notes were ones that his wife had left him on a daily basis, such as 'You bastard you ate my last crackers!' and practical reminders ('Turn off onions if burning'), present a view of the couple's life together, and as Martin Parr (2007) observes, Arnatt 'understood how the smallest detail or observation could be transformed by the act of isolation'.

Jo Spence extended the use of handwritten text in her artwork by writing over parts of her own body (for example, in *How Do I Take Responsibility for My Own Body*, 1984) to express her feelings during medical treatment for breast cancer. She regarded her body as being overtaken and fragmented into parts by the medical system, and this work was an act of defiance, an attempt to regain control over her own body.

Photographers such as Duane Michals and Francesca Woodman utilize personal, anecdotal and narrative captions to enhance the subjective nature of their work. Michals's work often consists of a single image with handwritten text (for example, in *This Photography is My Proof*, 1967) or narrative sequences that explore his emotions, fears and desires. The handwritten words enhance the personal character of his work and draw the viewer into his fictional narratives, suggesting an alternative reality beyond that of our immediate external world. As Katerina Lagassé comments, 'these still sequenced images mark his insertion of a delay in narrative through his handwritten notations and in his photograph sequences. In his careful construction of images, Michals' work drifts past merely 'looking at things', beyond the idea of a bracketed truth or reality. Instead, it relays the critical importance of the intimate, the social and the metaphysical present in his work' (Yoon and Carasquillo 2016).

Whilst the stories Michals creates may be open-ended, their message is clear in comparison to Francesca Woodman's rather gnomic approach to her work, where the symbolic elements are deeply personal and at times cryptic. In the series 'Some Disordered Interior Geometries' (1980–1981), she presented her photographs in a novel way, pasting them into old school textbooks in order to contemplate her personal affairs in relation to traditional geometry. As Isabella Pedicini notes, 'She unites geometric order with personal disorder' (2012: 28). Woodman had applied Tippex or correction fluid over the original book in order to be able to add her own inscriptions. Underneath two photographs

of herself dressed scantily in antique clothing and peering into a mirror on the floor, she writes: 'These things arrived from my grandmothers they make me think about where I fit in this odd geometry of time. The mirror is a sort of rectangle although they say mirrors are just water specified.' In another example, a slightly skewed photograph is captioned with 'almost a square', reflecting a niggling need for perfection. Peres comments in relation to the works of Michals and Woodman that:

> [S]uch approaches extend photography beyond what had become fine art photography's limitations and conventions by suggesting other models of what might constitute the veracity of the image. This conceptual approach addressed the possibility that photography is capable of documenting something more than the external world while also corresponding to the renewed interest of contemporary artists in narrative and anecdote. (Peres 2007: 186)

Shirin Neshat is an Iranian artist based in New York. Her series, 'Women of Allah' (1993–1997) consists of black-and-white images of chador-clad women that focus on body parts such as face, hands and feet; the images are covered with handwritten Persian text in black ink, written by Neshat directly on the images. The texts consist of poems written by feminist Iranian writers, and this series explores the complexities of female identities in the changing cultural landscape of Iran. Linda Komaroff, Curator of Islamic Art at LACMA, observes, 'While they may seem disempowered by

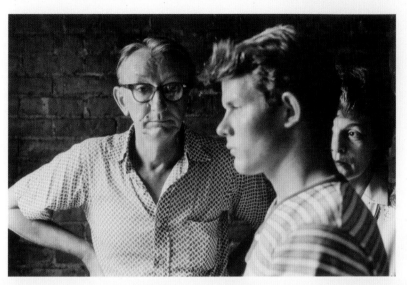

A LETTER FROM MY FATHER

As long as I can remember, my father always said that one day he would write me a very special letter. But he never told me what the letter might be about. I used to try to guess what intimacy the two of us would at last share, what family secret would be revealed. I know what I had hoped to read in the letter. I wanted him to tell me where he had hidden his affection. But then he died, and the letter never did arrive. And I never found that place where he had hidden his love.

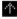

Title: *A Letter from My Father*, 1960/1975

Photographer: Duane Michals

Michals recalls and reinterprets intimate relationships in his works. He has likely used a fountain pen to write the words that refer to a lost, painful relationship: about a father who has 'hidden his love' so well that his son failed to ever feel it, and the 'very special letter' promised to his son that never arrived. The awkward body language and gazes of the subjects in the photograph, which suggest fractured relationships within this family, accentuate the power of the narrative. Michals comments on 'a frustration with the silence of the photograph', and the importance of words to his art-making in an interview for *Aperture* magazine: 'Writing, for me, is the possibility of being more intimate. I think I can be much more private in language than I can in a photograph. There's a certain presumption made about photographs, which may in fact have absolutely nothing to do with reality at all. So it's a great responsibility to write' (Sand 1997: 53).

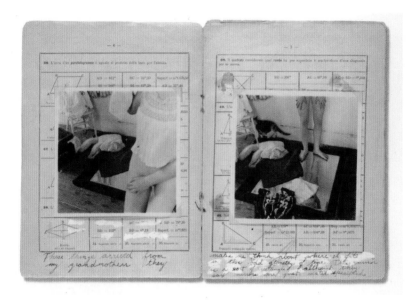

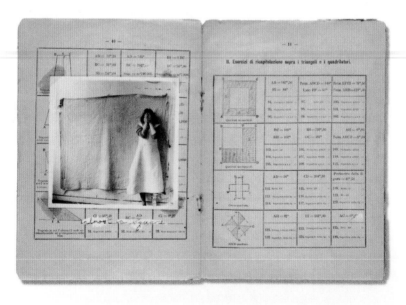

Title: *Some Disordered Interior Geometries*, 1980–1981

Photographer: Francesca Woodman

Chris Townsend observes that in this series, Woodman's captions 'imply but not state a narrative' (2006: 239). She creates a relationship between her images, the handwritten captions and the content of the textbook she uses. In this example, she draws parallels between the geometric problems that need solving and the complexities of her life experiences, referring to her contemplations of where she is placed in 'this odd geometry of time'.

their faith, Neshat's women are strong, even heroic; they are eroticized by their weapons and sanctioned by the Persian texts inscribed on their bodies, which enable them to speak although they are forced to remain silent' (Komaroff 2015).

In a MoMA interview, Neshat makes reference to the silence of the female subject who is forbidden from speaking her mind, of a person who is 'crying out for her desire to be socially active and not to be left at home' (Neshat 1996). She observes, 'In cultures where citizens struggle with heavy social control, magic realism is a natural tendency. For Iranians, who have endured one dictatorship after another, poetic-metaphoric language is a way to express all that is not allowed in reality' (Heartney 2009: 158).

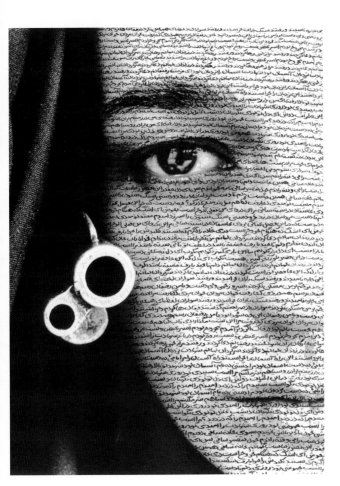

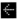

Title: *Speechless*, 1996

Artist: Shirin Neshat

In this example, a gun is positioned next to a female subject's face, at first glance resembling a earring or a piece of jewellery. Neshat states in the *Guardian*, 'The lines you see . . . are verses by the Iranian poet Tahereh Saffarzadeh, in which she addresses her brothers in the revolution, asking if she can participate: "O, you martyr / hold my hands / I am your poet / I have come to be with you / and on the promised day / we shall rise again." I wrote them out by hand. The meaning of those words, combined with the beauty of Arita's face, is disrupted by the violence of the weapon' (Frizzell 2017).

I am mourning that I don't have my mother with me and her Protecting shadow over my head.

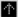

Title: *Reza, Born 1991, Afghanistan; Arrived in Kent 2004, Resettled in Kent*

Photographer: Wendy Ewald

An interview extract: 'I don't have any contact with my family or friends there because my father was killed and my mother's missing. My father was killed somewhere in Kabul. And as for my mom, she fled one day while I was at school because there was fighting. When my brother returned, he told me that my mother had gone missing. I am in mourning, because I don't have my mother with me and her protecting shadow over my head. If the whole world forgave me for a mistake, it wouldn't be as much as a tiny amount of forgiveness from my mother' (Neri 2006: 116).

Case study 1

American photographer Wendy Ewald was commissioned by London-based international arts organization Artangel to undertake a project entitled 'Towards the Promised Land' (2005) which entailed working with migrant children to explore their experiences of displacement and relocation. Based in Margate, a sea-side town in the UK well-known as a site where migrants and refugees are temporarily housed, Ewald worked with twenty children over an eighteen month period. While some of these children have fled war and persecution, others have moved towns within the UK because of domestic upheaval.

She photographed and interviewed the children about their past and current experiences, as well as taught them to use cameras to make their own photographic records. In addition to an exhibition in Margate's local gallery, Ewald enlarged her portraits of the children as well as some of their most important possessions to billboard-sized proportions and installed them in strategic locations all over the town, allowing the faces and voices of migrant experiences to occupy prominent and central positions in Margate, permeating the everyday lives of its residents.

The accompanying book publication contains Ewald's case studies, as well as detailed transcripts of interviews with the children recounting their experiences, and images of their own materials (photographs, drawings etc.). She explains, 'I edited each interview transcript to make a more or less coherent story. Then I looked at each kid's interview with him or her and we picked out some lines that best described his or her journey. We decided how to position the texts over their portraits, then they wrote the texts on Mylar sheets placed over the photographs' (Neri 2006: 150). In the digital age when images can be mass circulated, the addition of handwritten text on the photographs will, to some degree, control the meaning of the image and to connect it to its original context.

Wendy Ewald has, for over thirty years, engaged in participatory photography projects that explore identity and cultural difference involving children. Duke University's *Literacy Through Photography* site states that Ewald herself often makes photographs within the communities she works with and has the children mark or write on her negatives, thereby challenging the concept of authorship, raising questions around who the photographer or the subject is, as well as blurring the boundaries between the observer and the observed ('Wendy Ewald' n.d.).

I didn't believe it – me, in Europe? No, it's not me!

Title: *Christian, Born 1995, Democratic Republic of Congo; Arrived in Margate 2004, Resettled in Scotland*

Photographer: Wendy Ewald

An interview extract: 'We came from Congo on a plane. We left because there is a war in Kinshasa. We left my cousins, the house and friends. I brought nothing . . . well, a little bit. It was just me and my mom. The journey wasn't good, but I liked the plane. We always fastened our seatbelts and in the window it made clouds' (Neri, 2006: 62).

'Some of the best stories are born of these collaborations. Not every story needs it, but when there's a good mix of art and writing, those are the most memorable stories.'

Laura Helmuth, 2013

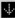

Title: *Margate, UK*, 2005

Photographer: Theirry Bal

In July 2005, Wendy Ewald's billboard-sized photographic portraits of the children were displayed along Margate's Sea Wall. These were followed in 2006 by similar works being exhibited in public spaces within the town centre.

Untitled, **from the series 'The Life and Times of Strider Wolf'**

Photographer: Jessica Rinaldi

'Oxford, Maine – 5/4/2015 –
Strider reached up to grab high
on a sapling revealing a scar that
snaked its way up his stomach and
a dimple that marked the place
where a feeding tube had once
been as he climbed a tree in the
first of several campgrounds that
would come to be home throughout
the course of the summer.'

Case study 2

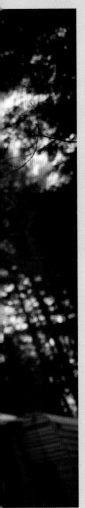

There are numerous examples where photographers have collaborated with writers in the production of photobooks, photostories and photo-essays. For example, *You Have Seen Their Faces* (1937) which consisted of photographs by Margaret Bourke-White and writing by Erskine Caldwell; *Let Us Now Praise Famous Men* (1941) by photographer Walker Evans and writer James Agee; as well as numerous publications by the partnership of the writer John Berger and photographer Jean Mohr. In addition to book publications, the photo-essay has a long history within mass-produced publications such as daily newspapers, weekend supplements and features as part of news items. Today, digital storytelling is a common feature in the way that stories are created and disseminated, and content can be repurposed on multiple platforms to reach diverse audiences. As Phil Bicker, senior photo editor at *Time* observes (2015):

> In an age when we're saturated with an omnivorous barrage of distracting and singular imagery, there is still a role for subtleties embodied within the traditions of long form storytelling. Through innovative, full screen photo-centric web designs and effective digital dissemination, these photo essays are drawing our attention—in different and often more meaningful ways—to important issues that we otherwise would ignore or at best feel we had seen too many times before.

Jessica Rinaldi, a photographer for the *Boston Globe*, won the 2016 Pulitzer Prize for Feature Photography, having produced a body of work entitled 'The Life and Times of Strider Wolf', which was described by the organizers as a 'raw and revealing photographic story of a boy who strives to find his footing after abuse by those he trusted' ('The 2016 Winner of the Pulitzer Prize in Feature Photography', n.d.). Rinaldi, along with writer Sarah Schweitzer, followed Strider and his family for six months to tell a story of child abuse and poverty in rural Maine, New England. The photographs in the series are accompanied by a long-form narrative piece. In a 2015 interview with Aleszu Bajak of *Storybench*, Rinaldi explains that the aim is to create a set of images that can stand on their own and comments on the writer-photographer collaboration:

> I try to take in the mood and the tone of what's going on and distil that into the pictures so that what you see is a reflection of how it felt in the moment. Sarah and I were together for so much of the reporting and at the end of each day we would talk about what we had just seen and

experienced. We were very much on the same page and I think that comes through in the final product. (Bajak 2015)

In a roundtable discussion led by Erik Vance for *The Open Notebook* (2013) involving a range of photographers, writers and editors regarding the photographer-writer relationship, Jamie Shreeve, executive editor at *National Geographic* comments:

To make the best possible *National Geographic* story the photography and narrative need to be conceived and executed with a lot of communication between the team members, lots of cross-pollination of ideas, and ideally, some overlap on reporting in the field. I think the same would apply increasingly to other outlets as the visual components of a story become more and more a driver for the story, rather than conceived as a response to a written draft.

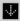

***Untitled*, from the series 'The Life and Times of Strider Wolf'**

Photographer: Jessica Rinaldi

'Oxford, Maine – 5/29/2015 – After two years of not paying the rent the Grant's landlord had given them 30 days to pack their things and leave. On the night of the eviction as Lanette and Larry worked to move their possessions into a rented semi-truck parked on a lot Strider and Gallagher were left in the back of the car. Tired and acting out Gallagher bit Strider who recoiled, pressing himself against the car window.'

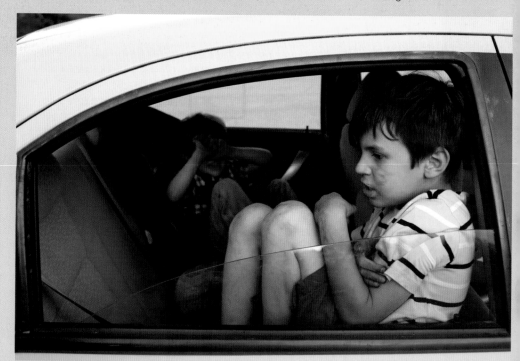

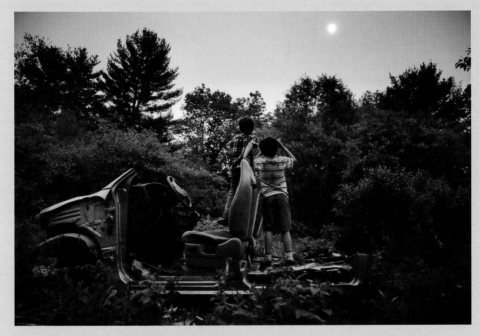

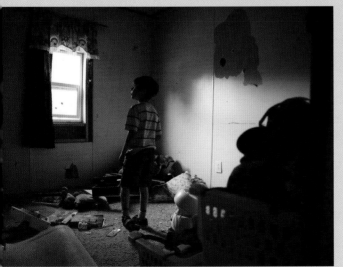

***Untitled*, from the series 'The Life and Times of Strider Wolf'**

Photographer: Jessica Rinaldi

'Oxford, Maine – 5/29/2015 – On the night of the eviction the boys climbed into a rusted Ford sunk behind the horse field. Strider held a broken automotive hose to his eyes like a pair of binoculars. He tipped his head upward. "What's on the moon?" Strider asked.'

***Untitled*, from the series 'The Life and Times of Strider Wolf'**

Photographer: Jessica Rinaldi

'Oxford, Maine – 5/29/2015 – As Larry and Lanette worked to pack up their belongings Strider wandered into his bedroom and peered up at his things. Much of what was left in the room would be left behind, along with his bicycle and many of the family's other possessions.'

Exercises: Using text

⇥ Watch Alan J. Pakula's 1974 film *The Parallax View*, specifically the 'test film' sequence. Observe the use of text, sound, sequencing and shuffling of images in relation to the text. Also, see if you can spot some well-known photographs.

⇥ Produce a short 'test film' sequence yourself in the style of *The Parallax View*. Choose a theme or a point you wish to make. Present your sequence to your peers and discuss their responses in relation to your intention.

⇥ Look at three different photographers of your choice and write a 1,500-word short comparative essay on their use of text.

⇥ In groups with your peers, swap prints with their titles removed and take turns retitling each print. You could devise a system of five or so contexts in which the prints could be seen and produce a different title for each print. Share your results and discuss.

⇢ Choose a short selection of text from a piece of prose, poem or
 song and use it to initiate a short project. Create a visual poem.

⇢ Experiment with multiple exposures, analogue and digital
 postproduction techniques to combine image and text.

⇢ Using photographs and text, keep a diary of the details of an
 ordinary day in your life.

⇢ Find letters, postcards and old photographs (borrow these from a
 family member or relative if necessary). Consider ways that they
 could form the basis of a project or artwork.

Image: *Missile Silos*. August 2007, from 'Greenham Common' series, 2006–2010

Photographer: Richard Chivers

In the UK, during the 1980s and 1990s, Greenham Common became synonymous with the Cold War and the peace protests against the storage of nuclear missiles at the site. The strength of these protests was significant and Greenham became an international icon for peace against nuclear war.

'When scholars write theses and give lectures before students and when writers or artists publish or exhibit their works, they offer their thoughts and intentions to their fellow men and in this way influence society and politics. The greater the artistic or scholarly work, the greater its influence on the times and the stronger the likelihood that the work may pave the way for political change.'

Daisaku Ikeda, photographer, writer, educator and international promoter of peace (2007: 71)

Conclusion

This book has explored how expectations relevant to the use of photography as a medium, the intended function of a photograph and the context in which it is shown can inform the meaning of an image and the choices photographers make in relation to their use of visual language and appropriate technical decisions. In turn, these choices shape the narrative behind the work. Even though, as mentioned in chapter 4, 'Visual Narrativity', not all images are narrative in the strict sense of the term, a work consists of a number of considerations and elements that define its meaning beyond what it literally represents.

Recognizing the significance of context, and employing the appropriate narrative devices, can be an in-the-moment reflex of a photographer tuned into both their environment and their personal approach to visual language. It can also be an experimental, explorative or considered journey as the photographer uses the process of photographing to develop their own ideas, responses and creative methodology.

As Bill Jay passionately states in his article, 'The Thing Itself: The Fundamental Principle of Photography':

> If the subject of the photograph is the vehicle for profounder issues, then it is the photographer's responsibility to think and feel more deeply about those issues. [. . .] The ultimate aim is an oscillation between self and subject with the image being a physical manifestation of this supercharged interface between the spirit and the world. It demands reiteration: this conscience of the photographer is not learned, not appropriated, not discovered, not acquired quickly or without effort. It is a function of the photographer's life. (1988: 7)

We can derive from this perspective that the relationships among concept, subject, technique and outcome is a symbiotic and often complex experience, which extends beyond a two-dimensional image. Also, we could say that the relationships among the photographer's internal understanding of themselves, their relationship with the world around them, their motivation and discipline as well as their desire to grow and develop are all manifested in their work.

Ultimately, the driving force behind the photograph is the conceptual approach of the photographer, as this will shape and inform both the process and the outcome. However, because of their polysemy, images have the capacity to exceed initial intentions. Images can be used in contexts different to the ones intended by the photographer, and in the process they can become de/re-contextualized. As such, photographers should also be mindful of the communicative possibilities of their work within wider and changing socio-political, historical and cultural circumstances.

References

Chapter 1: The photograph

Adams, A. (1943), 'A Personal Credo', in V. Goldberg (ed), *Photography in Print*, 377–80 Albuquerque, NM: University of New Mexico Press.

Barrett, T. (1990), *Criticizing Photographs: An Introduction to Understanding Images*, 3rd edn, New York: McGraw-Hill.

Barthes, R. (1980), *Camera Lucida*, London: Vintage.

Briet, S. (1951), *What is Documentation?* Paris: Edit. Available online: http://ella .slis.indiana.edu/~roday/what%20is%20 documentation.pdf (accessed 15 July 2013).

Edwards, E. and Hart, J. (2004), *Photographs Objects Histories: On the Materiality of Images*. London: Routledge.

Hurn, D. and Jay, B. (1997), On Being a Photographer: A Practical Guide, Anacortes, WA: LensWork Publishing.

Johnson, R. and Brunel Chatwood, A. (1895), *Photography, Artistic and Scientific*, London: Downey and Co. Available online: https:// archive.org/stream/photographyarti00john goog#page/n191/mode/2up (accessed 20 July 2016).

Leonard, Z. (Spring 2014), 'Art Interview: Shannon Ebner and Zoe Leonard' *BOMB* (127). Available online: http://bombmagazine .org/issues/127 (accessed 20 July 2016).

Manovich, L. (1995), 'The Paradoxes of Digital Photography', in: L. Wells (ed), *The Photography Reader*, 240–48, London: Routledge.

Ohrn, K. B. (1980), *Dorothea Lange and the Documentary Tradition*, Baton Rouge: Louisiana State University Press.

'Oral History of British Photography: Arnatt, Keith (4 of 5)' (1993), [audio recording] British Library. Available online: https://sounds.bl .uk/Arts-literature-and-performance/photo graphy/021M-C0459X0036XX-0400V0 (accessed 7 January 2019).

Rowland, R. (2007), *The Regency Project*, Brighton: Anotherpublication.

Smith, W. E. (2013), 'I Didn't Write the Rules, Why Should I Follow Them?' *New York Times*, 23 January 1953. Available online: http://lens .blogs.nytimes.com/2013/01/03/w-eugene -smith-i-didnt-write-the-rules-why-should-i -follow-them/?_r=0 (accessed 20 July 2016).

Sontag, S. (1971), *On Photography*, London: Penguin.

Stimson, B. (Spring 2004), 'The Photographic Comportment of Bernd and Hilla Becher', *Tate Papers* (1). Available online: http:// www.tate.org.uk/research/publications /tate-papers/01 (accessed 20 July 2016).

Szarkowski, J. (1966), *The Photographer's Eye*, New York: The Museum of Modern Art.

Szarkowski, J. (1976), *William Eggleston's Guide*, 2nd edn, New York: The Museum of Modern Art.

Talbot, W. H. F. (1844), *The Pencil of Nature*, Salt Lake City, UT: Guttenberg. Available online: http://www.gutenberg.org /files/33447/33447-pdf.pdf (accessed 15 November 2014).

Temple, S. (2010), 'Graduate Photography Online 2010: Shaleen Temple,' *Source: The Photographic Review*. Available online: http:// www.source.ie/graduate/2010/univulstba /univulstba_folder/univulstba_student _folder_10_10_34_01-05-10/univulstba _student_details_10_10_34_01-05-10.xml (accessed 20 July 2016).

Chapter 2: Visual approaches

Barrett, T. (1990), *Criticizing Photographs: An Introduction to Understanding Images*, 3rd edn, New York: McGraw-Hill.

Brady, P., Campany, D. and Higgie, H. (2010), *China Between*, Dewi Lewis.

Bullaty, S. (1978), 'Remembrances of Sudek' in Josef Sudek and Sonja Bullaty, *Sudek*, New York: Clarkson N. Potter Inc.

Campion, L. (2013), Artist's statement, Summer exhibition, University of Northampton, UK. June 2013.

Cartier-Bresson, H. (1952), 'Foreword', in *The Decisive Moment*, New York: Simon and Schuster, in collaboration with Editions Verve, Paris, no pagination.

Estate of Keith Morris (2008), 'Keith Morris – A Rocker Behind a Lens'. Available online: http://www.keithmorrisphoto.co.uk/profile /keith-morris-a-rocker-behind-a-lens/ (accessed 23 June 2016).

Irvine, M. (1997), 'Interview: Eve of Victory', *The Independent*, 8 October. Available online: http://www.independent.co.uk/life -style/interview-eve-of-victory-1234728.html (accessed 4 July 2016).

Isolation (2010), [Film] Dirs. Luke Seomore and Joseph Bull, UK: Institute For Eyes.

Kennedy, H. (2010), in *Eve Arnold – Lifetime Achievement Award at the Sony World Photography Awards 2010* [TV programme]. Available online: https://www.youtube.com /watch?v=7WqlvbadCbQ (accessed 29 August 2016).

Kurtis, S. (2009), 'Studio: Salam, 2009', *See Saw*. Available online: http://www.seesaw magazine.com/kurtispages/kurtisintro.html (accessed 23 October 2016).

Kurtis, S. (2010) 'Shoe Box', in *Conscientious Extended*, 28 April. Available online: http:// jmcolberg.com/weblog/extended/archives /seba_kurtis_shoe_box/ (accessed 17 October 2016).

Lyons, N. (ed.) (1966) *Photographers on Photography: A Critical Anthology*, Englewood Cliffs, N.J.: Prentice-Hall.

'Marilyn Silverstone Profile' (n.d.), *Magnum Pro*. Available online: https://www.magnum photos.com/photographer/marilyn-silver stone/ (accessed 27 September 2016).

Mensah, B (2016), Artist's statement, Summer exhibition, University of Northampton, UK. June 2016.

Mussai, R. (2014), 'Of Ghostly Apparitions and Insurgent Image-Operations' in *Aida Silvestri, Even This Will Pass*, London: Roman Road Publishing, in association with Autograph ABP.

'Oral History of British Photography: Arnatt, Keith' (1993) [audio recording], British Library, 14 April.

Padley, G. (2013), 'Aida Silvestri's "Even This Will Pass", *British Journal of Photography*, July. Available online: http://www.bjp-online .com/2013/07/aida-silvestris-even-this-will -pass/ (accessed 5 November 2016).

Pannack, L. (n.d.) introduction to *Glass* project. http://laurapannack.com/personal /glass/#PHOTO_1 [Accessed: 27 September 2016]

Rose, G. (2007) *Visual Methodologies*, 2nd edn, London: Sage Publications.

Sank, M. (n.d.), 'Young Carers,' *michellesank .com* (blog). Available online: http://www .michellesank.com/8-portfolios?start=4 (accessed 23 June 2016).

Schuman, A. (2005), 'Landscape Stories: An Interview with Jem Southam', *See Saw*, February. Available online: http://seesaw magazine.com/southam_pages/southam _interview.html (accessed 23 June 2016).

Sherwin, B. (2008), 'Art Space Talk: Michelle Sank', *myartspace>blog* (blog). Available online: http://myartspace-blog.blogspot.co .uk/2008/09/art-space-talk-michelle-sank .html (accessed 23 June 2016).

Wroe, N. (2010), 'A Life in Photography: Don McCullin', *The Guardian*, 22 May. Available online: https://www.theguardian .com/culture/2010/may/22/don-mccullin -southern-frontiers-interview (accessed 15 September 2016).

Xu, Q. (2016), Artist's statement, Summer Exhibition, University of Northampton, UK, June 2016.

Chapter 3: Contexts of presentation

Badger, G and Parr, M. (2004), *The Photobook: A History, Volume 1*, London: Phaidon.

Baker, G. (2005), 'Photography's Expanded Field', *October*, 114 (Fall): 120–40.

Barrett, T. (1990), *Criticizing Photographs: An Introduction to Understanding Images*, 3rd edn, New York: McGraw-Hill.

Barthes, R. (1977), 'The Photographic Message', in *Image-Music-Text*, trans S. Heath, London: Fontana.

Clarke, S. (2014), 'Review of *Post-Photography*', *Photomonitor*. Available online: https://www.photomonitor.co.uk/post-photography-the-artist-with-a-camera/ (accessed 4 January 2017).

Collins, M. (2002), 'The Long Look', *Tate Magazine*, 1 October. Available online: http://www.tate.org.uk/context-comment/articles/long-look-bernd-hilla-becher (accessed 5 January 2017).

Cotter, H. (2014), 'Testimony of a Cleareyed Witness: Carrie Mae Weems Charts the Black Experience in Photographs', *New York Times*, 23 January. Available online: https://www.nytimes.com/2014/01/24/arts/design/carrie-mae-weems-charts-the-black-experience-in-photographs.html?_r=0 (accessed 3 June 2016).

Fried, M. (2008), *Why Photography Matters as Art as Never Before*, New Haven: Yale University Press.

Gefter, P. (2015), 'Mishka Henner Uses Google Earth as Muse', *New York Times*, 28 August. Available online : http://www.nytimes.com/2015/08/30/arts/design/mishka-henner-uses-google-earth-as-muse-for-his-aerial-art.html (accessed 4 January 2017).

Godfrey, M. (2005), 'Photography Found and Lost: On Tacita Dean's *Floh*', *October*, 114 (Fall): 96–7.

Golden, T. (1998), 'Some Thoughts on Carrie Mae Weems', in *Carrie Mae Weems* (ed.) *Carrie Mae Weems: Recent Work 1992–1998*, with essays by Thomas Piché and Thelma Golden. New York: George Braziller.

Griffiths, P. J. (1971), *Vietnam Inc.*, New York: Collier Books

Jobey, L. (2015), 'Why Photobooks Are Booming in a Digital Age', *Financial Times*, 27 February. Available online: https://www.ft.com/content/be1fd978-bceb-11e4-a917-00144feab7de (accessed 20 August 2016).

Kirsh, A. and Sterling, S. F. (1993), *Carrie Mae Weems* [exhibition catalogue], Washing DC: National Museum of Women in the Arts.

Leiser, E. (1994), 'The Saddest Streets in the World: Shimon Attie Projects a Jewish Past on to Present-Day Berlin. Erwin Leiser, Himself a Child of the Thirties Ghetto, explains', *Independent*, 7 May. Available online: http://www.independent.co.uk/arts-entertainment/the-saddest-streets-in-the-world-shimon-attie-projects-a-jewish-past-on-to-present-day-berlin-erwin-1434580.html (accessed 03 October 2016).

Lennon, P. (2004), 'The Big Picture', *Guardian*, 31 January. Available online: https://www.theguardian.com/artanddesign/2004/jan/31/photography (accessed 20 December 2016).

Meiselas, S. and J. Garnett (2007), 'On the Rights of *Molotov Man*: Appropriation and the Art of Context', *Harper's Magazine*, February.

Mitchell, W. J. T. (1992), *The Reconfigured Eye: Visual Truth in the Post-Photographic Era*, Cambridge: MIT Press.

Mobasser, A. (2014), 'A Life Told with ID Photos', *LensCulture Emerging Talent*. Available online: https://www.lensculture.com/articles/ali-mobasser-a-life-told-with-id-photos (accessed 17 December 2016).

Poynor, R. (2015) 'Exposure: Mother and Child by Philip Jones Griffiths', *Design Observer*, 17 February. /available online: http://designobserver.com/feature/exposure-mother-and-child-by-philip-jones-griffiths/38770 (accessed 5 January 2017).

'Recent History: Photographs by Luc Delahaye, July 31–November 25, 2007' (2007), The J. Paul Getty Museum. Available online: http://www.getty.edu/art/exhibitions/delahaye/ (accessed 20 December 2016).

Rosengarten R. (2013), 'How Close Is Closer?', *London Grip*. Available online: http://londongrip.co.uk/2013/11/ruth-rosengarten-how-close-is-closer-the-work-of-dayanita-singh/ (accessed 20 November 2016).

Saxby, T. and Garcia, D. C. (2016), *Foreigner: Migration into Europe 2015–16*, London, A John Radcliffe project, http://www.johnradcliffestudio.com/.

Sayre, H. (1989), *The Object of Performance: The American Avant-Garde since 1970*, Chicago: University of Chicago Press.

Schmid, J., 'Other People's Photographs' (blog). Available at: http://www.lumpenfotografie.de/2013/07/21/other-peoples-photographs-2008-2011/ (accessed 14 January 2019).

Sekula, A. (1984) *Photography Against the Grain: Essays and Photo Works 1973–1983*, Halifax: The Press of Nova Scotia College of Art and Design.

Shore, R. (2014), *Post-Photography: The Artist with a Camera*, London: Laurence King.

Stange, M. (2005), 'Transnationalism in Contemporary African American Photography: Memory, History and "Universal" Narrative in the Work of Carrie Mae Weems', in D. Holloway and J. Beck (eds), *American Visual Cultures*, London: Continuum, 274–83.

Štrba, A. (2006) in *Deutsche Bank Art Mag*. http://db-artmag.de/archiv/2006/e/8/1/501-2.html [Accessed: 3 January 2017]

Sullivan, B. (2003), 'The Real Thing: Photographer Luc Delahaye', *Artnet Magazine*. Available online: http://www.artnet.com/magazine/features/sullivan/sullivan4-10-03.asp#8 (accessed 20 December 2016).

Tripathi, S. (2015), '"I am Loyal to Obsessions"', *The Hindu*, 11 December. Available online: http://www.thehindu.com/features/magazine/photographer-dayanita-singh-tells-shailaja-tripathi-she-has-moved-from-images-to-museums/article7976394.ece (accessed 20 November 2016).

Walker, J. A. (1997), 'Context as a Determinant of Photographic Meaning', in J. Evans (ed) *The Camerawork Essays: Context and Meaning in Photography*, London: Rivers Oram Press, 52–63.

Weems C. M. (2000), 'Carrie Mae Weems. From Here I Saw What Happened and I Cried. 1995' [audio recording], *MoMA 2000: Open Ends*, The Museum of Modern Art and Acoustiguide, Inc. Available online: http://www.moma.org/explore/multimedia/audios/207/2012 (accessed 6 June 2016).

Weems, C. M. (n.d.), 'Carrie Mae Weems on Her Series "From Here I Saw What Happened and I Cried"' [audio recording], Khan Academy. Available online: https://www.khanacademy.org/humanities/global-culture/identity-body/identity-body-united-states/v/weems-from-here-i-saw-what-happened (accessed 3 June 2016).

Wong, L., ed (2000), *Shootback: Photos by Kids from the Nairobi Slums*, London: Booth-Clibborn Editions, http://www.shootbackproject.org/students/.

Chapter 4: Visual narrativity

Ahronot, Y. (2012), 'Adi Nes: Yediot Ahronot Interview', trans G. Tishkoff, *Adi Nes* [website]. Available online: www.adines.com/content/VgrossEN.pdf (accessed 28 February 2017).

Alter, R. (1984), *Motives for Fiction*, Cambridge: Harvard University Press.

Baetens, J. (2001) 'Going to Heaven: A Missing Link in the History of Photonarrative.' *Journal of Narrative Theory*, 31.1 (Winter 2001), pp. 87–105.

Barnes, M. (2010), *Shadow Catchers: Camera-less Photography*, London: Marrell Publishers.

Bussard, K. A. (2006), 'Jill and Polly in the Bathroom', Art Institute of Chicago Museum Studies 32 (1). Available online: https://www.jstor.org/stable/4104514?seq=1#page_scan_tab_contents (accessed 7 January 2019).

Cole, J. (n.d.), *Jill Cole Photography* [website]. Available online: http://www.jillcole.com/ (accessed 28 February 2017).

Crewdson, G. (2006), 'Photographs by Gregory Crewdson', *Victoria and Albert Museum* [website]. Available online: http://www.vam.ac.uk/content/articles/p/gregory-crewson/ (accessed 28 February 2017).

References

Edwards, K. A. (2005), *Acting Out: Invented Melodrama in Contemporary Photography*, Iowa: The University of Iowa Museum of Art.

Grafik, C. (2008), 'Graduate Photography Online / 2008', *Source Photographic Review*. Available online: http://www.source.ie /graduate/2008/selection1/selection.html (accessed 28 February 2017).

Greenberg, C. (1964), 'Four Photographers', in J. O'Brian (ed), *Clement Greenberg. The Collected Essays and Criticism. Vol. 4, Modernism with a Vengeance*, 183–7, Chicago: The University of Chicago Press.

Hunter, T. (n.d.), 'Persons Unknown', *Tom Hunter* [website]. Available online: http:// www.tomhunter.org/persons-unknown/ (accessed 28 February 2017).

'Israeli Artist Adi Nes's "The Village" Series at Jack Shainman Gallery' (2012), *Huffington Post*, 22 May. Available online: http:// www.huffingtonpost.com/2012/05/22 /israeli-artist-adi-nes_n_1499681.html (accessed 28 February 2017).

Larrain, S. ([n.d.]). Magnum Photos. Available online: https://pro.magnumphotos.com /C.aspx?VP3=CMS3&VF=MAGO31_9 _VForm&ERID=24KL535Z8S (accessed 28 February 2017).

Lemoine, E. (2014), 'Interview of Duane Michals: "It's a liberation not taking yourself too seriously"', Actuphoto. Available online: https://actuphoto.com/30053-interview-of -duane-michals-its-a-liberation-not-taking -yourself-too-seriously.html (accessed 28 February 2017).

Loh, A. and A. Vescovi (2013), 'In Conversation: Interview with Photographer Gregory Crewdson', *The American Reader*. Available online: http://theamericanreader. com/interview-with-photographer-gregory -crewdson/ (accessed 28 February 2017).

López, A. (2001), 'Q & A with Gregory Crewdson', Cours sur la photo numérique [website]. Available online: http://photo numerique.codedrops.net/Q-A-with-Gregory -Crewdson (accessed 7 January 2019).

Navarro, J. (n.d.) 'Trashumantes*', Reportage*. Available online: http://reportage.co.uk /portfolio/trashumantes/ (accessed 28 February 2017).

Prince, G. (2008), 'Narrative, Narrativeness, Narrativity, Narratability', in J. Pier and J. A. García Landa (eds), *Theorizing Narrativity*, 19–27, Berlin: Walter de Gruyter.

Prix Pictet (2008), *Prix Pictet: Water*, London: teNeues.

Rejlander, O. G. (1863), 'An Apology to Art Photography', in V. Goldberg (ed), *Photography in Print*, 141–147, Albuquerque, NM: University of New Mexico Press.

Taylor, B. (2010), *Beds*, n.p.: author.

Wolf, W. (2005), 'Pictorial Narrativity', in D. Herman, M. Jahn and M.L. Ryan (eds), *The Routledge Encyclopedia of Narrative*, 431–5, London: Routledge.

Chapter 5: Photographic discourse

Alvarado, M. (2000), 'Photographs and Narrativity' in E. Mazur, E. Buscombe and R. Collins (eds), *Representation and Photography*, New York: Palgrave.

Barthes, R. (1977), *Image-Music-Text*, trans. S. Heath, New York: Hill and Wang.

Barthes, R. (1980), *Camera Lucida*, London: Vintage.

Barthes, R. (1983), 'Introduction to the Structural Analysis of Narratives', in S. Sontag (ed), *A Barthes Reader*, New York: Hill and Wang, 251–295.

Berger, J. (1978) 'Ways of Remembering', *Camerawork* (10).

Burgin, V. (1982), *Thinking Photography*, London: The MacMillan Press Ltd.

Bustamante, J. M. (2000), *Contacts*, Volume 2 [video], ARTE Video. Directors of the Contacts series are: Divers, Robert Delpire, Sarah Moon, Roger Ikhlef (see http://sales .arte.tv/fiche/479/CONTACTS).

Clarke, G. (1997), *The Photograph*, New York: Oxford University Press.

Coleman, A. D. (1976), 'The Directorial Mode: Notes Toward a Definition', *Artforum*, September: 55–61.

Conversations with History (1997), 'Images, Reality and the "Curse of History"' [video], UCTV: University of California Television, 10 April. Available online: http://www.uctv.tv /shows/Images-Reality-and-the-Curse-of -History-with-Gilles-Peress-Conversations -with-History-7134 (accessed 15 Mar 2017).

diCorcia, P. L. (1995), *Philip-Lorca diCorcia*, New York, Museum of Modern Art.

diCorcia, P. L. (2015), 'Reflections on Streetwork (1993–1997)' ASX, 1 August. Available online: http://www.american suburbx.com/2015/08/philip-%C2%ADl orca-dicorcia-reflections-on-streetwork -1993-%C2%AD1997.html (accessed 30 March 2017).

Frank, R. (1958) The Americans, France: Robert Delpire

Fusco (2008) The Fallen [multimedia presentation], *The New York Times* [online]. http://www.nytimes.com/interactive/2008 /06/01/magazine/20080601_RFKTRAIN _FEATURE.html?action=click&content Collection=Magazine&module=Related Coverage®ion=Marginalia&pgtype =article [Accessed: 25 March 2017]

Galassi, P. (1991), *The Pleasures and Terrors of Domestic Comfort*, New York: Museum of Modern Art.

Greenough, S. (2010), Inside photographer Robert Frank's The Americans. https://www .youtube.com/watch?v=mHtRZBDOgag (accessed 4 January 2019).

Kinley, C. (n.d.), 'Art Now: Jean-Marc Bustamante: Something is Missing', *Tate Britain* (website). Available online: http://www.tate.org.uk/whats-on/tate-britain /exhibition/art-now-jean-marc-bustamante (accessed 26 March 2017).

Kozloff, M. (1986), 'Through the Narrative Portal', *Artforum*, 24 (8), April: 97.

Lefebvre, M. (2007), 'The Art of Pointing: On Peirce, Indexicality, and Photographic Images', in J. Elkins (ed), *Photography Theory*, New York: Routledge.

Mahr, M. (n.d.), *Mari Mahr* [website]. Available online: http://marimahr.com/ (accessed 26 March 2017).

Neri, L. (2001), *Settings and Players: Theatrical Ambiguity in American Photography*, London: White Cube.

Niwa, H. (2009), 'The Photographer as Pendulum – the Arc between the Moment and Eternity', in *Foam Magazine*, (14).

'Photographer Mari Mahr: Inventory of Ourselves and Other Works' (2014), *The Telegraph*, Available online: http://www .telegraph.co.uk/culture/photography /10612487/Photographer-Mari-Mahr -Inventory-of-Ourselves-and-Other -Works.html?frame=2809603 (accessed 26 March 2017).

Puranen, J. (1999), 'Faces from the Past' in *Imaginary Homecoming / Kuvitteellinen kotiinpaluu*, trans. P. Landon, Pohjoinen, Finland.

Schröter, J. (2013), 'Photography and Fictionality', *Mediascape: UCLA's Journal of Cinema and Media Studies*, Winter. Available online: http://www.tft.ucla.edu/mediascape /Winter2013_Photography.html (accessed 15 February 2017).

Smith, D (2009) 'Legends of the Bang Bang Club', *David Smith's Letter from Africa* [podcast] in *Guardian*, 22 September. Available online: https://www.theguardian .com/world/audio/2009/sep/22/south-africa -bang-bang-club (accessed 4 April 2017).

Stewart, S. (1993), *On Longing: Narratives of the Miniature, the Gigantic, the Souvenir, the Collection*, Durham, NC: Duke University Press

Szarkowski, J. (1966), *The Photographer's Eye*, New York: Museum of Modern Art.

West, R. (1998) 'Review: Between Ourselves – The Photographs of Mari Mahr', *Source* 15, 5 (1). Available online: http://www.source.ie /issues/issues0120/issue15/is15revbetour .html (accessed 25 March 2017).

Chapter 6: Image and text

A Few Days in Geneva (n.d.). Available online: http://v1.zonezero.com/exposiciones/fotografos/mahr/geneva/geneva01.html (accessed 11 January 2019).

Armstrong, S. (2010), 'Cage Fighter', Sublime, issue 19, 1 January. Available online: http://sublimemagazine.com/cage-fighter (accessed 1 April 2017).

Bajak, A. (2015), 'An Artful Telling of the Tragic: Behind the Scenes with a Boston Globe Photojournalist', Storybench, 2 December. Available online: http://www.storybench.org/artful-telling-tragic-behind-scenes-boston-globe-photojournalist/ (accessed 24 March 2017).

Barth, M. (1998), Weegee's World, New York: Little, Brown.

Barthes, R. (1977), Image-Music-Text, trans. S. Heath, New York: Hill and Wang.

Batchen, G and N. McClister (2008), 'Taryn Simon', Museo Magazine. Available online: http://www.museomagazine.com/filter/Geoffrey-Batchen/TARYN-SIMON (accessed 16 February 2017).

Berger, J. and Mohr J. (1989), Another Way of Telling, Cambridge: Granta.

Bicker, P. (2015), 'Ways of Seeing: The Contemporary Photo Essay', Time LightBox, 1 January. Available online: http://time.com/3626915/ways-of-seeing-the-contemporary-photo-essay/ (accessed 25 March 2017).

Boothroyd, S. (2015), 'Mary Frey', Photoparley [blog]. Available online: https://photoparley.wordpress.com/2015/07/15/mary-frey/ (accessed 18 March 2017).

Frizzell, N. (2017), 'Interview: Shirin Neshat's Best Photograph: An Iranian Woman with a Gun in Her Hair', Guardian, 5 January. Available online: https://www.theguardian.com/artanddesign/2017/jan/05/shirin-neshat-best-photograph-iranian-woman-with-gun-in-her-hair (accessed 4 April 2017).

Genette, G. (1997), Paratexts: Thresholds of Interpretation, Cambridge: Cambridge University Press.

Goldberg, J. (2015) 'In My Own Words: Jim Goldberg, Photo Storyteller', Huck, 7 May. Available online: http://www.huckmagazine.com/art-and-culture/photography-2/flipping-gaze-photos-jim-goldberg-documentary-storyteller/ (accessed 25 March 2017).

Jean-Marc Bustamante: Biography' (n.d.), Galerie Thaddaeus Ropac [website]. Available online: https://www.ropac.net/artist/jean-marc-bustamante (accessed 11 January 2019).

Heartney, E. (2009), 'Shirin Neshat- An Interview with Eleanor Heartney', Art in America, p.152-9]

Helmuth, L. (2013), in Erik Vance, 'When Photographers and Writers Work Together', https://pulitzercenter.org/blog/pictures-and-prose-when-photographers-and-writers-work-together (accessed 11 January 2019).

Holschbach S. (n.d.), 'Sophie Calle', Media Kunst Netz [website]. Available online: http://www.medienkunstnetz.de/works/hotel/ (accessed 3 March 2017).

Jaschinski, B. (1996), Zoo, London: Phaidon

Jobey, L (2004), 'Six Reflections on the Photography of Robert Frank', Tate Etc., Issue 2.

Komaroff, L. (2015), 'Intentionality and Interpretations: Shirin Neshat's Speechless', Unframed, Los Angeles County Museum of Art [website]. Available online: http://unframed.lacma.org/2015/11/02/intentionality-and-interpretations-shirin-neshat%E2%80%99s-speechless (accessed 25 March 2017).

Lambert-Beatty, C. (2009), 'Make Believe: Parafiction and Plausibility', October (129).

Martin, D. (2007), 'Alexandra Boulat, War Photographer, Is Dead at 45', New York Times, 6 October. Available online: http://www.nytimes.com/2007/10/06/arts/06boulat.html (accessed 25 March 2017).

Merlino, G. (2008), 'Sophie Calle: A Lover's Monologue', Aperture (191).

Neri, L. (2006), Wendy Ewald: Towards a Promised Land, Göttingen/London: Steidl/Artangel.

Pedicini, I. (2012), Francesca Woodman: The Roman Years: Between Flesh and Film, Rome: Contrasto.

Parr, M. (2007), 'Small thing writ large', Guardian, 18 May. Available online: https://www.theguardian.com/theguardian/2007/may/19/weekend7.weekend4 (accessed 4 March 2017).

Peress, G. (1983), Telex Iran: In the Name of Revolution, New York: Aperture.

Peres, M. R. ed (2007), The Focal Encyclopedia of Photography, Oxford: Focal Press.

Power, M. (2005), 'Between Something and Nothing', visiting lecture delivered at the University of Brighton, November. Available online: http://www.markpower.co.uk/media/pdf/Between%20Something%20and%20Nothing.pdf (accessed 4 March 2017).

Ritchin, F. (1989), In Our Time: The World as Seen by Magnum Photographers, New York: The American Federation of the Arts.

Sand, M. (1997), 'Duane Michals', Aperture, (146).

'Shirin Neshat. Speechless. 1996' [audio recording] (1996), MoMA [website]. Available online https://www.moma.org/explore/multimedia/audios/27/652 (accessed 4 April 2017).

Simon, T. (2008), An American Index of the Hidden and Unfamiliar.

Soutter, K. (2016), 'Showing and Telling: Narrative Photography from Pictures to Parafictions', in R. Barilleaux (ed) , W. Chiego, A. Garza, G. Harris, L. Soutter. Telling Tales, San Antonio, Texas: McNay Art Museum.

Spence, J. (1986), Putting Myself in the Picture: A Political, Personal and Photographic Autobiography, London: Camden Press

'The 2016 Winner of the Pulitzer Prize in Feature Photography' (n.d.). Available online: https://www.pulitzer.org/winners/jessica-rinaldi (accessed 11 January 2019).

Townsend, C (2006), Francesca Woodman, London: Phaidon Press.

Vance, E. (2013) 'Pictures and Prose: When Photographers and Writers Work Together', The Open Notebook, 15 October. Available online: http://www.theopennotebook.com/2013/10/15/pictures-and-prose-photographers-writers-work-together/ (accessed 6 April 2017).

Van Gelder, H. and Westgeest, H. (2011), Photography Theory in Historical Perspective, Chichester: Wiley-Blackwell.

'Wendy Ewald' (n.d.), Literacy through Photography Blog, Centre for Documentary Studies, Duke University. Available online: https://literacythroughphotography.wordpress.com/wendy-ewald/ (accessed 3 April 2017).

Yoon, R. and M. Carasquillo (2016), 'An Interview with Duane Michals', The Ground Magazine. Available online: http://www.thegroundmag.com/an-interview-with-duane-michals/ (accessed 25 March 2017).

Conclusion

Ikeda, D. and Toynbee A. (2007), Choose Life: A Dialogue, London: I.B.Tauris.

Jay, B. (1988), 'The Thing Itself: The Fundamental Principle of Photography', Bill Jay on Photography. Available online: www.billjayonphotography.com/The%20Thing%20Itself.pdf (accessed 6 April 2017).

Online resources

1000wordsmag.com
An online magazine highlighting the best in contemporary photography.

americansuburbx.com
Edited archive of photography's past and present.

aperture.org
The Aperture Foundation supports photography in all its forms. This online resource details exhibitions, books, magazine, lectures and other Aperture-supported activities.

bjp-online.com
The British Journal of Photography was established in 1854 and is the world's longest-running photography magazine.

centreforthestudyof.net
A research centre focusing on the impact of digital technologies and network cultures on art and photography.

deutscheboersephotography foundation.org
An international organization supporting contemporary photography and organizing the prestigious Deutsche Börse Photography Prize.

foto8.com/new
A biannual print publication and online magazine of photojournalism and documentary photography.

fotomuseum.ch/en/explore/still-searching/28677_about
'A continually growing online discourse on the media of photography' by Fotomuseum Winterthur.

fulltable.com
An enormous online resource of visual storytelling.

icp.org
The International Centre of Photography has an extensive online resource including The Photographers Lecture Series Archive.

lensculture.com
An online magazine celebrating international photography.

magnumphotos.com
Founded in 1947, Magnum Photos is an international photographic cooperative owned by its members.

photomediationsmachine.net
An online curated space devoted to photography in combination with the concept of 'mediation'.

photovoice.org
Organization supporting participatory photography and projects encouraging social change.

photoworks.org.uk
Photoworks commissions and publishes contemporary photography in the southeast of England.

portfoliocatalogue.com
This site shows contemporary photography in Britain; it has been discontinued in print, but the online resource covers details of past issues.

seesawmagazine.com
An online photography magazine.

source.ie
A quarterly magazine of contemporary photography with an online archive.

worldpressphoto.org
One of the oldest photography contests and award-winning collections, focusing on journalism.

Cover: Seba Kurtis

Page 3: Glenn Bowman

Page 8: Courtesy Alexander Gray Associates, New York; © Luis Camnitzer/Artists Rights Society (ARS), New York

Page 12: Sandy Springs Bank Robbery (c. 1920) © Library of Congress, Prints & Photographs Division, LC-DIG-npcc-29055

Page 14: Photo by W. Eugene Smith/The LIFE Picture Collection/ Getty Images

Page 15: Gladys, East London, South Africa, 2009. Image courtesy of artist, Shaleen Temple

Page 17: © 2019. Digital image, The Museum of Modern Art, New York/Scala, Florence

Page 19: Courtesy of Leikun Nahusenay

Page 21: Unknown

Page 23: Mother of Martyrs © Newsha Tavakolian, Courtesy of Magnum Photos

Pages 24 and 25: Ghost of a Tree: Image courtesy of the artist. Badlands Concrete Bend: Image courtesy of Grimm Gallery, Amsterdam, NL.

Page 27: Robert Johnson and Arthur Brunel Chatwood

Pages 30 and 31: Richard Kolker

Page 33: Elisavet Kalpaxi

Page 34: © Richard Rowland/ Millennium Images, UK

Page 37: Miss Grace's Lane 1986-87 All images © Keith Arnatt Estate. All rights reserved. DACS 2019

Page 38: Zoe Leonard, copyright © 2012 Camden Arts Centre

Page 42: © Ray Fowler LRPS

Page 47: Josh and Luke and Bronwyn from 'Young Carers' © Michelle Sank

Page 49: Dr Feelgood © Keith Morris Archive www. keithmorrisphoto.co.uk

Page 51: Copyright © 2016 Xu Qunhan

Pages 53 and 54: Copyright © 2016 Benjamin Mensah

Page 55: © Polly Braden

Page 57: Cuba, Havana. Bar Girl in a Brothel in the Red Light District. 1954. © Eve Arnold/Magnum Photos.

Pages 58 and 59: photography by Olena Slyesarenko

Page 60 and 62: © Jem Southam

Page 64: © Laura Pannack

Pages 65 and 67: © 2013 Liza Campion

Pages 69 and 71: Seba Kurtis

Pages 72 and 75: © Stuart Griffiths

Pages 76 and 79: Copyright © 2013 Aida Silvestri

Page 82: Annelies Štrba

Page 85: Courtesy Luc Delahaye and Galerie Nathalie Obadia, Paris and Brussels

Page 87: © Mishka Henner

Page 89: © Christian Boltanski

Page 91: Copyright © 2016 Ali Mobasser

Page 93: NICARAGUA. Esteli. 1979. Sandinistas at the walls of the Esteli National Guard headquarters. © Susan Meiselas/Magnum Photos.

Page 95 above: Saidi Hamisi - SHOOTBACK

Page 95 below: Peter Ndolo - SHOOTBACK

Page 97: Shimon Attie © DACS 2019

Page 99: Stephen White. Dayanita Singh, Go Away Closer, 2013. Installation view, Hayward Gallery, London, 2013 © Stephen White

Page 100 above: © Lalage Snow

Page 100 below: Jamie Sinclair

Pages 102 and 105: © Simon Carruthers

Pages 106 and 109: Daniel Castro Garcia/John Radcliffe Studio

Pages 110 and 113: © Carrie Mae Weems. Courtesy of the artist and Jack Shainman Gallery, New York.

Page 116: © Tina Barney

Pages 120 and 121: © José Navarro/Pangeafoto

Page 123: © Duane Michals. Courtesy of DC Moore Gallery, New York

Page 125: © Jill Cole/Millennium Images, UK

Page 127: © Barbara Taylor

Page 128: Pole vault, chronophotography by Etienne-Jules Marey, 1887 (Photo by Apic/ Getty Images)

Page 129: Photo by The Royal Photographic Society Collection/ National Science and Media Museum/SSPL/Getty Images

Page 131: Elisavet Kalpaxi

Page 134: © Gregory Crewdson. Courtesy Gagosian Gallery

Page 135: Women Reading Possession Order, courtesy of the Artist Tom Hunter

Page 137: Robert DOISNEAU/ RAPHO

Page 138 above: L. Mukabaa

Page 138 below: Andrea Cavallini/ Getty Images

Page 142: Susan Derges

Pages 144, 146 and 147: Adi Nes, Courtesy Jack Shainman Gallery, New York

Page 150: Walker Evans © Library of Congress, Prints & Photographs Division, FSA/OWI Collection, LC-USF342-T01-008098-A

Page 155: © 2017 Philip-Lorca diCorcia, courtesy David Zwirner, New York

Pages 156 and 157: Courtesy Marian Goodman Gallery, New York © Gabriel Orozco

Page 159: Copyright © 2014 John Sunderland

Page 160: Robert Frank/Pace/ Macgill Gallery

Page 162: © 2016 Nikol Parajová

Page 163: © Jorma Puranen, courtesy of Purdy Hicks Gallery, London

Page 165: © Risaku Suzuki, Courtesy of Taka Ishii Gallery

Page 167: Copyright © 2014 John Sunderland

Page 169: © Paul Fusco/Magnum Photos

Pages 170, 172 and 173: Copyright Mari Mahr

Index

Sri-Kartini Leet is an experienced academic who has taught photography at universities for over two decades. Her research, encompassing practice and theory, explores photography within a larger cultural context with reference to different modes of practice, migration and identity. She is currently Head of School for Art, Design and Performance at Buckinghamshire New University, UK.

Elisavet Kalpaxi is an artist, lecturer and researcher. Her discursive interests lie with narrativity and photography's contemporary criticality; also, with discursive shifts in art history, theory and practice, influenced by technological and socio-political/economic developments. She has presented her work in numerous exhibitions and conferences internationally and is currently teaching at the University of Northampton, UK.

Maria Short is a photographer, writer and a Senior Lecturer in Photography at the University of Brighton, UK. Her long-term professional practice explores photographic portraits of the domestic animal and the ways in which the human-animal relationship is visually represented. She was author of the first edition of this text.